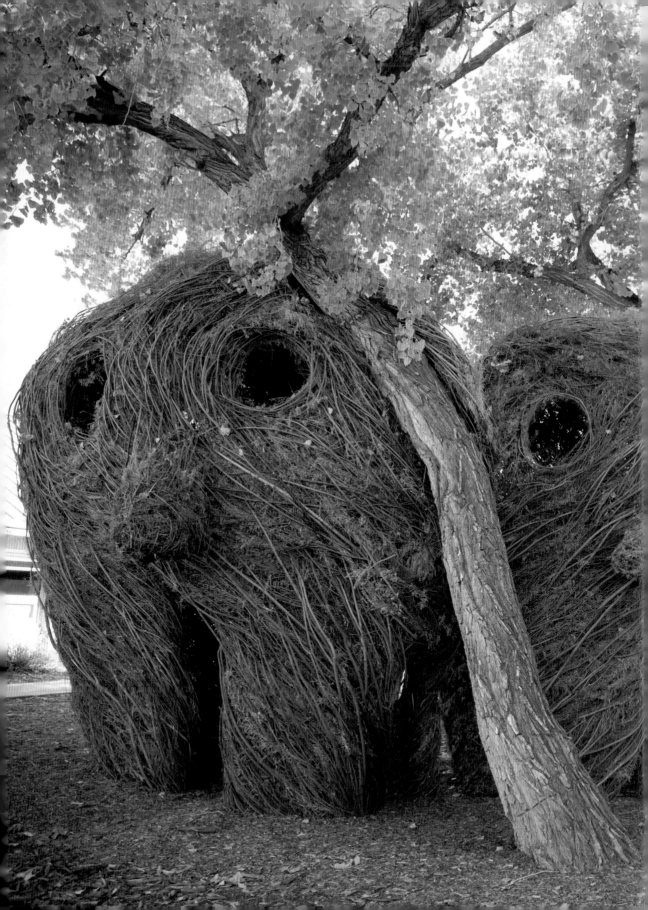

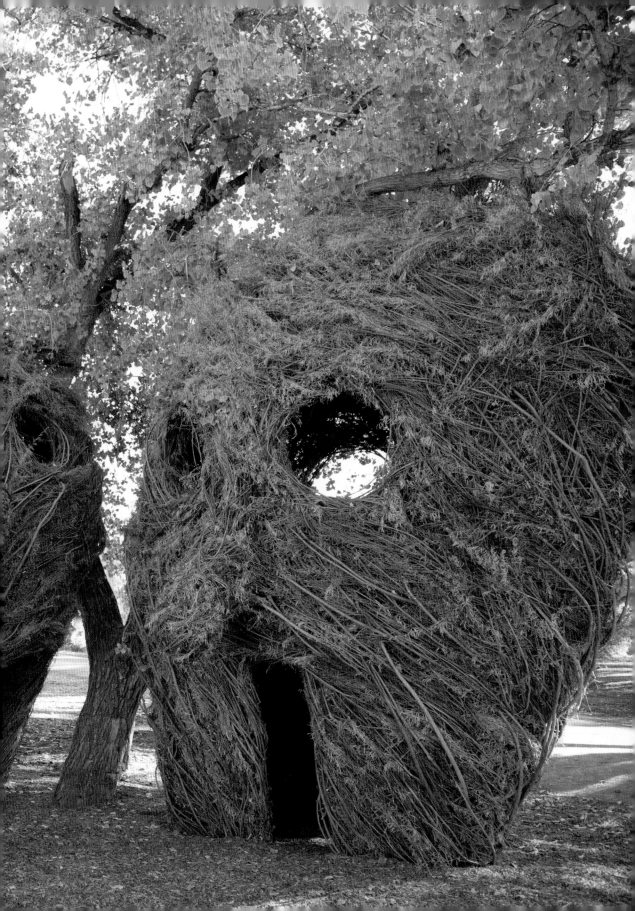

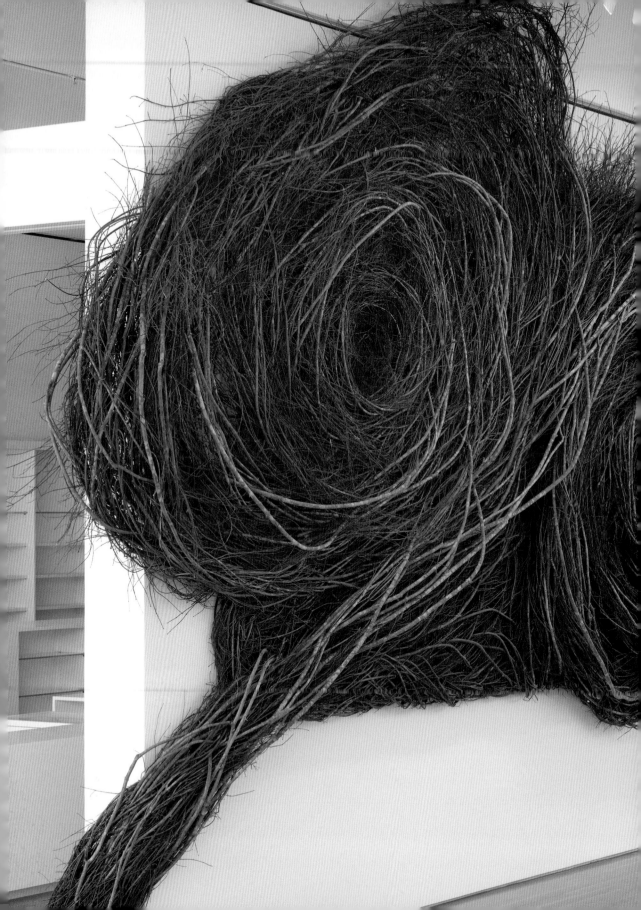

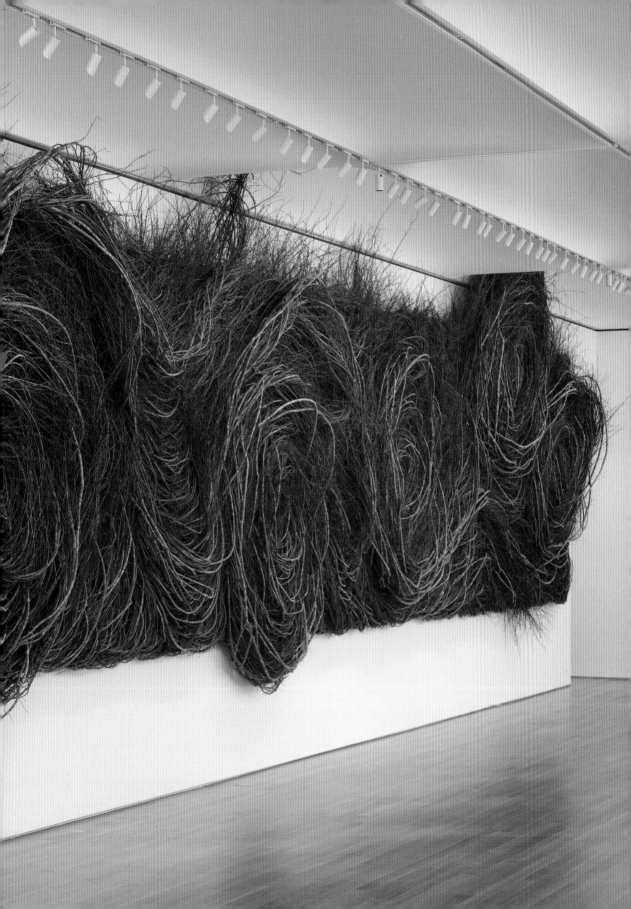

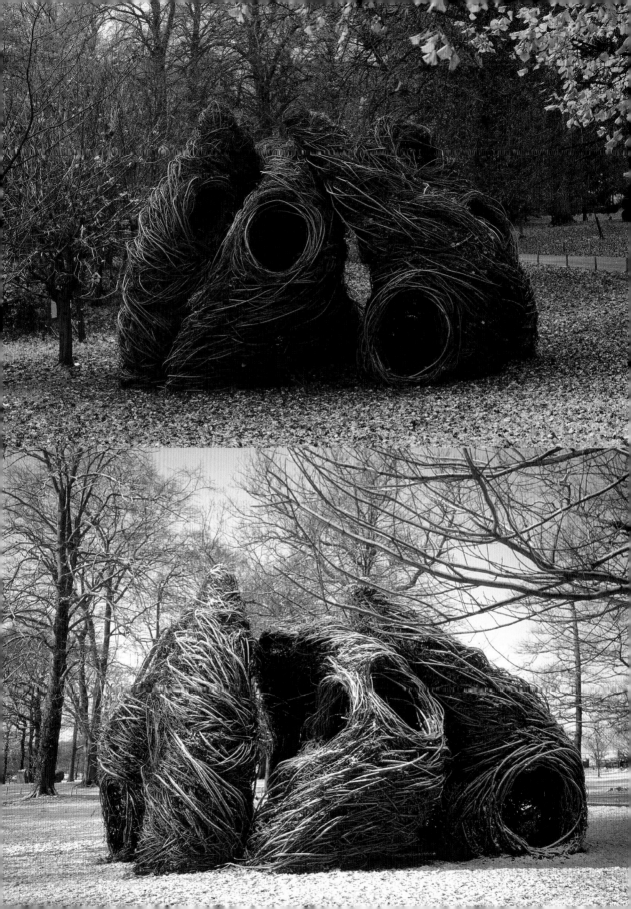

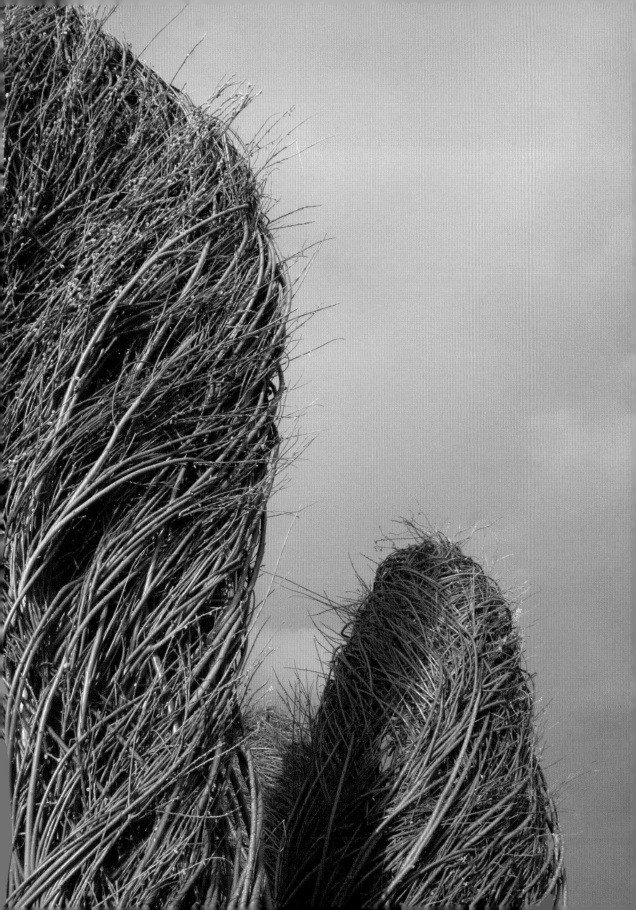

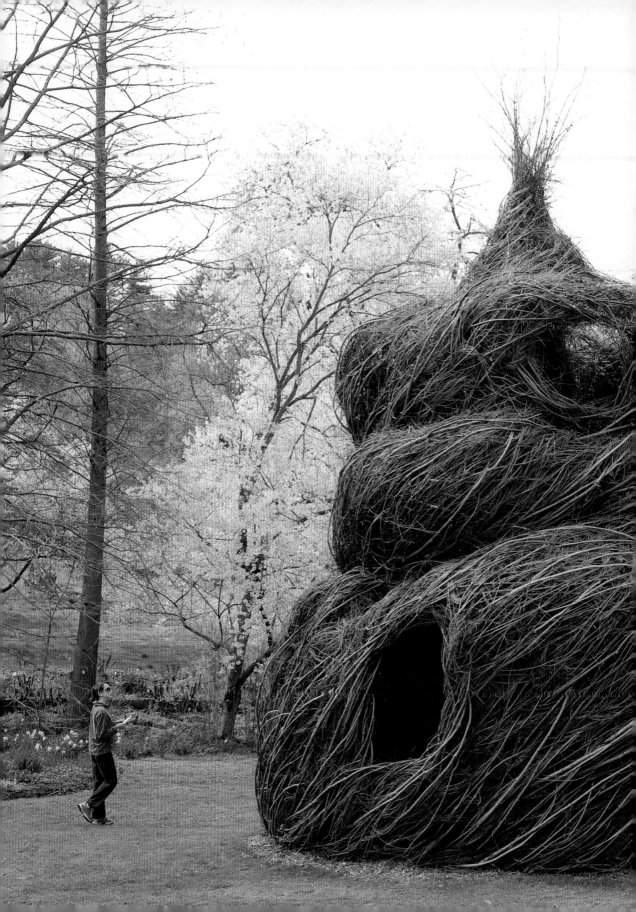

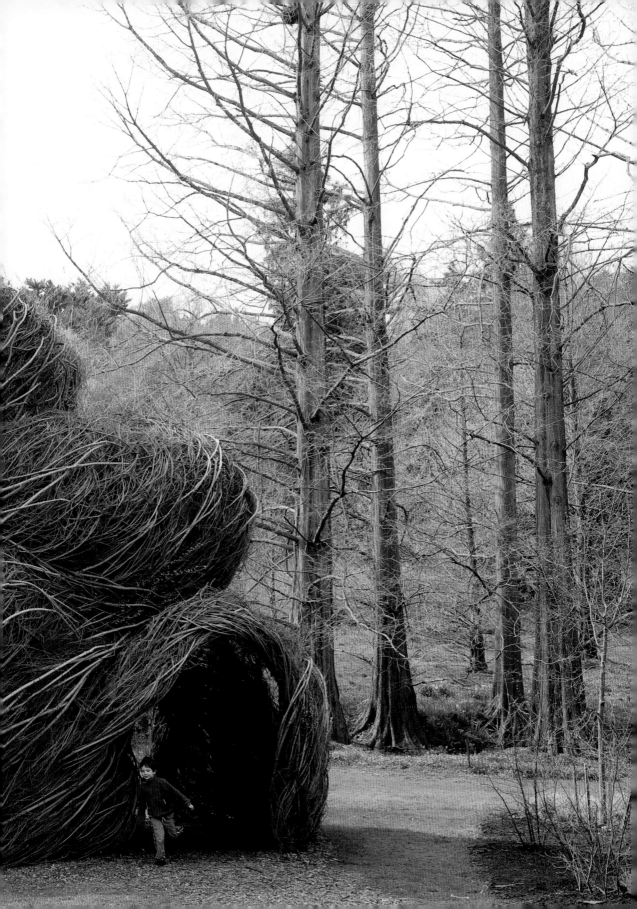

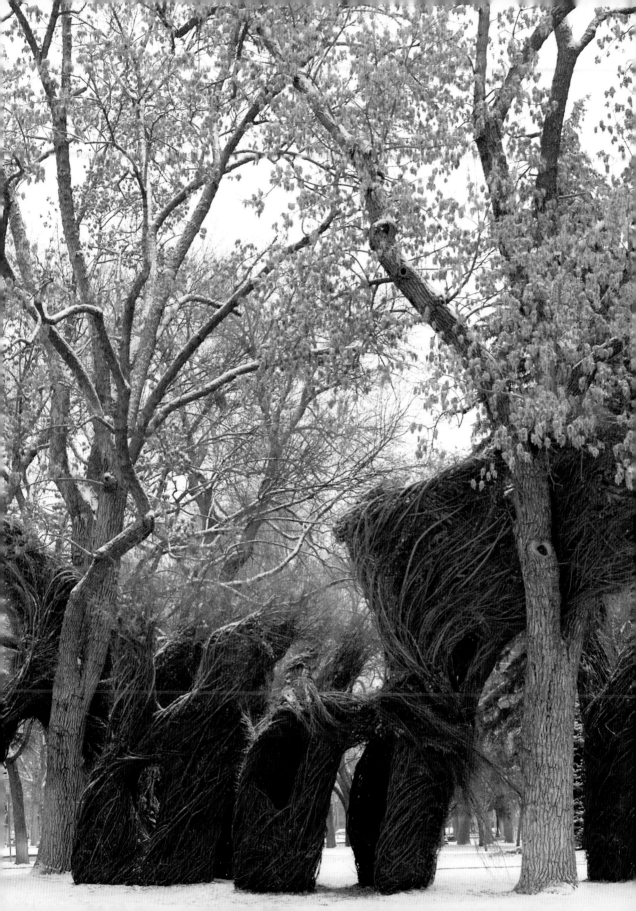

STICKWORK

Patrick Dougherty

Princeton Architectural Press
New York

Published by
Princeton Architectural Press
A McEvoy Group company
202 Warren Street
Hudson, New York 12534

Visit our website at www.papress.com.

2-3 *Here's Looking at You,* 2009, Bosque School, Albuquerque, NM. Sponsored by The FUNd at the
 Albuquerque Community Foundation.
4-5 *Out of the Box,* 2009, North Carolina Museum of Art, Raleigh, NC
6 *Huddle Up,* 1993, Yorkshire Sculpture Park, West Bretton, England
8-9 *Summer Palace,* 2009, Morris Arboretum of the University of Pennsylvania, Philadelphia, PA
10 *Creature Comforts,* 2008, Colorado College, Colorado Springs, CO

Editor: Linda Lee
Designer: Jan Haux

Special thanks to: Nettie Aljian, Bree Anne Apperley, Sara Bader, Nicola Bednarek,
Janet Behning, Becca Casbon, Carina Cha, Tom Cho, Penny (Yuen Pik) Chu, Carolyn Deuschle,
Russell Fernandez, Pete Fitzpatrick, Wendy Fuller, Laurie Manfra, John Myers,
Katharine Myers, Steve Royal, Dan Simon, Andrew Stepanian, Jennifer Thompson, Paul Wagner,
Joseph Weston, and Deb Wood of Princeton Architectural Press
—Kevin C. Lippert, publisher

Library of Congress Cataloging-in-Publication Data
Dougherty, Patrick, 1945-
Stickwork / Patrick Dougherty. — 1st ed.
208 p. : ill. (chiefly col.) ; 25 cm.
ISBN 978-1-56898-862-7 (hc.) — ISBN 978-1-56898-976-1 (pbk.)
1. Dougherty, Patrick, 1945 — Themes, motives. 2. Plants as art material — United States.
3. Site-specific sculpture. I. Title.
NB237.D68A4 2010
730.92—dc22

2009050120

Contents

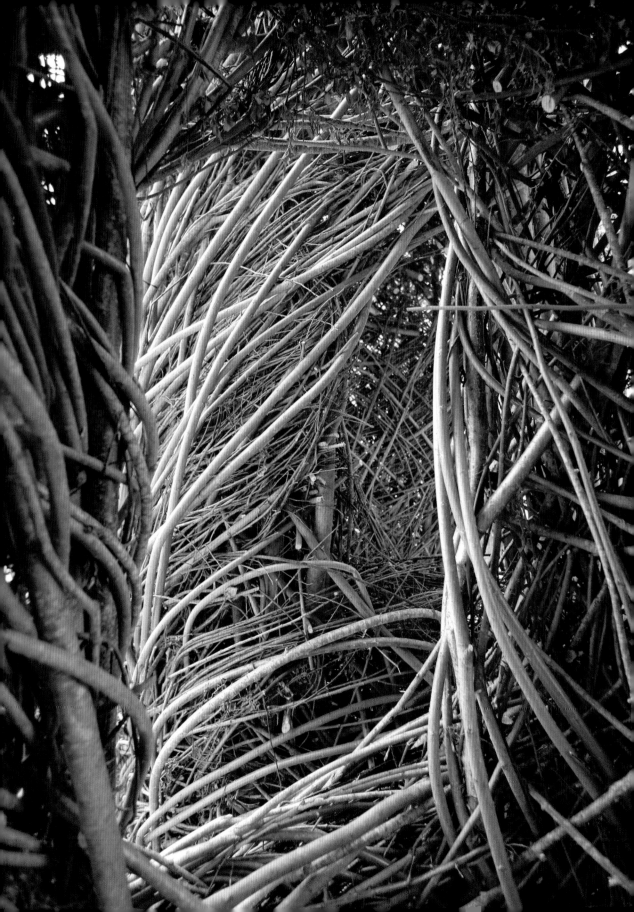

Preface

I love to make things, and as a child I bugged my mother by constantly declaring, "I bet I could make that" about everything from bicycles to rock gardens to a new pair of shoes. When I decided to pursue postgraduate work in the art department at the University of North Carolina, I was surprised to find so many others like me, dedicated people who love working with materials and seeing their ideas realized. As a novice sculptor, I learned the ropes from more developed artists at Center Gallery, an artist-run space in Carrboro, North Carolina. In addition, I received enormous encouragement from my friends, Scott Bertram, the Juhlin family, Christy Lee, Mike Cindric, Dawn Barrett, and my sister, Kate Farrell. During this formative time, I met Susan Peterson, a visiting professor to UNC, who mentioned that the only requirement for becoming a "national" artist was the willingness to be "in the nation." Soon I set sail on a bigger sea, realizing that full-time work would mean constant travel.

Taking advantage of a new art trend of building sculptures on location, I began to work on-site for museums, artist-run spaces, sculpture parks, gardens, and private individuals around the United States and then farther afield. I initially exported saplings from North Carolina to other places, using a truck and trailer purchased with money from a North Carolina Arts Council artist fellowship. However, I quickly found that the typical cycle for urban expansion meant that I could find a supply of saplings in almost every community; that is, when forests are cut at the edge of town, the scrubby regrowth is available until the bulldozers arrive for final clearing.

I would like to thank all the organizations who have sponsored me over the years. It has been a wonderful adventure and a rich learning experience. I also offer heartfelt thanks to all those who have reached out to me in every community — the hundreds of people who have volunteered their time to help with the logistics or actually bend the sticks into place. Finally, hats off to all the passersby who stopped to look at the work and chat with me about their reactions to sculpture and other important issues. These encounters made the travel worthwhile and had a profound influence on the course of my work. Closer to home, I would like to thank my wife, Linda, for her encouragement over the years and my assistant, Dorothy Juhlin Bank, for all her hard work in the preparation of this book.

The Incredible Rightness of Being

Jennifer Thompson

Everyone has a stick story. It may be as simple as how our family
collects kindling when walking through the woods, or about the
tepee we made as kids by leaning sticks up against a tree to
create a secret hiding place, or a collection of bird nests found
in the forest, each remarkable in the way small branches have been
intricately woven into a lightweight basket capable of holding a
family of small creatures, protecting them from rain, wind, and
predators.

There is something elemental, almost primal, in the appeal
of sticks and their parents, trees; their history precedes our own,
and they have been man's constant companion since the earliest
days, as shelter, nourishment, and fuel. Several trees alive today
are more than four thousand years old, and the oldest known living
organism, a Quaking Aspen in Utah, is believed to be as much as
eighty thousand years old. No wonder the human connection to trees
is, in many cultures, a spiritual one, symbolic of both life and
immortality. Ancient trees like the Pion Pine take on deep spiritual
meaning for many cultures and have come to epitomize humankind's
deep dependence on trees. In Genesis the tree represents both life
and knowledge. In Egyptian mythology, the acacia tree of the goddess
Saosis is seen as the tree of life as well as the birthplace of
deities. The world tree, a tree that connects the heavens with earth
and is rooted in the underworld, is found in the iconography of
most Pre-Columbian Mesoamerican cultures as well as in Hungarian,
Norse, and Finnish mythologies. In Chinese lore, the peach tree that
bears fruit every three thousand years offers eternal life to the
one who eats it. In India, two varieties of fig trees, the banyan
and the peepal, are revered as the trees of life. More interesting
is the myth of the Green Man, a figure found in many variations and
cultures throughout the world. The Green Man is an artistic work of
a face made of leaves, often including other types of foliage, such
as vines, branches, and flowers. These works are common on church
facades symbolizing rebirth and the changing of the seasons. People
take their sticks seriously, and always have.

Artist Patrick Dougherty's stick story is both more complex
and rewarding. Indeed, his work invokes the metaphysical appeal
of trees through the ages, along with the comfort we all find

in inhabiting spaces made of natural materials. For many, tree houses are the perfect places for solitude, and the wooden cocoons Dougherty weaves out of sticks are very much the spaces of dreaming, if not spiritual retreat.

In addition to freestanding structures, Dougherty's works function just as easily as adornment, as seen in the installations *Highfalutin'* (1988), *Holy Rope* (1992), *Running in Circles* (1996), and even *Cell Division* (1996), a lattice woven on the facade of the Savannah College of Art and Design. What shape the works take depends very much on the site and the methodology used: he works on a building, using existing architecture as a base; he uses trees as a matrix; or he creates freestanding structures situated independently.

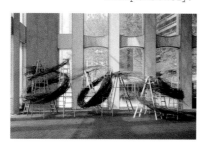 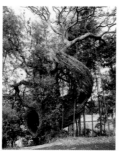 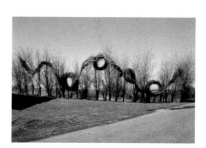

Dougherty experiments successfully with more assertive structures in *Spinoffs* (1990), in which hives grow out of the roof of an existing building but also interconnect to a freestanding hut on the ground. In this case the work depends on the architecture for support. In *Spring Forward, Fall Back* (1992), and in other works from this period, Dougherty began to work without support — no trees or buildings hold up these pieces. In *Spring Forward* reeds and forest bamboo are interwoven to make a train of loop the loops that appear to fly across the sky, but are actually anchored to the ground by more reeds.

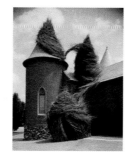 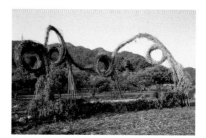

In *Huddle Up* (1993) the freestanding figures look wind-blown, almost as if swaying. Dougherty took his inspiration from the Neolithic grave sites in Yorkshire, the shape being both boulder and overcoatlike. Although surrounded by trees, these shapes are supported only by one another and their own internal structure.

Dougherty's recent work is his most architectural yet. In *Square Roots* (2006), an installation at Brown University, Dougherty is very interested in the idea of stacking, and this installation is filled with geometric blocklike forms stacked one atop the other, like so many rooms gone awry. *Square Roots* is followed by *Xanadu* (2007), a complicated piece that includes an inner dome and oculus surrounded by eight small chambers, which the artist refers to as "a small enchanted city." Although Dougherty references Samuel Coleridge's poem "Kubla Khan" (1816) as inspiration, you can't help but think of a small rudimentary Pantheon made of sticks instead of stone. The fine line between architecture, landscape, and art is here very blurry indeed. Dougherty's work defies simple classification and oscillates between architectural folly and teapot, between giant creature and city of forms. The variations in scale and form are ever-changing.

The majority of Dougherty's intricate designs are completed within a self-imposed deadline of three weeks, the magical time period for Dougherty and one that allows him to create an installation a month. "One week isn't enough time, two weeks is pushing it, and three weeks is just enough time to pull it off and get people organized. Any longer and you might as well live there," he recounts. Nevertheless, the fifteen working days are often "bracketed by indecision." When materials are gathered in advance, Dougherty has the full fifteen days to work on the project (he returns home most weekends to be with his wife and teenage son); when he has more time Dougherty can create larger-scale installations. On the other hand, when Dougherty has to look for and harvest materials himself or has to spend time organizing or finding volunteers his time to construct a project decreases. These variables explain the myriad sizes of each of the installations as well as the differences in levels of intricacy.

Dougherty's creative interest in sticks began during his childhood, exploring the pine forests that grew outside his North Carolina childhood home. In the late 1970s, as a young man, he built

his own house using wood gathered from abandoned local tobacco barns, as well as found stone salvaged from his land in rural North Carolina. Making his home with his hands was the catalyst that led Dougherty to pursue an artistic career. This home is also where Dougherty returns

to be inspired and to plan out most of the two hundred plus sculptures that he has created in the past twenty-five years. Fascinated by the creative possibilities of woodworking, Dougherty applied and was admitted in 1980 to the art department at the University of North Carolina at Chapel Hill — a bold step for a man with an existing career in hospital administration.

Dougherty's first project, *Maple Weave* (1982), allowed him to investigate the process of creating sculpture out of sticks. It is a project in which he discovered what birds already know, that branches have a wonderful tendency to entangle with each other. The process of weaving is one the material itself wholeheartedly embraces. To this day, Dougherty only uses sticks in his work, which coincides with the transient nature of the sculptures. He says,

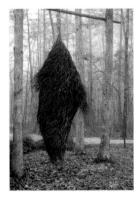

"The use of such ephemeral materials means that the sculpture has the same life cycle as the sticks themselves, and ultimately it disintegrates and fades back into the landscape, becoming mulch for new life." It was his next project, *Maple Body Wrap* (1982), however, that propelled him into the art world. Dougherty created the piece for his last student show; a curator at the North Carolina Museum of Art in Raleigh saw it and encouraged Dougherty to submit the work to the 1982 North Carolina Artist Exhibition. From there, he received the attention and commissions needed to ignite his career as an artist.

While the scale and intimacy of Dougherty's work invites individual reverie, there is a community aspect that is no less compelling; Dougherty's works — supporting institutions vary from project to project — are created in conjunction with a local organization that agrees to provide logistical assistance. Dougherty uses this partnership as a way to gain goodwill and leverage in the community, which in turn helps gain support for the sculpture. He is very hands-on and able to guide, teach, and explain to both the sponsoring organization and the group of volunteers to get the job completed. It is this ability to work with all types of people — students, farmhands, curators, maintenance workers — that keeps Dougherty focused, but it also keeps the work progressing in a timely manner. This facility for bringing people together is key to Dougherty's efficient process, a process where time and organization are crucial factors in the completion of each work.

In exchange for a stipend, vehicle, lodging, and meals, a stick creation is born from the site, saplings, and Dougherty's imagination. Drawing from culture, mythology, history, science, literature, and dreams, Dougherty creates from scratch structures that are at once willowy and robust. Dougherty's early works were modest in size; more object than installation. But as Dougherty gained access to larger and larger spaces — from a small corner in an exhibition show, to a gallery space, to the outdoors — his projects grew in scale and took on architectural elements that played against existing buildings or within the natural setting of trees and landscape. "It's the idea of creating something that is responsive to its site, of folding something into a space to make it feel like it has always been there, a rightness of being. These ideas of process I use again and again," Dougherty explains.

For a typical project, Dougherty makes an initial visit to sketch out his plans and find the perfect site within the campus, plaza, street, or town. He works with the local administrations of the city or host institution to select the spot best suited for his large nestlike structures. He then returns to the site for three weeks and organizes a team of workers — usually up to four people at a time, which means potentially fifty participants for a single project — as well as access to saplings. When he has to hunt materials down himself, he scavenges from vacant lots or riverbeds, the sides of highways, or under power lines. He looks for places where there is overgrowth or where thinning can take place without endangering

the habitat. Often, in these cases, the first step is to hunt and gather with a group of volunteers. One person or team may cut; others may bundle until many truckloads (typically as many as fifteen) are transported to the site. Since not all saplings are easily shaped nor have the necessary resistance to the elements, Dougherty prefers to work with sticks, like maple and willow, that are the most malleable.

With raw materials in hand, Dougherty anchors the sculpture to the site by securing larger saplings to the ground, like fence posts, to create a structural foundation. Young saplings, limber and malleable, are woven between the larger supports. Scaffolding is used in every project to surround the work. In this way, Dougherty can create the shape he wants as well as work on the sculpture's surface. (At times, Dougherty has used a crane or platform lifts to create the tallest structure possible.) From here, the surface of the structure begins to emerge. Once the structure is sound, a second layer of sticks is added. Dougherty fills in holes and walls, shapes doorways and windows to create a variety of recognizable shapes: teapots, tepees, towers, roping, hives, nests, Jungian archetypes of almost gigantic proportions. Sticks become lines with which to draw: Dougherty employs conventional drawing techniques to create compelling and sumptuous surface textures, a practice similar to drawing on paper. To finish off, smaller sticks are added to hide any imperfections, giving the final creation a natural but finished surface.

Throughout this process, Dougherty is often met with skepticism from the public and even his volunteers. The early stages of a project — with bare and uninspiring sticks protruding from an empty space — only hint at the final sculpture. Day by day, as the project takes shape, people start to come around both physically and psychologically. Passersby stop and ask questions and are won over, many even volunteering to help. Every step of the way, Dougherty is an active, hands-on participant in the fabrication, and makes himself available to explain his process. He believes that a good sculpture allows the viewer to have many personal associations and interpretations. Dougherty's work — as well as his goodwill, patience, and clarity of vision — transforms an empty site to an inspiring artistic triumph that speaks to everyone, their own stick story now writ large.

Sailors Take Warning

Early in my career, when my work was still based almost exclusively in and near North Carolina, I felt the lure of New York City and dreamed of having my sculptures noticed there. To that end, in 1988 I eagerly accepted three opportunities to work in the Big Apple.

The first was to produce an installation for Broadway Windows, on the corner of Broadway and Tenth Street. *No Such Thing as Nervous,* a line of human figures made from twigs that seemed to sweep through several show windows, was named in honor of a phrase my mother used to calm my early jitters. I needed that reminder again as I drove my trailer of saplings through the Lincoln Tunnel and into the unfamiliar mayhem of Manhattan. The second effort, *High Falutin'* — which I described as "big city calligraphy" — was made of red maple saplings swirled around ladders borrowed from Putnam Ladder Company on Howard Street and constructed in the lobby of One World Trade Center. The final piece was constructed at the Newhouse Gallery on the grounds of the Sailors' Snug Harbor, Staten Island. *Sailors Take Warning* was built in the sailors' quarters and was suggestive of a rogue wave that spilled in through an opening on the third floor, washed over the second-floor banister, and splashed energetically into the lobby below.

I was surprised at the logistical problems of building a sapling sculpture in an urban environment. At Broadway Windows, parking, unloading, and storage of the sticks during construction proved almost impossible. Ultimately I finagled storage for my saplings in a nearby New York University dance studio. The World Trade Center proved even more challenging. Only materials that arrived on a union truck were permitted in the building. (I owe a debt of thanks to a kind guard willing to break the rules and open an exit door after I had surreptitiously ferried my saplings across the plaza.) During the construction of *Sailors Take Warning*, a concerned citizen called the fire department, and after being thoroughly chastised by the fire chief for bringing sticks into an historic building, I went on the hunt for some appropriate fire retardants.

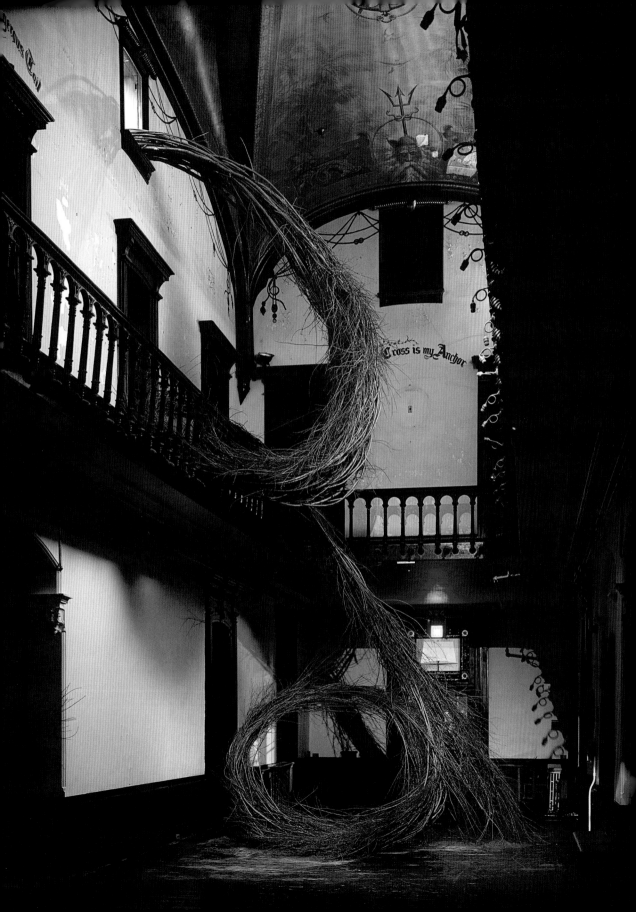

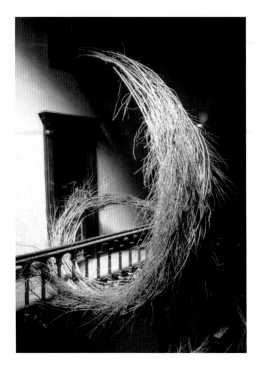 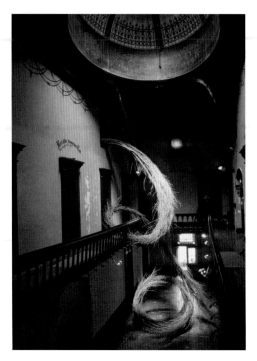

Construction phase: April 17–27, 1988

Exhibition dates: April 27–May 28, 1988

Site: Newhouse Gallery, Snug Harbor Cultural Center, Staten Island, New York

Sponsoring organization: Snug Harbor Cultural Center

Materials: Maple saplings

Size: 24' high x 2' wide

Perhaps it was the rigor of facing the big city alone or the fear of remaining a rube forever, but I decided not to limit myself to New York City. The United States is peppered with smart people, big buildings, and plenty of possibilities. I also realized the limitations of going at it alone and tried to develop more involved partnerships with sponsoring organizations. I realized it would have been more economical to gather sticks locally rather than transporting them hundreds of miles from North Carolina. My experience with the fire marshal alerted me to the future necessities of fire retardants and fumigation. But perhaps the biggest lesson in problem solving I learned was that when asked nicely, most people will lend a hand. These three projects helped to shape my approach during the next twenty years and in the over two hundred installations I've created since.

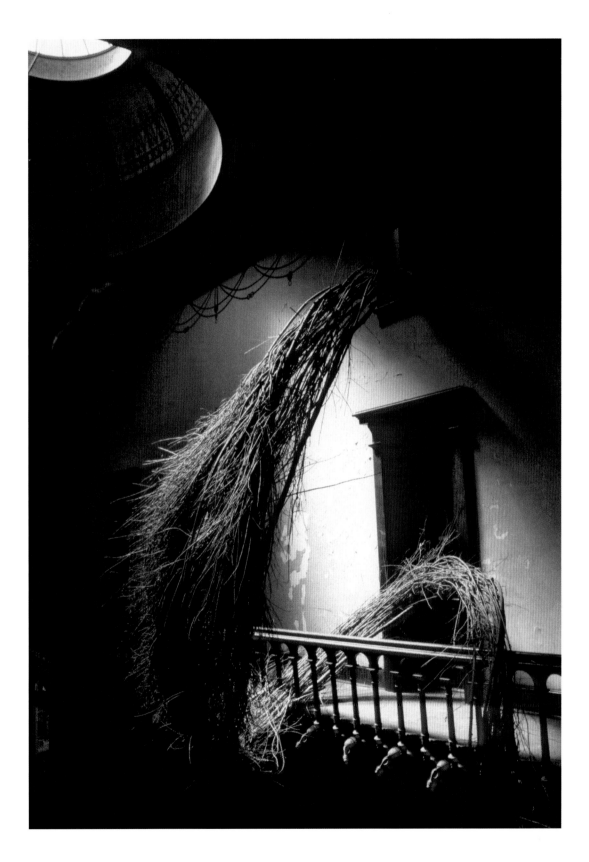

Woodwinds

Construction phase: February 16–March 8, 1989

Exhibition dates: March 8–April 16, 1989

Site: Contemporary art gallery at Brooks Museum of Art, Memphis, Tennessee

Sponsoring organization: Birmingham Museum of Art's traveling exhibition Looking South: A Different Dixie,
hosted by Brooks Museum of Art

Materials: Red maple, gathered along the banks of the Mississippi River

Size: Total length 50'; each enclosure 6' high and 10' in diameter

In the mid-eighties, when I began building sculptures on-site, some organizations were unfamiliar with installation work. Direct collaboration with a sculptor to create artwork for exhibition was uncommon. In some cases I was the first artist who had ever remained within the museum walls after closing time. I always needed accommodations while building my pieces, but early on, my sponsors were unsure how the arrangements should be handled. Should I be boarded in a hotel, or should someone affiliated with the organization welcome me into his or her home? And who should be responsible for these and other expenses? Museums were comfortable buying premade art from galleries, but writing a check to a sculptor to cover a work-in-progress required a different kind of faith in the artist's creative process.

Without any established protocols to follow, unforeseen problems arose every day. Museums are sterile, controlled environments, so gaining access for a large load of saplings fresh from the woods often caused a stir. It was unclear where the lines of responsibility were drawn and whether in a pinch I could ask for help. As time went on, I realized that these "first encounters" would have consequences for the artists who would follow. I tried to set a positive example by working regular hours and finishing on time, and to dispel the myths and misconceptions surrounding the word *artist*.

In 1988, in conjunction with the Birmingham Museum of Art's traveling exhibition entitled Looking South: A Different Dixie, I built works on location in three cities: Birmingham, Alabama; Memphis, Tennessee; and Columbus, Georgia. *Woodwinds*, the work created for the Brooks Museum of Art in Memphis, focused on the transitional space in the two-level contemporary gallery. Using very long maple saplings, the sculpture began as an enclosure on the upper floor and, through sleight of hand, flew through the air

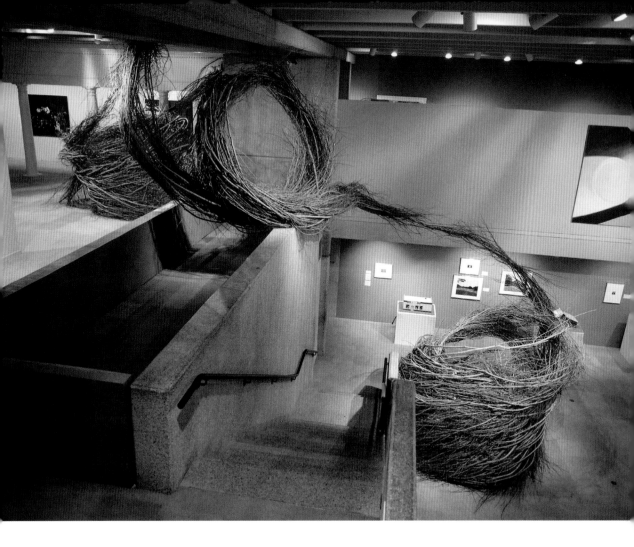

and settled down on the lower level as a rudimentary shelter. For balance, the aerial segment of the sculpture relied on several well-placed saplings subtly woven into the ceiling grid. I always enjoy the challenge of finding an impromptu way to integrate the saplings into the architecture itself and, with that link, to suggest a kinship between the sculpture and its architectural surroundings.

Building *Woodwinds* was a process full of adventure. The biggest challenge occurred when the Mississippi River flooded our sapling-gathering site. My fears subsided, though, when I realized I was in good hands. Steeped in the duck-hunting tradition, the stalwart gathering crew handed me a pair of rubber waders and a pocket flask of Jim Beam, and we got down to business.

Speedball

In 1989 I received an award from the Southeastern Center for Contemporary Art in Winston Salem, North Carolina, as part of their Awards in the Visual Arts program. I traveled with the Visual Arts 8 national traveling exhibition to build a new work for each of four venues: the High Museum of Art in Atlanta, the Museum of Contemporary Art San Diego, the Henry Art Gallery at the University of Washington in Seattle, and the BMW Gallery in New York City. *Speedball* was conceived for the segment at the Henry Art Gallery.

During my initial site visit to the Henry, I realized that identifying a workable site for the sculpture might be a bigger problem than I had anticipated. I was free to work outdoors on the museum grounds, but Seattle has an average of 158 rain days a year, and I wanted to avoid weaving sticks in the cold drizzle of January. On the other hand, the Henry is rather small, and the work of the other nine artists in the traveling exhibition seemed to have filled every nook and cranny of traditional exhibition space.

One day I found myself in the gallery's entry hall, which has an Islamic dome overhead. At a loss for a solution to avoid bad weather, I pointed to the dome and jokingly said to the curator, Chris Bruce, "I will take that space up there." I ribbed him further with "You haven't filled the space in front of the receptionist's desk downstairs either — maybe I should take that space too. Perhaps you should throw in the descending stairway in between." Completely unruffled by my teasing, Chris said, "Fine, you have a deal." Somewhat shocked, I began to plan a work that would make the best of my bravado.

First, I had to solve the problem of supporting a mass of saplings in the dome without putting weight on its rim or allowing sticks to scratch the dome's silver leaf-covered surface. This required tucking full-grown alder trees into the four decorative alcoves around the lower walls beneath the dome. These trees rose twenty-two feet from the floor and became the structural supports. I placed simple screens in front of the alcoves to hide the base of the larger trees, giving the impression that the finished sculpture defied gravity and magically swirled around the upper dome.

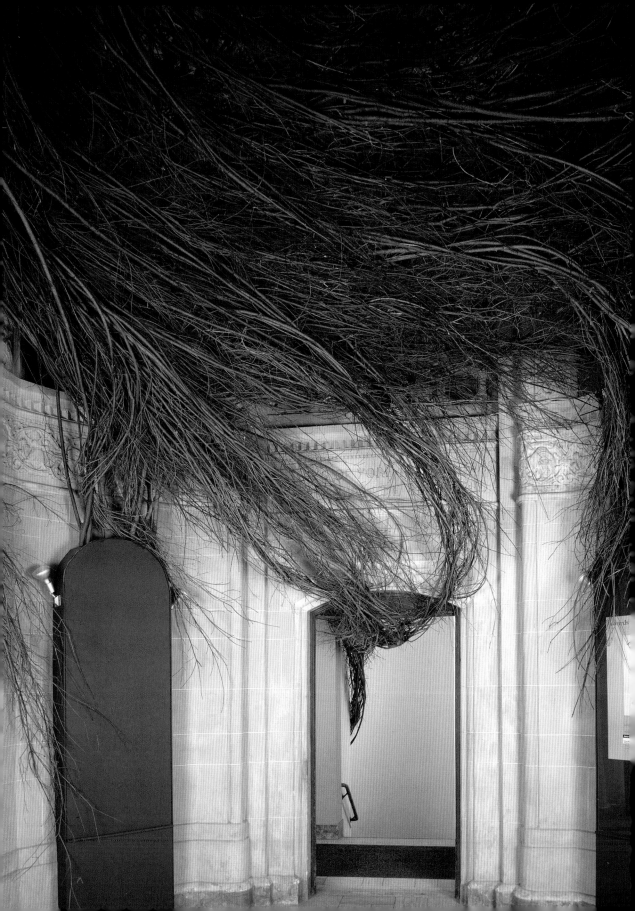

Construction phase: January 4–21, 1990

Exhibition dates: January 21–March 18, 1990

Site/sponsoring organization: Henry Art Gallery, Museum of the University of Washington, Seattle, Washington

Materials: Vine maple, alder and red twig dogwood, gathered from a nearby Weyerhaeuser forest

Size: 22' high at the dome and 16' in diameter at its lower rim; 2–4' wide and 20' long down the stairway;

6' in diameter twig ball

I bent the upper branches of the alder trees to follow the shape of the dome without touching it. Then from the top of a motorized lift, I began weaving in alder and maple branches gathered from a nearby forest. For the viewer below, these smaller branches became a maelstrom of natural lines that dripped down from the dome's lower rim. I directed this frayed bottom edge of branches into an energetic flow of saplings bounding down the stairway. This rambunctious cascade capitalized on an available steam pipe and the handrail for structural support, and despite its twists and turns, did not impede the flow of stairway traffic.

As I worked on the dome and the stairway section, I felt that I was creating some kind of natural machine. I imagined that I was developing an environmental cyclotron and that I would give the impression that a large particle, "a ball of sticks," had bounced down the stairs and arrived in front of that infernal desk. A little boy who was part of a school tour during my installation, described the event perfectly. He noted that the sculpture looked like an upside down plate of spaghetti and that the meatball had fallen down the stairs and rolled into the basement. His observation has led me in subsequent years to ask visitors, "What do you think it is? And what should I call it?" This simple inquiry has paid off in many of my interesting titles and has fueled new ideas.

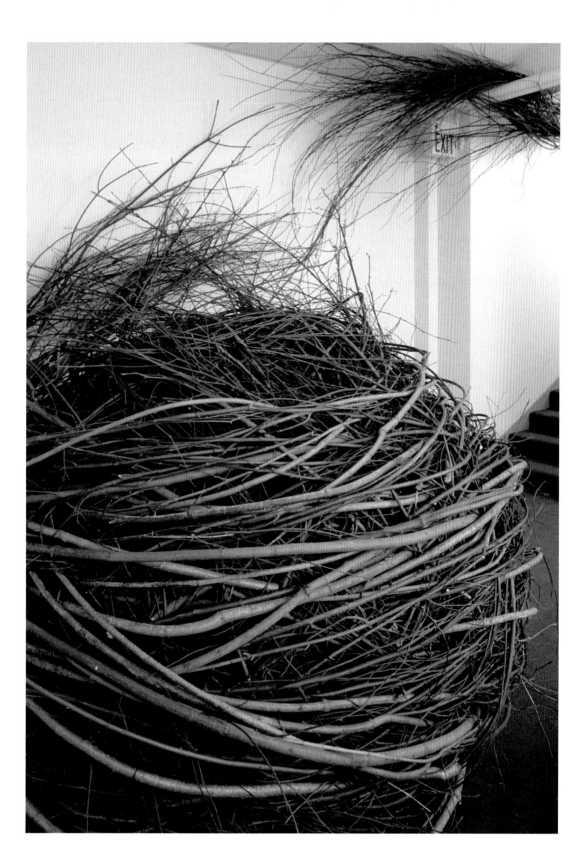

Spinoffs

The DeCordova Sculpture Park and Museum in Lincoln, Massachusetts, has undergone extensive renovations in the last two decades, but during my stay in 1990, the museum building had the dramatic feel of a feudal castle, with multiple turrets visible from the entry road. Taking note of both the towers and the building's grandeur, I immediately asked about the possibility of an installation on the roof. I proposed to mimic the building's conical tops in three ways. First, I envisioned a swirling skein of sticks capping the top of the museum's primary tower. Next, using saplings like lines in a drawing, I would connect this first segment to a second woven cone balanced on the roof below. The third stage would complete the composition with a primitive dwelling on the ground. In my mind, I saw a lofty tower, fit for a king, falling back to its architectural origins as a serf hut.

Since the slate roof was aging, it was necessary to prebuild the two roof components on the ground. This was accomplished by constructing rudimentary copies of the tower's cone and the lower pitched roof out of two-by-fours and plywood in the parking lot, and then shaping the saplings over these forms. When the time came, the sapling elements were lifted with a crane and gently placed on the roof. The last cone, the roof of the hut on the ground, was built in place. Near the end of the project, I used a bucket truck to hoist me up to weave the connecting portions of the sculpture. During this phase, I also added some thicker branches that provided larger lines and enhanced the sense of movement as viewed from the ground far below.

There is an interesting story behind the gathering of saplings for this project. On nearby land owned by the Concord Prison, there was a profusion of red maples in all the right sizes. However, everyone expressed doubt about my prospects of obtaining permission to gather there. After several days of calling the prison without luck, I broke protocol and went to the warden directly—this required driving through the front gate armed only with photos of my past work and a degree of persistence. The warden was very unhappy with my breach of etiquette and declared, "Take the damn saplings but get out of my prison."

The maple trees gathered from the prison woods were by far the best saplings that I have ever used, and this work was chosen by the Boston Globe as one of the best art works in the Boston area in 1990.

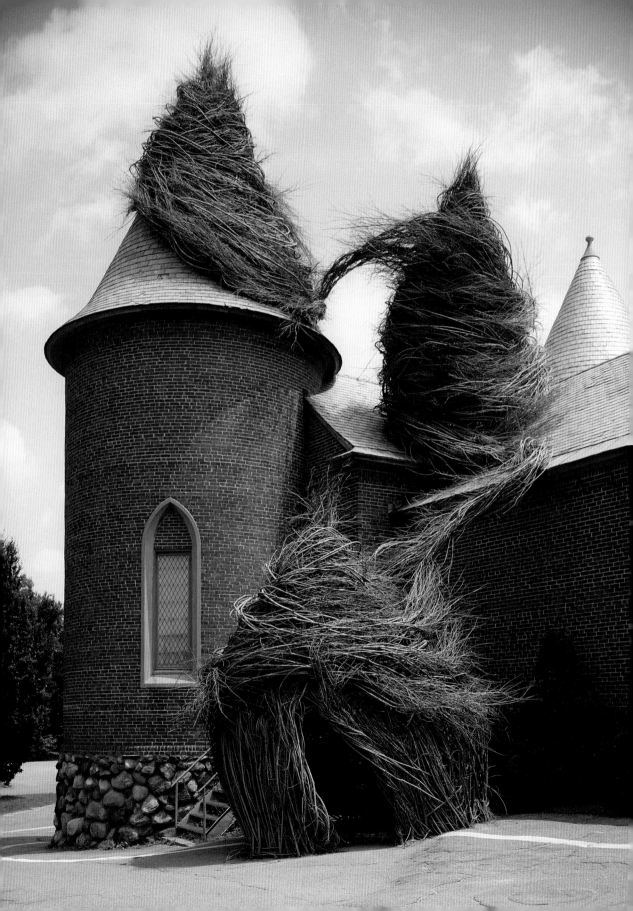

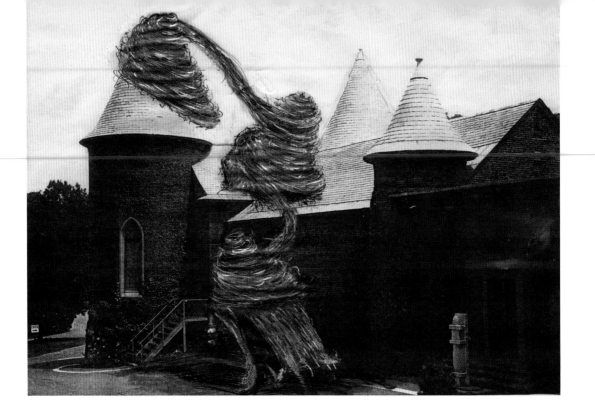

Construction phase: April 20–May 16, 1990

Exhibition dates: May 16, 1990–December 16, 1992

Site/Sponsoring organization: DeCordova Sculpture Park and Museum, Lincoln, Massachusetts

Materials: Red maple saplings, gathered from the fields of the nearby Concord Prison

Size: tower 70' high and 20' wide; ground hut 12' in diameter and 16' high

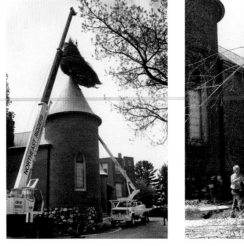

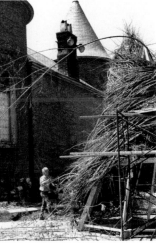

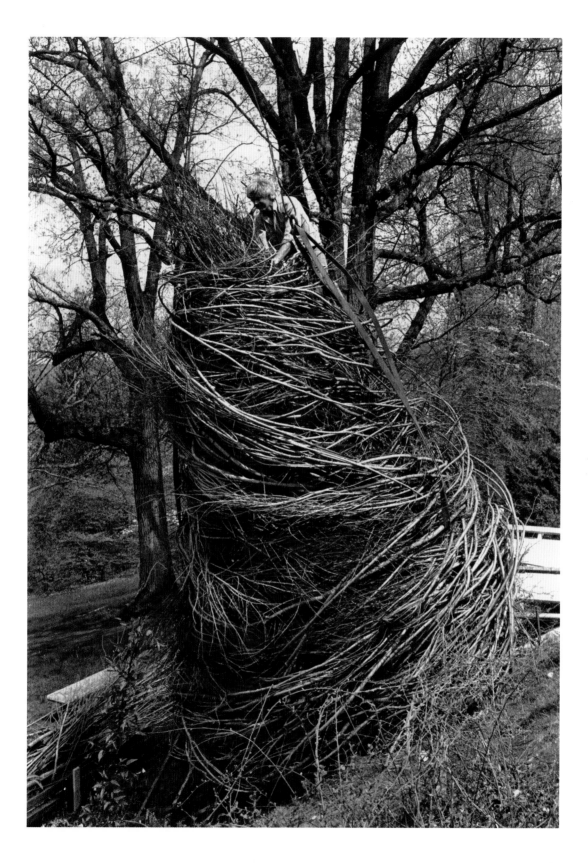

Rip-Rap

Projects Environment, a homegrown organization based in Manchester, England, helped create a pivotal moment for my career. In 1999, in keeping with its goal of promoting art and environment, it hosted "New Forms in Willow," an international conference that brought together willow users of every ilk. The organizers invited sculptors, basket makers, and other craftsmen from around the world to come to Ness Botanic Gardens, an affiliate of the University of Liverpool, to experiment with willow saplings.

Before my participation in this event, I had no idea that my own backyard material had such a time-honored place in traditional craft. It surprised me to learn how important sticks were before our modern era. In earlier days, farmers grew sticks as a crop, and basket makers, house builders, and many other tradesmen depended on the utility of willow. For example, a bundle of radishes or carrots might have been tied with a fine strand of willow for market.

I took my allotted share of the provided willow and started to work, concentrating my efforts on a massive leylandia hedge within the garden. Although the hedge looked solid, if one stepped behind the curtain of branches, one could see large cathedral-like spaces hidden within. My work, called *In and Out the Windows*, featured a series of large skylights that parted the foliage and allowed light into the hidden spaces in the heart of the hedge. It also included a long woven corridor to connect these spaces.

Celia Larner and Ian Hunter, the conference organizers, admired this effort at Ness Gardens and arranged for me to work at the nearby Manchester City Art Gallery before I returned home to the United States. I made a site visit and was drawn to the organic references in the capitals that top each column of the building's front. I tried to imagine how to make a compelling sculpture to celebrate the symmetry of the building's facade and also achieve the proper scale. With a little research, I found references in architectural history suggesting that tied bundles of sticks might have served as the first rudimentary columns. This inspired me to make *Rip-Rap*, which reintroduced the organic line and softened the facade with a kind of natural syncopation.

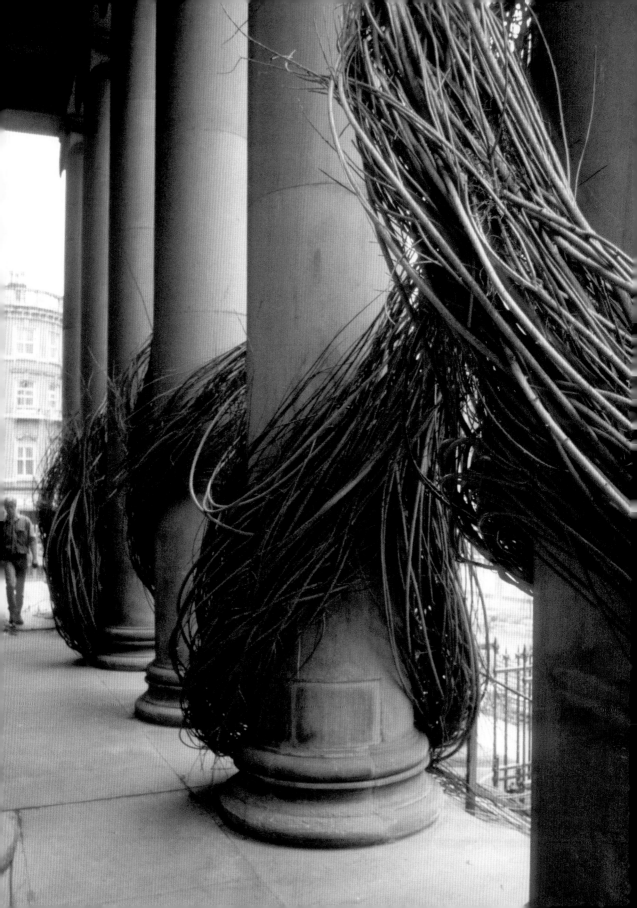

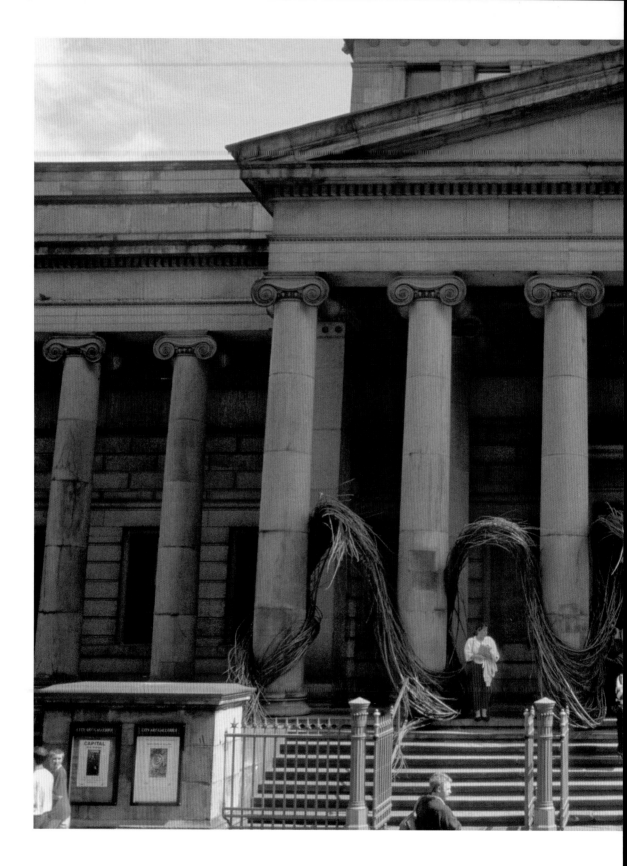

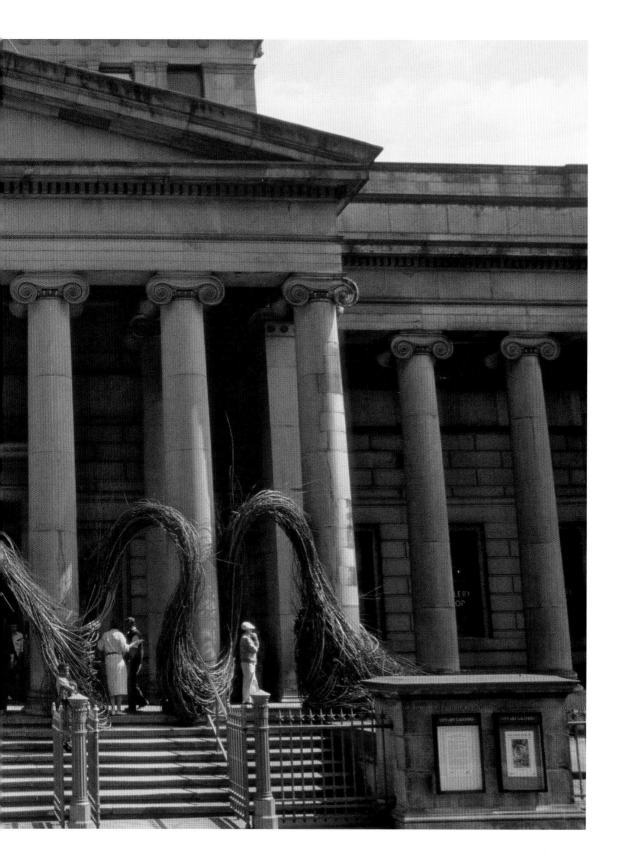

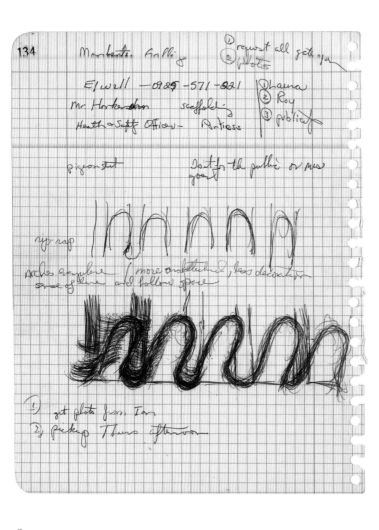

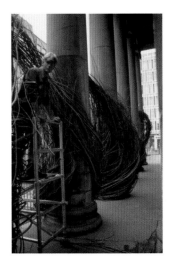

Construction phase: June 20–27, 1991

Exhibition dates: June 27–September 15, 1991

Site/Sponsoring Organization: Projects Environment and Manchester City Galleries

Materials: Willow saplings, from a willow bio-mass project in Yorkshire, England

Size: 14' high, 50' long, 3' wide

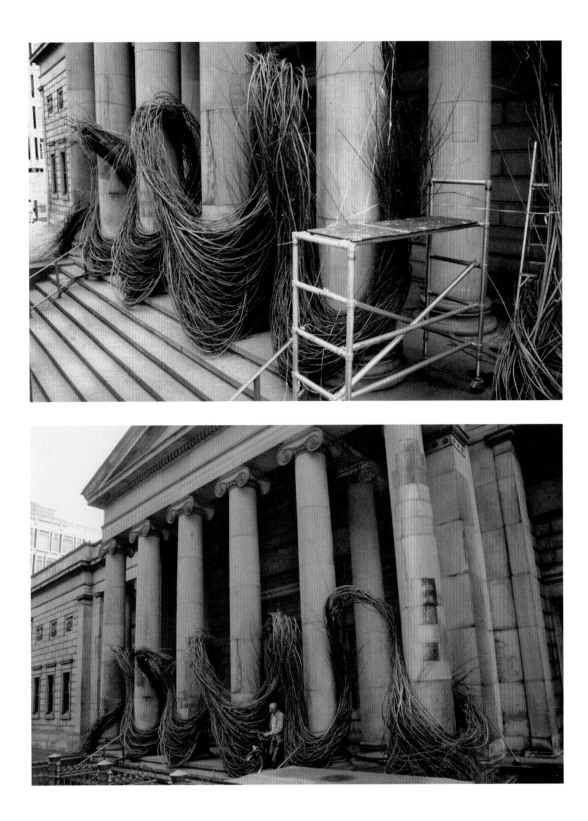

Holy Rope

In 1992 I was chosen by the National Endowment for the Arts in Washington, DC, to receive a six-month fellowship from the Japan-United States Friendship Commission, which allowed me to move to Tokyo. During my stay there, I traveled extensively, and the exposure to another culture had a profound effect on my work.

Since I did not speak Japanese and initially communicated through pantomime, everything seemed complicated, and my every action a cultural blunder. My naiveté lead to a number of embarrassing situations. For example, I did not know that, because Japan is essentially crime-free, anyone with a bank account can easily withdraw large sums of money from an ATM. Thus, I was shocked one Sunday, when I touched the wrong symbol on a banking machine and found the equivalent of 10,000 US dollars pouring out. At first I imagined that the machine had malfunctioned, and that I could buy a south sea island with this stack of money. This thought of ill-gotten gain was immediately replaced by the prospect of being robbed of my newfound wealth. Soon enough, I came to my senses and realized it was money from my own account and that on Monday I would somehow have to find a way to put it back.

With the help of new friends, I built three sculptures during my stay in Japan. The first, *Spring Forward, Fall Back*, functioned as a stage set for a world music festival in Fujino-Machi art village outside of Tokyo. The second was built at the Kakitagawa Museum in Mishima, in collaboration with landscape architect Tsutomu Kasai. The final work, *Holy Rope*, capitalized on an ancient tree that sat in front of the Rinjyo-in Temple, in Chiba.

This small temple belonged to several families who gathered there once a year to honor their ancestors. In earlier eras, monks staffed such temples, but in 1992, this one was unattended. A local sculptor, Ueno Masao, the caretaker for the temple, invited me to live in this 400-year-old Shinto shrine and to build a work there.

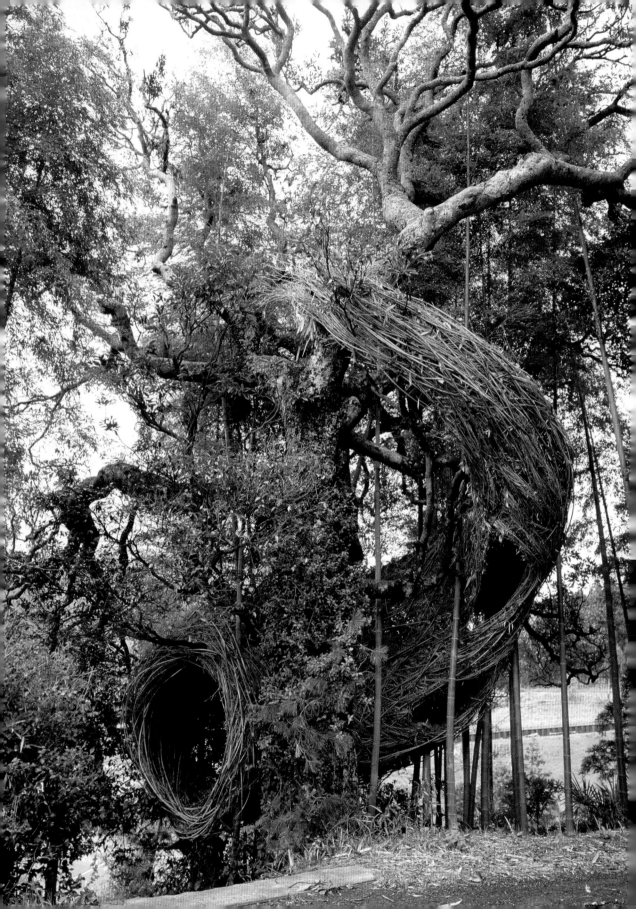

I was drawn to that massive oak tree located in the temple's front yard. Legend had it that this tree was planted to celebrate the completion of the temple in the 1600s. In my travels, I had noted that venerable trees like this one were often honored with a large rice rope wrapped around their base. Capitalizing on this imagery, I decided to build a larger-than-life "rope," a kind of welcoming cornucopia, as a companion for this tree. I set about cutting forest bamboo for my scaffolding and harvesting reeds from the thickets behind the temple.

The work went well, but living in the temple was unnerving. First, there were reports of monkeys who threw stones and were purported to steal things, including small children. Next, according to Mr. Ueno, there were snakes that came with the temple. "Don't kill them," he said. "If one bites you, call my wife, and she will take you to the hospital." Believe me, that was little comfort since I knew that his wife did not speak a word of English. After three sleepless nights on a tatami mat rolled out on the floor, listening for rustlings in the straw roof above, I gave up my anxiety and thought, "Oh, hell, just go ahead and bite me."

Construction phase: September 27–October 13, 1992
Exhibition dates: Oct 13, 1992–October 1, 1994
Site/sponsoring organization: Rinjyo-in Temple, Chiba, Japan
Materials: bamboo reeds, gathered in the back yard of the temple
Size: 25' high and 10' in diameter

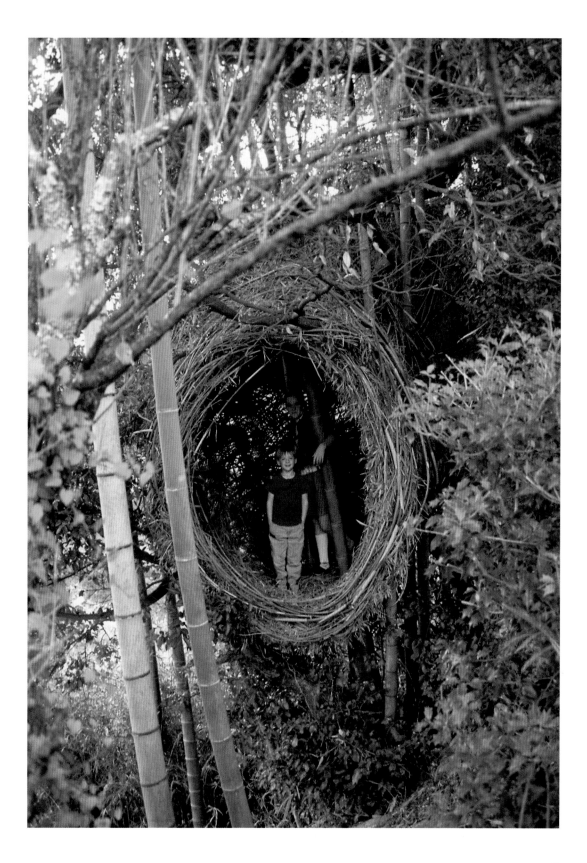

Little Big Man

Construction phase: July 28–August 13, 1994

Exhibition dates: August 13, 1994–July 1996

Site/Sponsoring organization: Krakamæken/Nature Art Park, Randers, Denmark

Materials: Willow saplings, gathered from a winter dumping area for snow

Size: 16' high, 35' long, 8' wide

Krakamarken was a sculpture park in Randers, Denmark, founded by Jorn Ronnau. It remained active from 1988 to 1999 and was organized around the concept of temporary sculpture built on-site using materials gathered from the surrounding area. In the summer of 1994, I was one of a number of sculptors from around the world invited to participate in a symposium and build work in the park.

Finding a starting point for my work was daunting with so many well-known sculptors working nearby. A theme for my work emerged as I listened to my fellow artists talk about their own projects. It struck me that when humans think about nature, or in this case, build sculptures that comment on nature, their attitude is often egocentric. This insight inspired the work entitled *Little Big Man*, a kind of man-creature perched atop alder trees along the shore of a small pond. In my mind, this figure dawdled before the mirrored surface of the lake, seeking his own reflection.

The interplay between humans and nature also played out in the sunshine of early spring, as Danish visitors to Krakamarken casually pulled off their clothes to enjoy the warm weather in the buff.

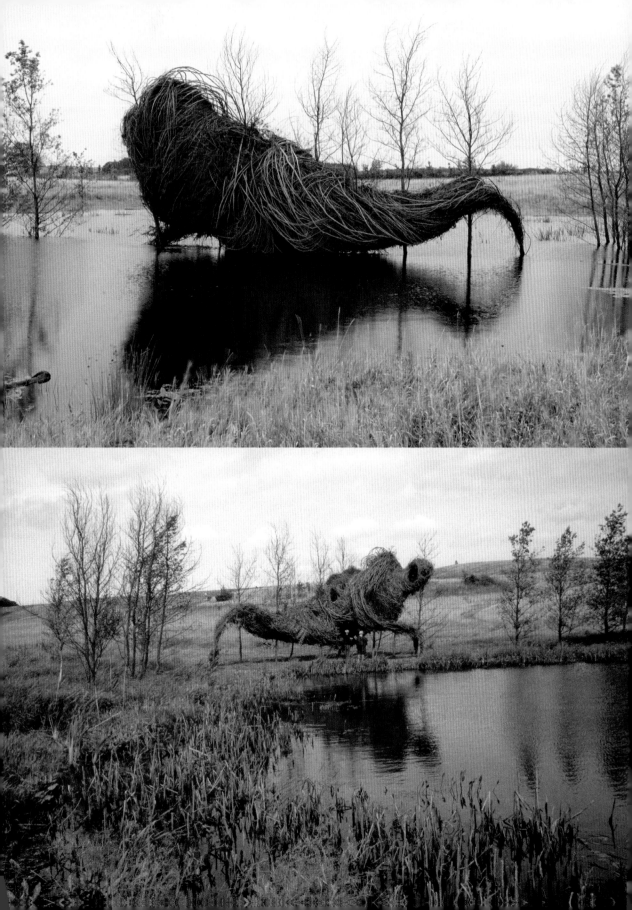

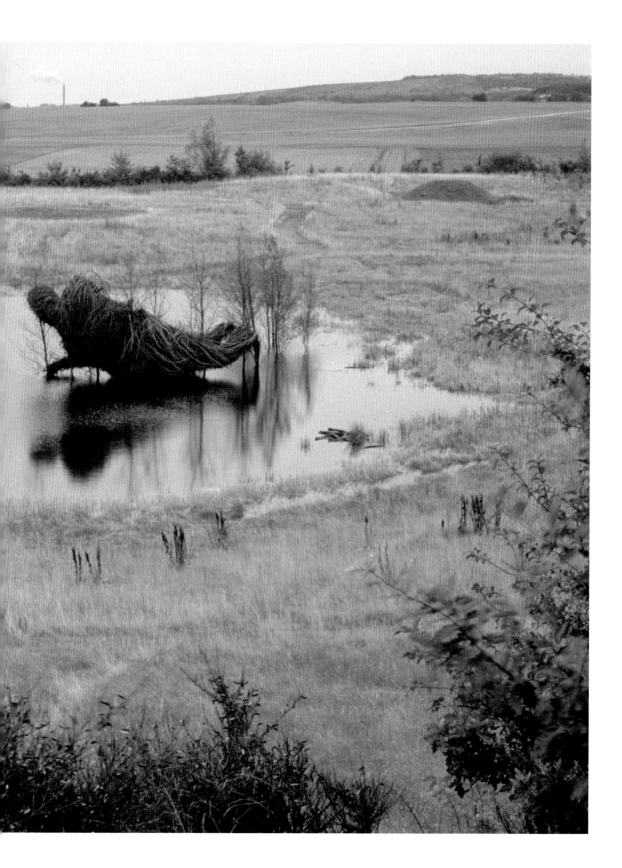

Sittin' Pretty

The momentum of my career depends on constant learning, and my time at the South Carolina Botanical Garden in 1996 provided important insight. The garden, situated on the campus of Clemson University, had initiated a nature-based sculpture program in 1995 in conjunction with the College of Architecture, Arts and Humanities. This program was based on a belief in creative problem solving and a high regard for an artist's working process. In addition, the garden staff teamed up with sculptors as equal partners to produce work. These concepts caught my imagination so strongly that close partnering with organizations and spontaneous problem solving have become central to my working style.

In 1996 I conceived a work entitled *Sittin' Pretty* for the garden and characterized it as a "common man's" version of Donato Bramante's Renaissance building, the Tempietto of San Pietro (1502) in Montorio, Rome. I wanted to contrast the traditions of great architecture with the simple construction methods of a backyard bird's nest. I imagined rendering Bramante's dignified classical form not in stone, but entirely from recycled prunings. I wanted a work that was both stately and rambunctious, with a sense of motion caught in its outer surface.

When I noticed that the height-to-width ratio of the Tempietto's central barrel was identical to that of many mature shrubs in the Garden, I wondered if Bramante had discovered the secret of pleasing proportions simply by measuring the bushes in his own Roman garden.

Sittin' Pretty was a significant departure from my previous work. To this point I had relied on intertwining saplings with an existing element such as a porch rail or a tree limb. This new design required that my rustic temple have a sturdy dome and stand on its own. To accomplish this, I placed small tree trunks (twenty-five feet tall) into postholes spread along the perimeter of the proposed shape. Then I set a scaffold system around these uprights and bent the supporting trees into the desired form. A structural layer of smaller saplings was then applied before a final layer of important lines was sketched onto the outer surface, giving it finesse and a sense of motion.

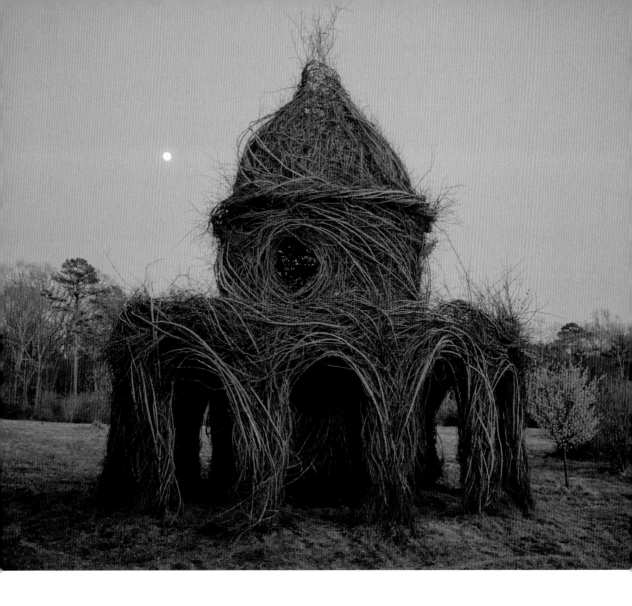

Sittin' Pretty has another distinction in that, for the first time in my work, living trees were planted within the woven walls at the time of construction. I believed that, as the weave deteriorated over time, these living trees would emerge and jog memories of the bygone sapling temple. This aspect of the work required a drip irrigation system and long-term maintenance by the garden staff. Three years after the construction, the damaged dome was removed and the living trees emerged. After five years, Sittin' Pretty had relaxed into an inner circle of living trees and a series of fatigued, woven arches interlaced with new growth.

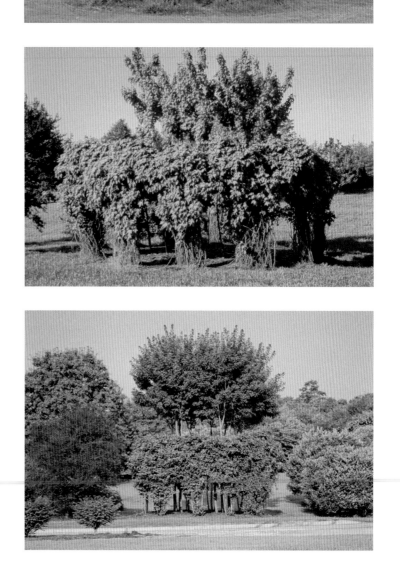

Construction phase: February 14–March 1, 1994

Exhibition dates: March 1, 1994–present, a living element of the original work still remains

Site/sponsoring organization: South Carolina Botanical Garden, Clemson, South Carolina, in conjunction with the

Rudolph E. Lee Gallery at the Department of Art, Clemson University

Materials: Red maple saplings and living red maple trees, from land managed by

the Clemson Department of Forestry and Natural Resources

Size: 28' high and 20' in diameter

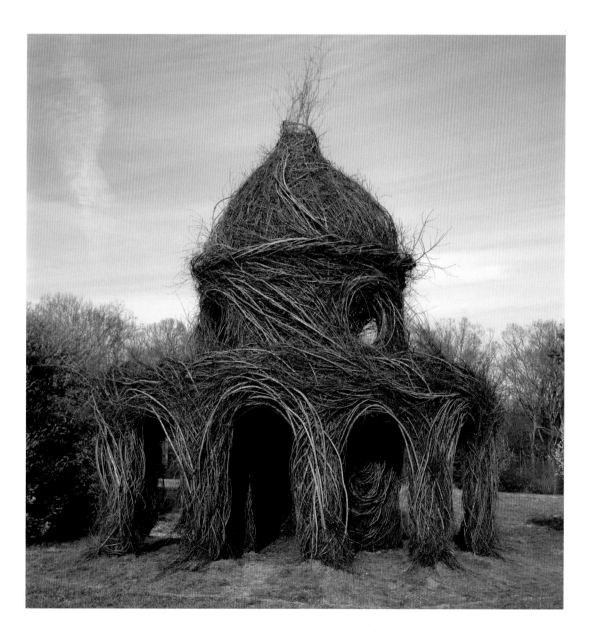

Running in Circles

TICKON is a sculpture park on the Danish island of Langeland. In 1996 its founder, Alfio Bonanno, met me in Copenhagen and we went first by train and then by boat to Rudkobing, the island's largest town. Because the sculpture park there had limited space, I needed to find a location for my work somewhere else on the island.

The office of cultural affairs offered a tour of some potential sites. Already tired from a long flight, I felt as if we were visiting all 110 square miles of the island in a single day. I was taken to the tallest hill, once a military lookout. I was shown the most remote spot on the island, a place of pristine wilderness. I was even offered a Neolithic burial chamber. All these sites were interesting, but I wondered whether the public would visit any of them.

I overcame this first hurdle when I found a row of poplar trees in the side yard of a converted cannery, now a painting studio. This line of trees stood beside the main thoroughfare between the ferry terminal and the town of Rudkobing. I now had found an audience for my work.

My wife, Linda, and baby, Sam, had accompanied me to Denmark, and we found a place to board at the art school in the small village of Magleby. The meals were good, and I could easily ride a bike along the coastal road to the chosen stand of trees.

After I gave a slide show of my work, it was easy to convince students to help with the construction. However, finding good scaffolding was a different matter. I tried using a medieval set of sawhorses, unearthed in a nearby barn, but when that proved too rickety, I tried a new approach. Whenever anyone of authority visited the site, I would point to the top of the trees and say plaintively, "I have to work way up there." Finally, someone understood my dilemma, and a perfect set of aluminum scaffolding arrived by ferry from Copenhagen.

As the idea for the sculpture evolved, I imagined a long sketched line, a single gesture, through the top of the trees—a show of penmanship with large ovals repeated against the sky. I wanted to suggest that the local forces of sea and wind had become enmeshed in the sculpture and had sent my woven sticks sprawling.

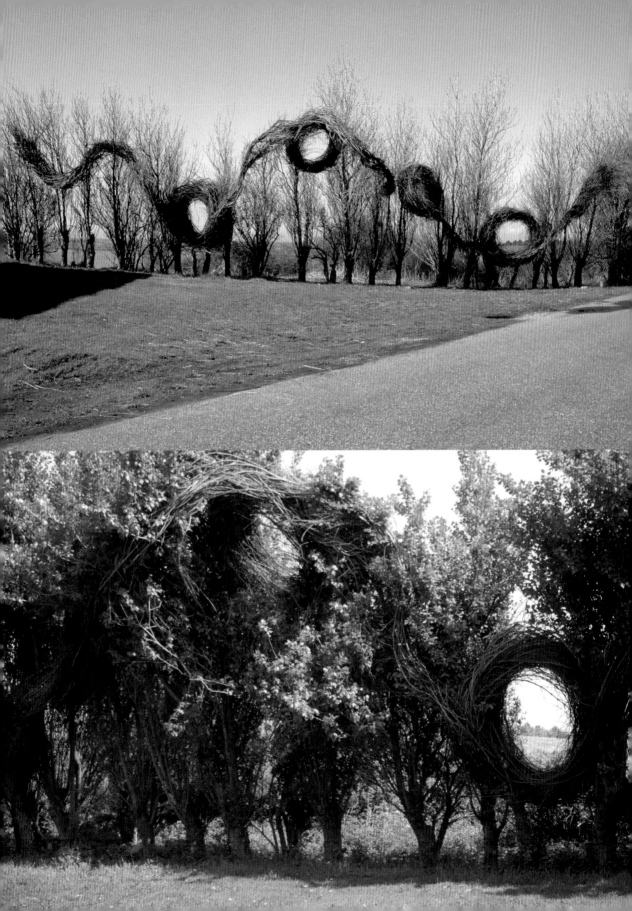

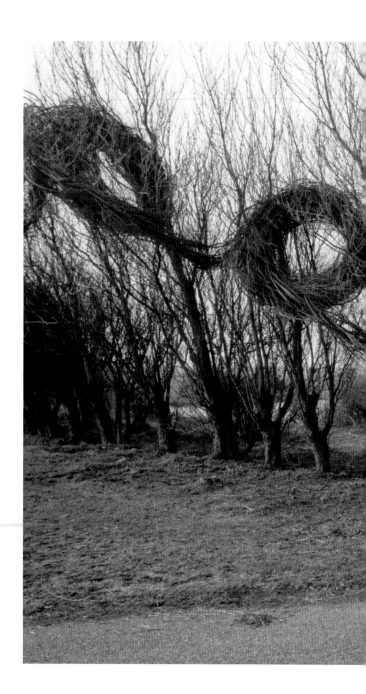

new, 5 in circles
running in circles

I envisioned a sculpture
which took advantage of the row of
trees near the art building at Maaleby...

Construction phase: April 12–27, 1996

Exhibition dates: April 27, 1996–June 15, 1998

Site/sponsoring organization: TICKON Sculpture Park, Fonden Tranekaer, Langeland, Denmark,

in cooperation with Langeland Kunsthojskole in Magleby, Langeland

Materials: Willow and Norway maple

Size: 8' high, 100' long, 3' wide

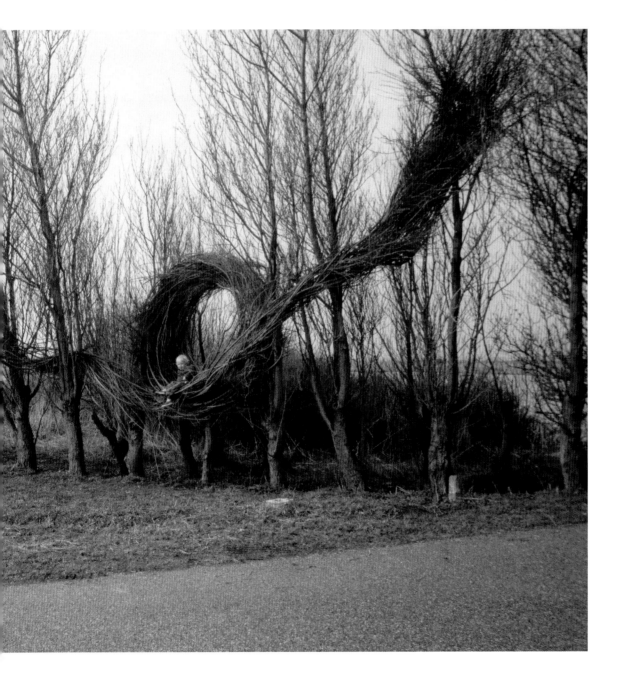

Crossing Over

Construction phase: June 11–28, 1996

Exhibition dates: June 28–November 3, 1996

Site: Stairway of the American Craft Museum building at 40 West Fifty-third Street, New York City

Sponsoring organization: American Craft Museum (now the Museum of Arts and Design)

Materials: Red maple gathered in Efland, North Carolina

Size: 23' high and 10' in diameter

In 1996 I was asked to work at the American Craft Museum (now the Museum of Arts and Design) in New York City. One of that building's best features is an impressive lobby with a grand three-story staircase. When given an opportunity to work there, I was eager to build a sapling sculpture which took advantage of the sweep of the stairs and presented interesting views from different levels.

It has always been my challenge to work without traditional fasteners and use only the weaving to lock the saplings together. In this work, I intertwined sticks with the handrail and gained an additional foothold by forcing larger saplings into a niche at the base of the stairs. Using this structural grip, I built a work that invited the viewer to step inside and experience the smells and feeling of the North Carolina woods while standing in a building in Manhattan. When seen from the floors above, the upper portion of the sculpture was a kind of three-dimensional drawing, a whirling topknot, which complimented the twisting of the stairs themselves.

Saplings are scarce in New York City, so I chose to gather red maple saplings from a farm in Efland, North Carolina. I fire-retarded the twigs and loaded a hundred large bundles on my trailer. I drove them up past Baltimore, across the George Washington Bridge, and down Broadway to the museum. There was no loading dock through which to bring in the bundled wood, and we carried in all the material through the front door while my truck idled on the sidewalk. This activity raised questions and got puzzled looks from the usually blasé New York public.

The installation at the American Craft Museum gave my work important exposure and much needed credibility in the art world.

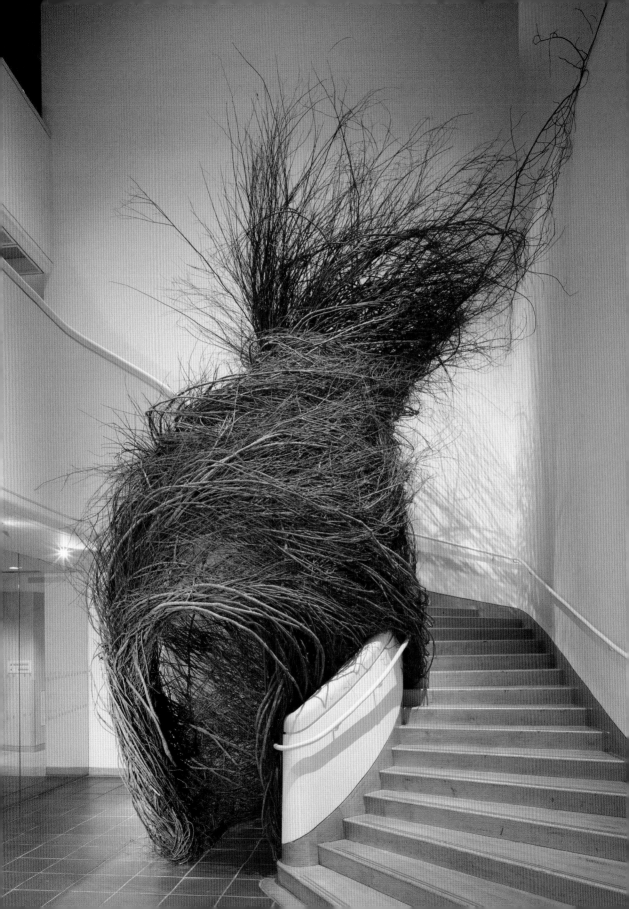

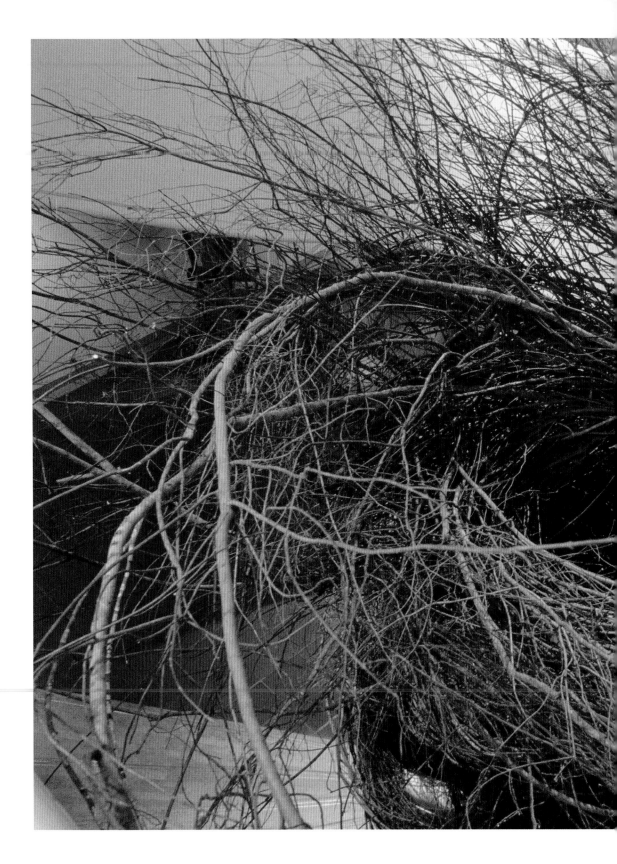

Roundabout

In 1996 Americans for the Arts, a nonprofit organization for advancing the arts in the United States, sponsored a month long residency for me in Ireland. I was paired with Tallaght Community Arts Centre in Tallaght, a suburb of Dublin, and arrived there in November 1997.

The program had limited funding, and I was given spartan accommodations with little heat and only a drip of hot water. In order to stay warm, I spent my free hours in the mall across the street, people watching. When an Irish American like me returns to Ireland, it can be disconcerting to realize that one's family quirks and personal predispositions might have deep ancestral roots. I would hear a turn of phrase, glimpse a gesture, or notice a familiar stance, and for a moment I was sure my grandpa Dougherty was nearby. I also learned that, in Ireland, if a father is sent to the mall with eight children in tow, losing one child is perfectly acceptable. The mall office was often packed with stranded children, and the loudspeaker was busy fishing for parents. One day I heard: "For the last time will Kevin Shannon's father come to the Lost-and-Found!" Followed by: "I mean it!!"

I was probably in the mall when the idea of building an Irish round tower occurred to me. These tall enigmatic structures were first built from stone in the eighth century by Catholic monks, and I imagined that Saturday shoppers would be startled to see this familiar icon rendered in woven sticks. I realized that the forty-foot ash tree in the art center's front yard could be commandeered to support such a structure.

Weather is always an issue in Ireland and it rained constantly with a temperature hovering around 40 degrees Fahrenheit. I lived in my rain suit and rubber gloves and, as I hauled bundles of sticks to the top of the scaffolding, I tried not to liken my sculpture to the Tower of Babel. Near the completion of my work, there was a day of true sunshine and interested viewers came, this time with cameras and not umbrellas. It took time for the idea of a sculpture made from sticks to take hold in this working-class community. I could see that, although everyone applauded my work ethic, even on my last day, there were still doubts about my sanity.

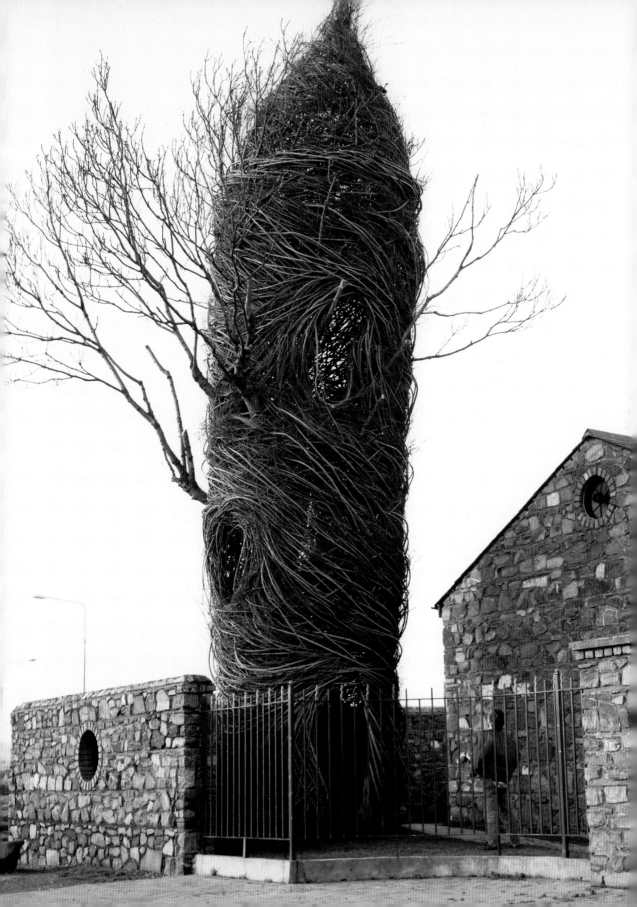

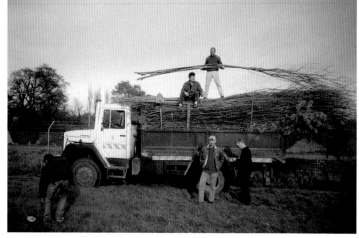

Construction phase: November 3–December 1, 1997

Exhibition dates: December 1, 1997–January 15, 2000

Site: Front lawn of the Tallaght Community Art Centre, Tallaght, a suburb of Dublin, Ireland

Sponsoring organization: Americans for the Arts Community Residency Exchange Program: U.S./Ireland
 in conjunction with Tallaght Community Art Centre

Materials: Willow harvested from an experimental willow station

Size: 42' high and 8' in diameter

/ Dublin Ireland 4 Nov 1997

① need something which draw attention to surf arts
② they love tree, front gates, and lawn
③ maybe something that could be made on the
 street and then added to something inside
④ or something ½ outside
⑤ needs participation ——— (maybe a corresponding project

still life which make
kind of ancient
tombs or cocoon
between them

stacks
of shapes

Bending over
backward

Irish
Tower

with real
Tree inside

Cell Division

Savannah College of Art and Design (SCAD) in Savannah, Georgia, invited me to build an installation on the college campus in 1998. During a preliminary visit, I happened upon Habersham Hall and I immediately began to see possibilities. Although the front of the building had been renovated, the rear wing, once the county jail, stood derelict with only its outer walls intact. The barred windows remained, but the roof was gone and full-sized trees had claimed the interior. The three-story facade on which I imagined working had been repainted and was dramatically lit at night.

Because of the building's history of incarceration, my first thought was a sculpture that featured a series of escape hatches or perhaps a magic carpet on which to make a getaway. With this as a starting point, I noted that the window grills would make excellent points of attachment for well-placed sticks. Ultimately, I decided on a wall-sized tapestry that featured a series of large swirling openings that I would title *Cell Division.*

Using scaffolding set up inside and a motorized lift to work on the exterior, I began by using larger saplings to sketch out the basic design. I made sure that some of these were threaded firmly into the window bars. After fleshing out a stout structural layer, I focused on the aesthetics of the sculpture, adding defining lines. As I worked, I considered the color and line quality of each stick. The final stage was the cosmetic work. I used tiny sticks to obscure any inconsistencies that seemed to conflict with the overall design. In *Cell Division* the fix-up phase included adding some very long white lines around the openings in order to emphasize a sense of movement. The maple saplings I used to create these lines were long and white because the pine trees that surrounded them in the woods were fast growing. In order to compete for light, the maples had shot up to reach for the sky.

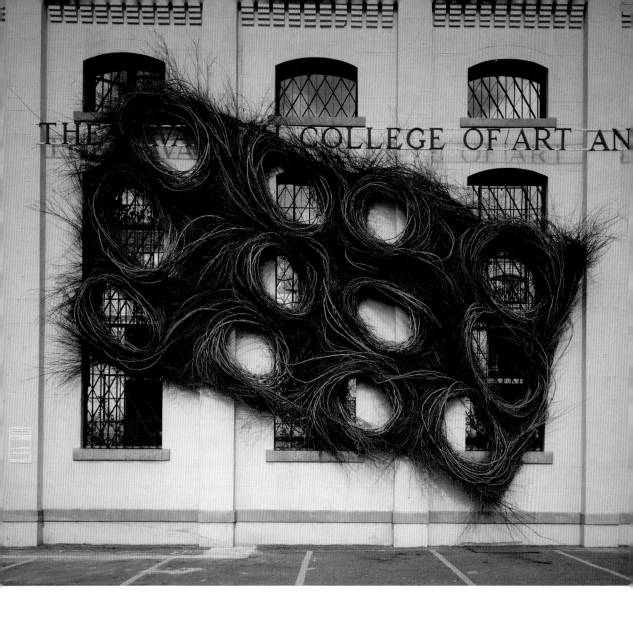

Savannah is a paper mill town, and on my initial site visit
I found a large quantity of flexible sticks at the back of a nearby
log storage area. It was July when I met with the forester, and he
pointed out the dangers of the wet swampy land in South Carolina:
alligators, water moccasins, bees, mosquitoes, and ticks. "On the
other hand," he said casually, "Don't worry. You will be gathering
in February; that's just before they wake up." Needless to say, when
February came, all the gatherers were on high alert as we maneuvered
through the underbrush.

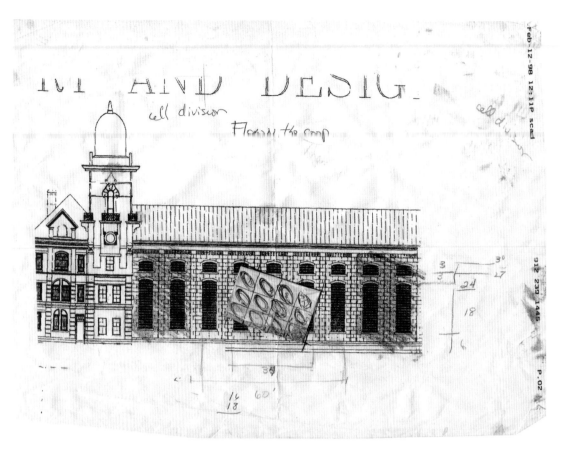

cell division

Floral, the coop

Construction phase: March 1–22, 1998

Exhibition dates: March 22, 1998–March 31, 2001

Site: Facade of the unrenovated portion of Habersham Hall, the former county jail

Sponsoring organization: Savannah College of Art and Design, Savannah, Georgia

Materials: Red maple, gathered from property of a nearby paper company

Size: 16' high, 35' long, 4' deep; upper corner of work 32' off the ground

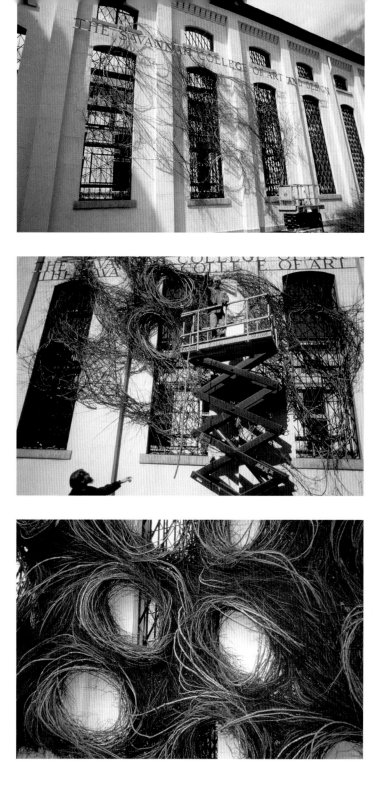

Jug or Naught

Construction phase: July 7-27, 1999

Exhibition dates: July 27, 1999-November 28, 2000

Site: Behind the window wall at the rear of the Visitor Center, adjacent to the Conservatory entrance, at the Fredrick Meijer Gardens & Sculpture Park, Grand Rapids, Michigan

Sponsoring organization: Fredrick Meijer Gardens & Sculpture Park

Materials: Willow and rough-leafed dogwood, gathered on property owned by the city of Grand Rapids

Size: Three figures, each 20' high and 8' in diameter

In June 1999 I was visiting a potential site in Austria when I found a small shard of pottery in a newly dug garden. This fragment evoked the idea of expanding a small kitchen object, like a milk pitcher, to house size. This large scale would allow the viewer to appreciate more fully the shape and to experience the sensation of standing within the form. The resultant work, entitled *From the Castle's Kitchen,* was built in the side yard of Schloss Ebenau in Weizelsdorf, Austria.

Flushed from the success of having built these mammoth shapes in the form of country pottery, I was especially attuned to ideas involving kitchenware. Thus, when I toured a Roman ruin a week before my return flight, I fixated on a group of pottery jars fashioned into heads with contorted faces. I was amazed by how similar these face jugs were to the ones produced by old-time potters in my own state of North Carolina. It seemed to me that the need to fashion a face in wet clay was a ubiquitous impulse regardless of the century.

A week later I arrived at the Fredrick Meijer Gardens & Sculpture Park in Grand Rapids, Michigan, still entranced with the similarities between working with wet clay and flexible sticks and how both can be shaped so easily. In fact, unfired clay vessels are called greenware, a word that could easily describe my oversized domestic shapes made from green, flexible saplings. I decided to try my hand at fashioning my own set of walk-in jugs with faces, a work entitled *Jug or Naught*.

With the help of the Fredrick Meijer Gardens' competent staff, finding saplings and producing the work proved easy, but it seemed crucial to build these tall "face jugs" in a provocative location. After considering all the predictable placements, I found the perfect spot immediately outside an extensive window wall in a well-used hallway. This large window provided a vista of the gardens in all seasons, and let me surprise those who looked out with a series of faces staring right back.

Sapling sculptures normally have a short life span, anywhere from two to four years. In this case, a heavy snowfall in the winter of 2000 brought an early demise. An avalanche of snow sheeted off the roof knocking the forms over. As they lay in the snow, the expressions on their upturned faces seemed to protest their predicament.

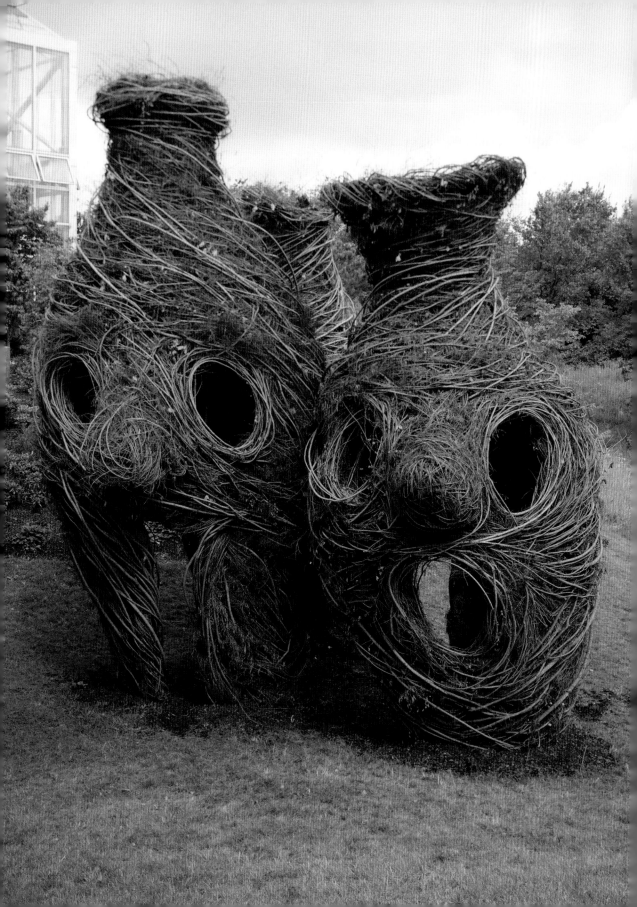

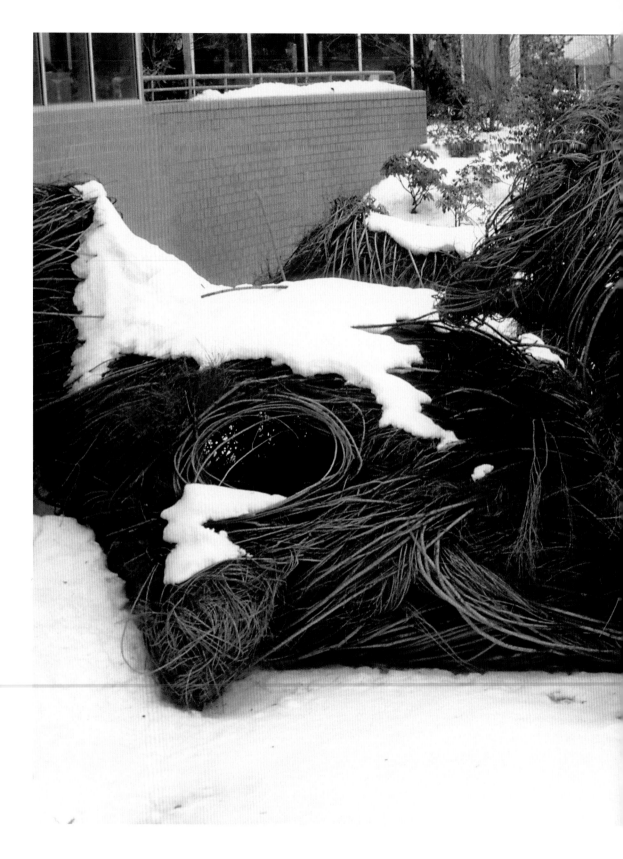

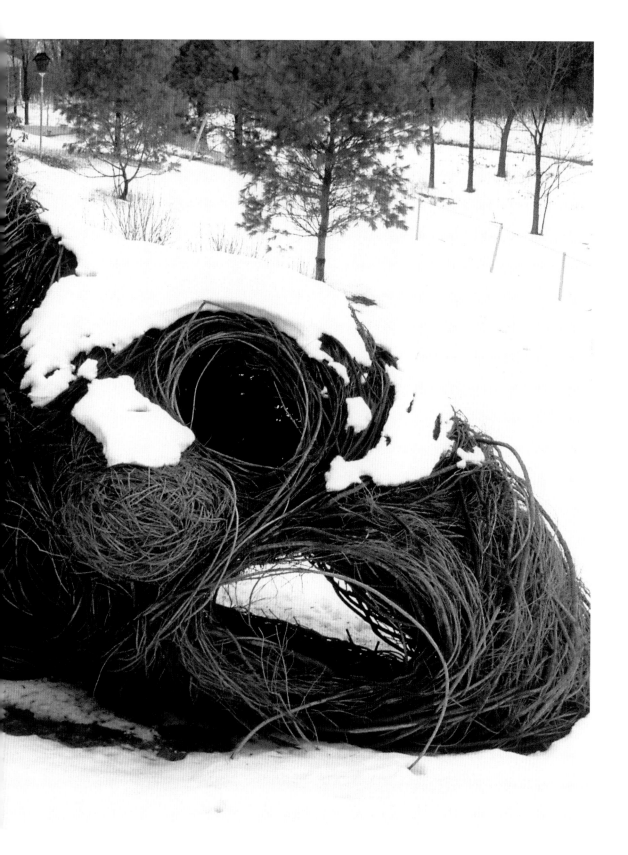

Owache

Construction phase: Sept 21–October 11, 1999

Exhibition dates: October 11, 1999–June 15, 2001

Site: Front entrance to Northern Illinois University, DeKalb, Illinois

Sponsoring organization: Northern Illinois University Art Museum

Materials: Willow, gathered behind the loading dock of an abandoned warehouse in downtown DeKalb

Size: Eight elements, each 16' high and 4' in diameter

Cahwanjica Ca Owache in Lakota Sioux means "willow trees dancing." The title of the work was central to the drama that developed during the conception and installation of the work, commissioned by the Northern Illinois University Art Museum in DeKalb, Illinois.

As I began to scout for saplings in Dekalb, word spread about my project and a question of its propriety arose in the university community. The concern was whether willow, a traditional material of tribal people, could legitimately be used by a non-Indian. These concerns came on the heels of a much publicized dispute about the names of sport teams that referred to American Indians, names like "chiefs" or "redskins" that were deemed derogatory by some.

This was a new issue for me. I was planning a group of thin cylindrical towers positioned in an intimate grove of trees. I did not mind that the sculpture might be seen as mystical or that some might imagine a connection with the secret rites of first people. In fact, I would have welcomed such connections as indicative of the human need for ritual we all share.

The museum staff decided that I must seek permission from the local Lakota chief before I could work with willow on campus. This led to a visit by a Lakota dignitary who was dressed as an ordinary citizen, but who arrived in a Cadillac with a cow's skull and horns mounted on the hood. After a discussion of my intention, he graciously offered his approval, but only if he was invited to the opening, could bless the work, and could provide a Lakota title. There was a statewide effort among the elders to find a name. The chosen title *Cahwanjica Ca Owache* poetically suggests that the sculpture's eight elements not only embodied the movement of willow trees in the wind but also mimicked a tribal dance step of early spring. On the day of the opening, the chief did return, with friends and a medicine bag. Tobacco was smoked and chanting ensued. No matter what I thought at the beginning of the ritual, by the end, I was moved by the sincerity of the proceedings, and by the chief's hope to conjure protection against mankind's abuse of the natural world. When asked to announce the title, I handed the microphone to the chief.

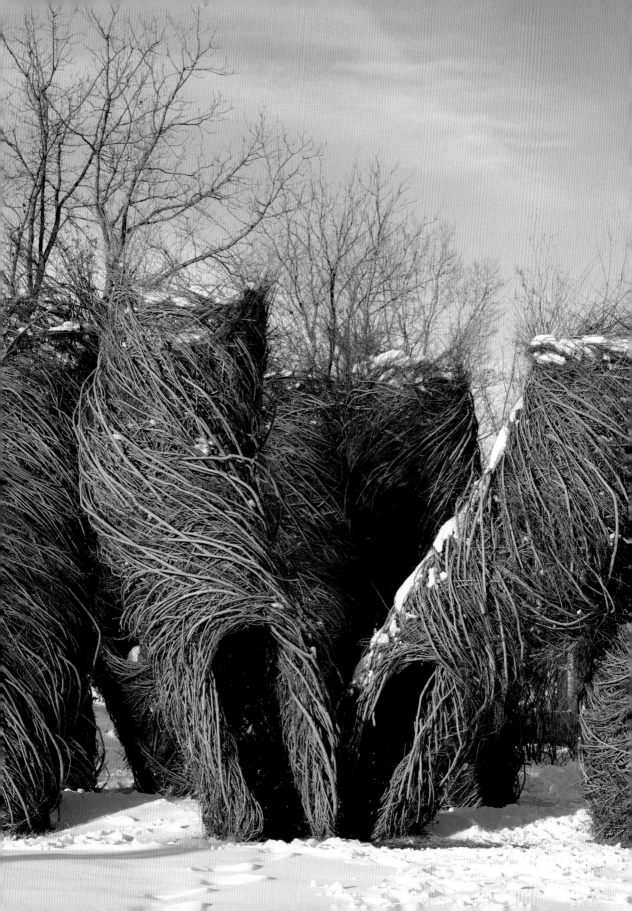

Sleepwalking

Construction phase: February 3–27, 2000

Exhibition dates: February 27–May 21, 2000

Site: Main gallery of Atelier 340 Muzeum, Brussels, Belgium

Sponsoring organization: Atelier 340 Muzeum

Materials: Willow saplings harvested from a local and nearby riverbank

Size: Five elements, each 27' high, 15' wide, 12' deep

Communicating in words about the peculiarities of saplings — their size, color, and flexibility — is often fraught with confusion. Thus, when I arrived at Atelier 340 in Brussels my anxiety centered on the need to find a large quantity of workable saplings. By transatlantic phone, the assurances had sounded vague: "Maybe the parks department has something," and "There is an artist we know who lives in the country, maybe he can help."

The hunt led to a farm where major pruning was underway. The Belgians have a cultural tradition of periodically cutting all the major limbs from huge trees. This produces large, gnarly trunks covered with a hairlike growth of very small branches. Pollarding trees once had the utility of creating a renewable source of firewood and new tool handles. But in modern times, this activity seems to survive only as an aesthetic practice.

Although I felt like protesting on behalf of the trees, climbers and machinery were already making quick work of pruning and stacking the upper branches for burning. With volunteers from Atelier 340, I scurried to load the discarded branches that might prove useful to my sculpture. Even this bonanza did not yield enough material, so a staff member and I meandered along country roads, looking for that particular blush of color that signals sapling groves in the early spring.

Finally, from atop a highway bridge, I spied a likely spot along a river. My guide and I located a nearby farm and sought permission. I gathered from nods and smiles that things were going well. My companion translated that the owner had magnanimously offered the willow along the river, commenting that, after all, it belonged to the "people of Belgium." It was not long after the crew began to cut and bundle that the river police arrived with lights flashing. This time, the gestures and tone were not so amiable. It emerged that, although our benefactor owned land to the river, she had no rights to cut there. Now her statement about "the rights of the people" took on new meaning. Our infraction led to hours of delay and a meeting with the "river commander." I showed pictures of my previous works and took an apologetic tone, and eventually he offered a drink of local schnapps and produced the required permit.

In comparison to the challenges of finding and cutting saplings for the project, actually building the work seemed easy.

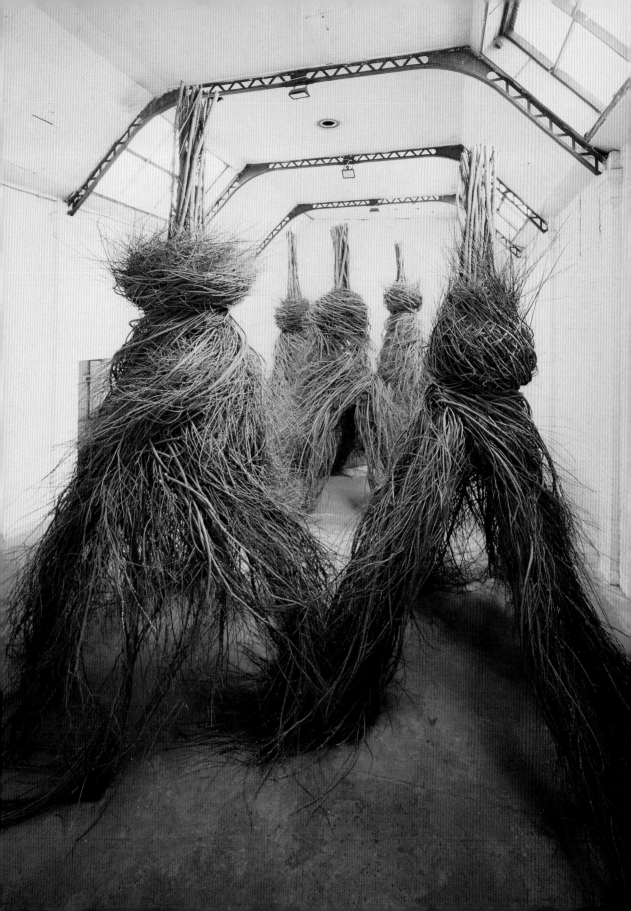

Abracadabra

I built *Abracadabra* at the center of the Swarthmore College campus
in Swarthmore, Pennsylvania, in 2000. The linden tree that I used
as a supporting structure had a trunk unencumbered by limbs on one
side and a full growth of large branches on the other. This situation
allowed me to weave a series of pods that started on the ground and
proceeded up through the limbs, giving the impression of a precarious
stack. The tenuous balance was made more plausible by the bold
vertical line of the linden's trunk.

The project was organized by the List Gallery at Swarthmore
College, partnered with the Scott Arboretum on campus. Scarcity of
materials provided the first challenge. After some effort, we made
contact with the nearby Tyler Arboretum in Media, Pennsylvania, and
they offered their crabapple collection, already slated for removal.
Despite my initial protests about the thorns and the difficulties
those would present for gatherers and leaf strippers, we persevered
and gathered tons of prickly crabapple saplings. In the process,
those thorns destroyed many pairs of work gloves.

The construction required elaborate scaffolding that took a
death-defying effort to erect and take down. It had to be set in and
around the tree limbs without any damage to the tree. No volunteers
were willing to help me with the precarious task of final scaffold
take-down. Claire Sawyers, the director of the Scott Arboretum and
an avid climber, came to the rescue. She went up forty feet to the
top of the linden tree, braced herself in a tight space, and received
each piece of scaffold as I removed it.

Pressed for a title to announce at the opening, I co-opted
the name *Abracadabra* off a local locksmith truck because it fit the
feeling of magic in the piece and my intended illusion.

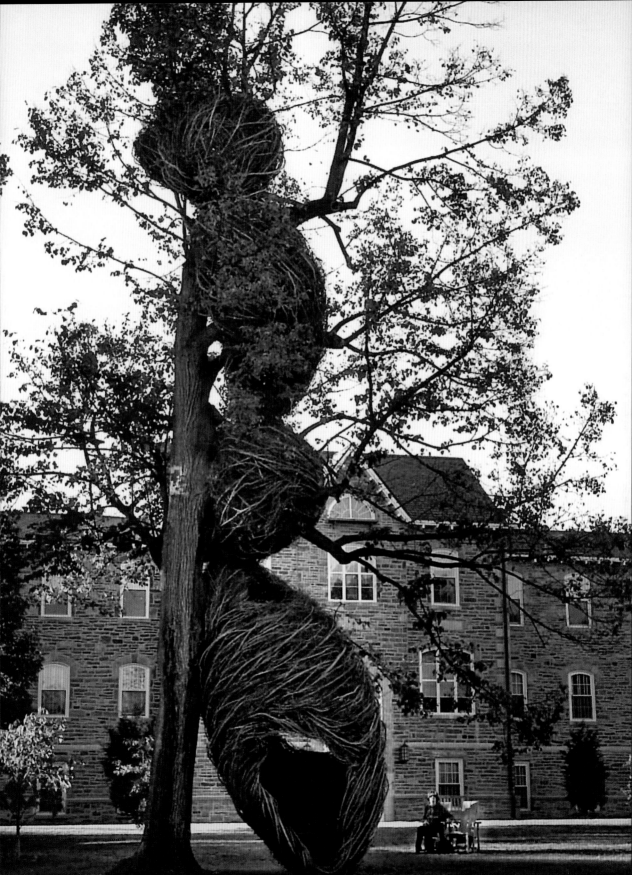

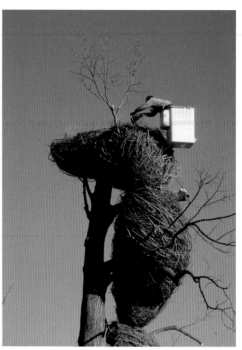

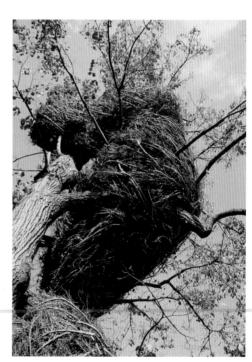

Construction phase: September 10–October 1, 2000

Exhibition dates: October 1, 2000–January 14, 2003

Site: Center of campus, Swarthmore College, Swarthmore, Pennsylvania

Sponsoring organization: Scott Arboretum, Swarthmore College, and the Swarthmore College Art

Materials: Crabapple, maple, and sassafras saplings, gathered from the nearby Tyler Arboretum

Size: 42' high, 10' wide, 10' deep

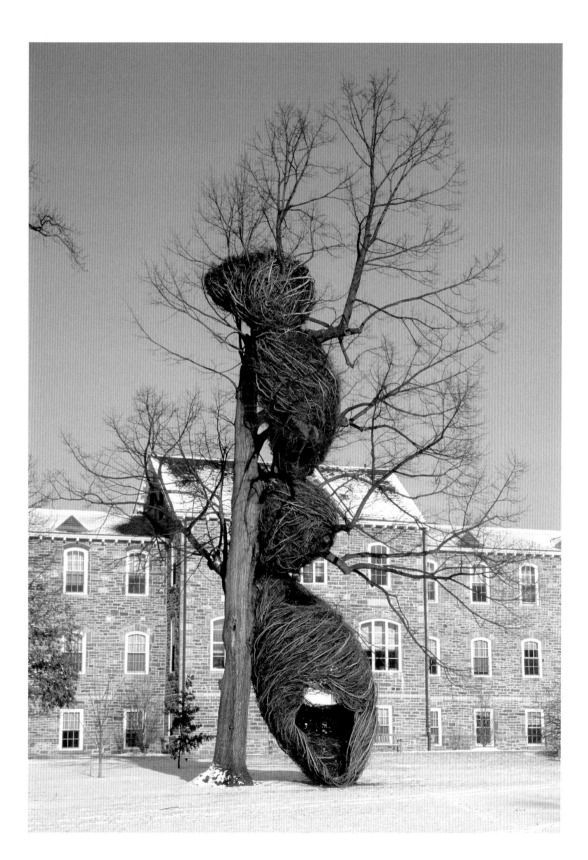

Spittin' Image

In February 2001 I returned to the South Carolina Botanical Garden in Clemson, South Carolina, and observed the remnants of my earlier work, *Sittin' Pretty* (see pages 52-55), in its new guise as a configuration of living trees. The site for my next sculpture was higher up the hill, overlooking *Sittin' Pretty*, and of course I felt compelled to outdo my earlier work.

In an effort to extend the more successful features of the 1996 work, I created a large architectural folly, a castle with three domed towers integrated at key points into a tall circular wall. Many well-appointed gardens of the past featured follies, or "eyecatchers," a kind of nonsense architecture that functioned as eccentric decoration. These structures were meant to evoke mystery and stimulate a longing for bygone days. Some historians even believe that the first follies were simply groups of trees designated as a special place. Evidence for this is contained in the Latin root word *foliate*, which *folly* and *foliage* share. It seemed appropriate that this new work, *Spittin' Image,* would combine folly with foliage and beckon viewers from its hilltop — an unlikely fortress knee-deep in a Southern garden.

Although the South Carolina Botanical Garden was one of the first gardens in the United States to institute a nature-based sculpture program (in 1995), the idea has become popular, and many gardens, forests, and nature trails have followed suit. These initiatives, which have boosted employment for sculptors, seem based in the public's growing concern for the environment. Faced with increasing urbanization, people often are drawn to organized green spaces for outdoor activity. The idea of enhancing that experience with an art component that capitalizes on nature has proved to be very popular and has increased attendance at parks. The overwhelming response to works like *Sittin' Pretty* and *Spittin' Image* has encouraged this national trend.

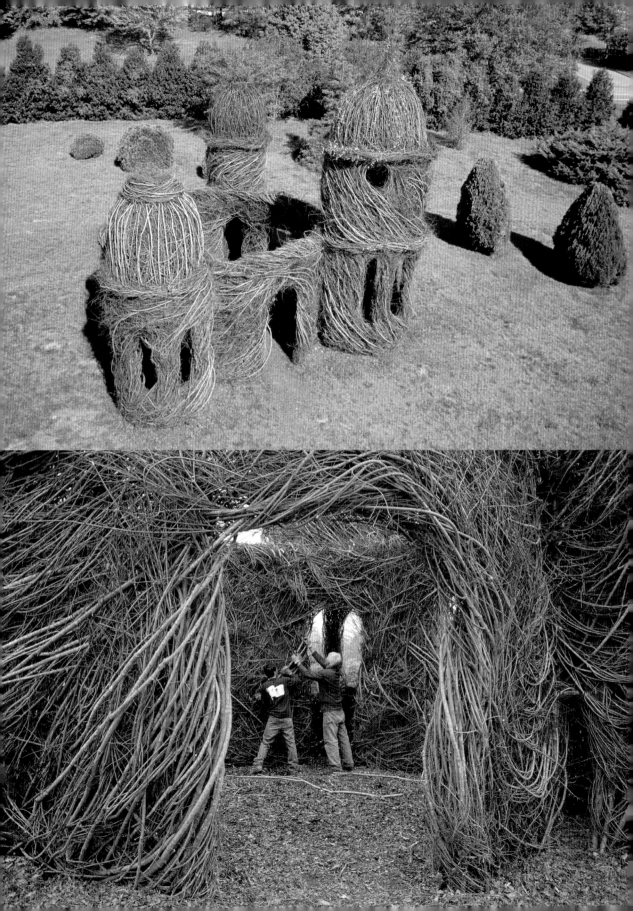

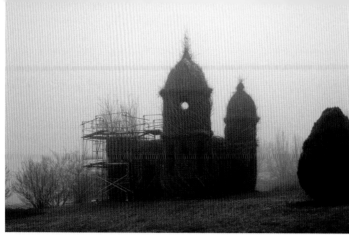

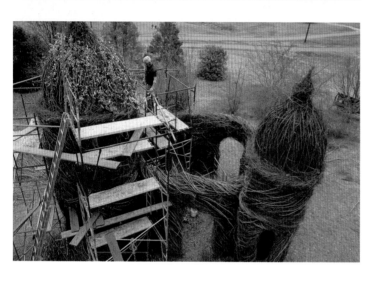

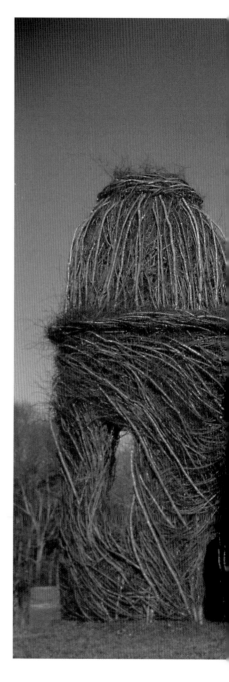

Construction phase: February 1–24, 2001

Exhibition dates: February 24, 2001–September 25, 2003

Site: Hillside overlooking site of *Sittin' Pretty* at the South Carolina Botanical Garden, Clemson, South Carolina

Sponsoring organization: South Carolina Botanical Garden

Materials: Red maple, sweet gum, beech, and peach tree prunings, gathered on land managed by the Clemson University Department of Forestry and Natural Resources

Size: 27' high, 30' long, 43' wide

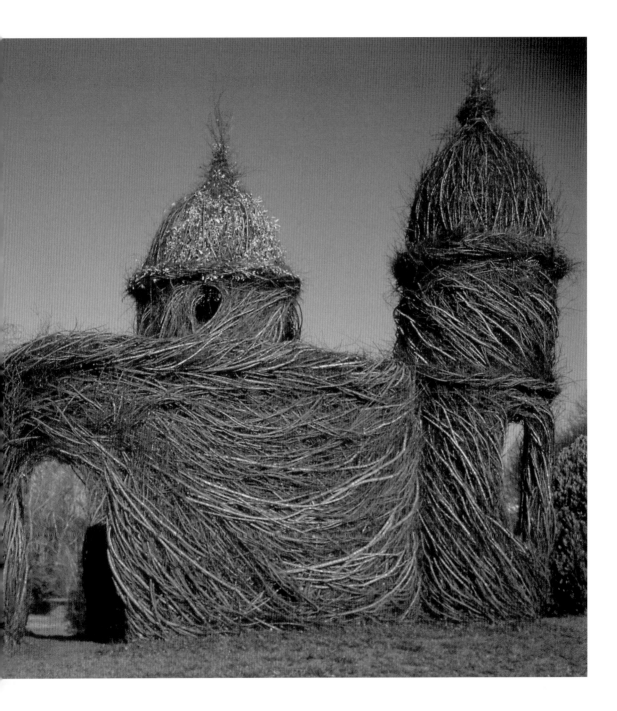

Simple Pleasures

Construction phase: September 7–29, 2001

Exhibition dates: September 29, 2001–Jun. 30, 2003

Site: The Quad, within sight of the Bowdoin College Museum of Art, Brunswick, Maine

Sponsoring organization: Bowdoin College Museum of Art

Materials: Mixed hardwood saplings, gathered behind a building supply house nearby

Size: Five elements, each 14' high and 5' in diameter

My early works were not constructed in public, but were built single-handedly for a sponsor and then displayed as part of an exhibition. It was clear that these installations were made from tree limbs, but the sticks were interpreted by the art world as found objects with little connection to nature. By contrast, for my work at the Bowdoin College Museum of Art in Brunswick, Maine, nearly twenty years later, I was billed with much fanfare as an environmental sculptor, one who used saplings to reminisce about nature. In addition, I was given a prominent site on the Quad, a beautiful natural area in the center of campus, and the building process became an important feature of campus life.

This change in my work's reception was based in part on my own increased "know how" and in part on changing public attitudes. During the two intervening decades, the public had become concerned about the environment, art goers had begun to celebrate the process with which art is created, and people of all walks of life seemed ever more interested in delving into the fundamentals of creativity. In the case of *Simple Pleasures*, the artwork on the Bowdoin College campus, this shift in public attitude led to a sympathetic college president who approved the placement on the school's most sacred ground. It produced a receptive student body that avidly watched the construction and offered their opinions. And it encouraged a museum director and staff to embrace the idea of a "museum without walls" and the relevance of a sculpture that had a limited life but unlimited community support.

The sculpture itself consisted of five elements with conical tops, which could easily resist Maine's heavy snows. The structural saplings hidden by the weave go two feet into the ground, but the sections of these "scrap shacks" were also joined together at the roofline to help to stabilize a sculpture that might have to deal with the rough and tumble of student leisure-time activities. My fears were unfounded, and the students not only respected the work, but petitioned more than once to the have the exhibition date extended.

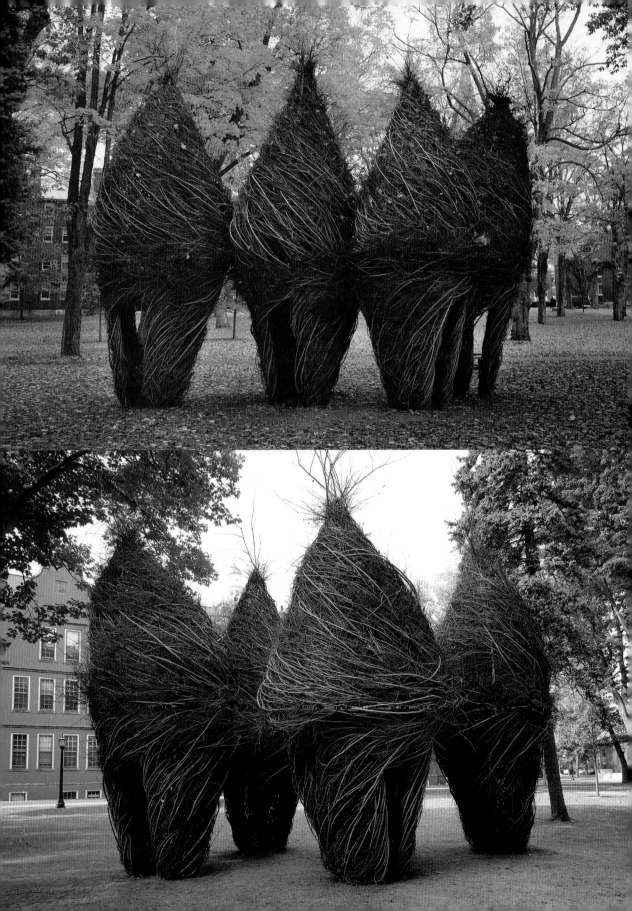

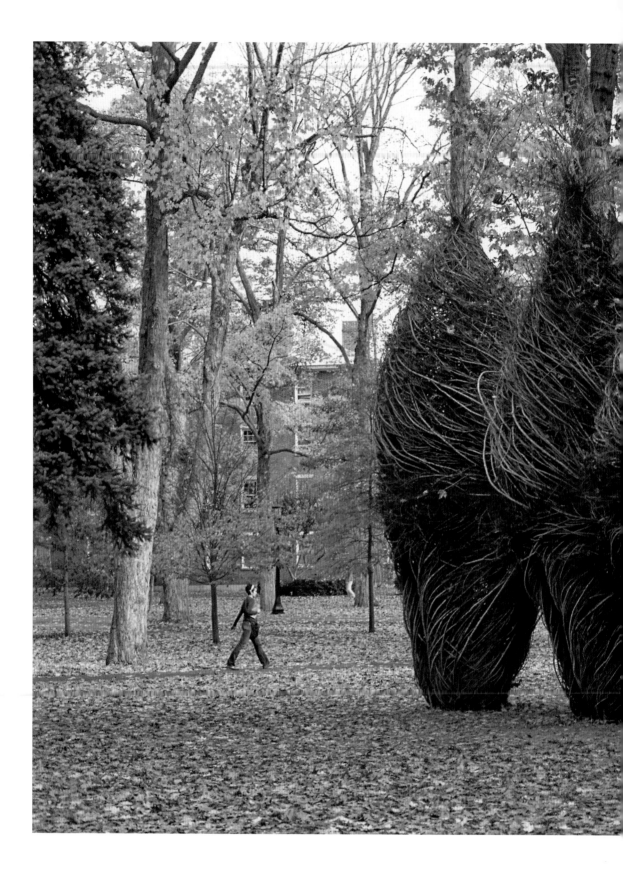

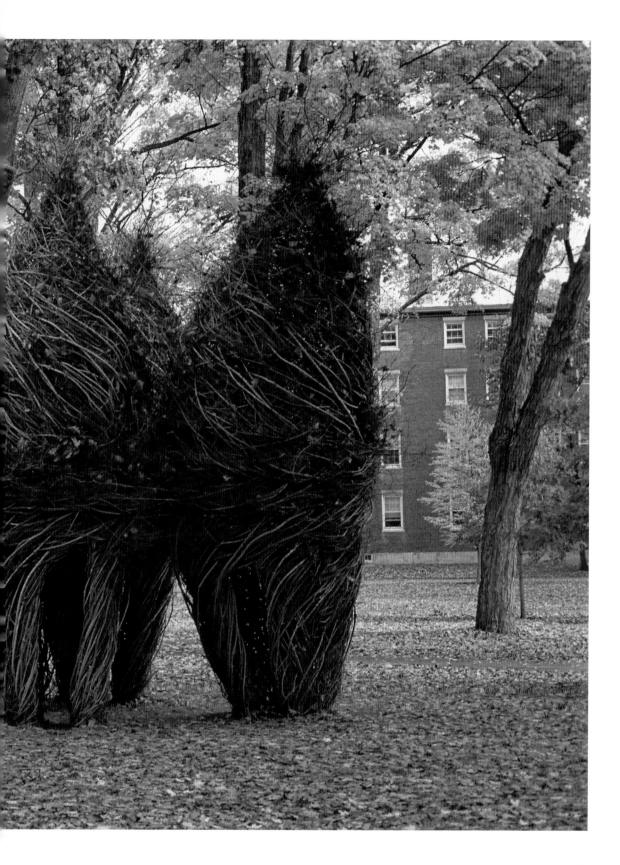

Threadbare

Construction phase: April 3-19, 2002

Exhibition dates: April 19, 2002-April 15, 2003

Site: In front of Blegen Library, at the University of Cincinnati, Cincinnati, Ohio

Sponsoring organization: DAAP Galleries of the College of Design, Architecture, Art and Planning at the University of Cincinnati

Materials: Willow and maple saplings, gathered near Lunken Airport

Size: 18' high, 60' long, 5' wide

When I hear a building contractor refer to a home as "stick built"; that is, one that is built on site, piece by piece, I am instantly reminded of the first pictures of "home" drawn by children. In the United States at least, these primary drawing always catch the essentials of doors, windows, and roofline. To my practiced eye, they give the impression of generic sticks stacked together as a childhood fort. It is not so far-fetched to see the connection between the marks pencils make and the outlines of sticks, and I use that drawing connection constantly to make my sculptures interesting. Almost all branches are tapered and when I organize many sticks in one direction, they give the impression of the momentum created by tapered lines on paper. Other drawing techniques, like cross-hatching and using shading lines for emphasis, also work with sticks.

This sculpture, built for the University of Cincinnati, consisted of five rudimentary drawings of home. Two of these "stick built" constructions leaned against the solid shoulder of a handy tree and in turn helped support this line of row houses. The sculpture stretched across the lawn of Blegen Library, and the series of doors attracted many students to veer off the sidewalk and take a look inside. During the summer, this grouping reminded me of the bivouac of sleepover camp, but as the snow began to fall, these simple shelters seemed frail against the cold. I thought about their drafty walls and refined the title to *Threadbare*.

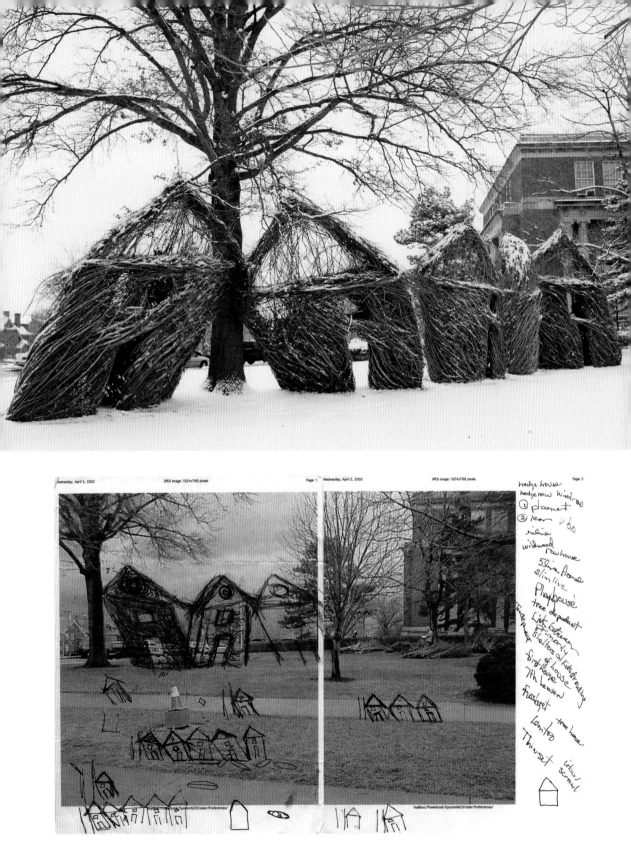

Call of the Wild

I was one of a small group of artists asked to make works for the opening of the new Museum of Glass in Tacoma, Washington. Thinking of both water and glass, I visualized building several oversized ornamental jars — common fixtures in a well-appointed garden. I was excited by the prospect of working on the museum's lower plaza with its central reflecting pool, but was stymied by how to attach structural supports and prevent the work from blowing over.

My strategy was to build a wooden form and pour my own concrete pad on top of the existing one. By working this new concrete base into the proper configuration, I was able to include part of the pool within the sculpture itself. This meant that the reflecting pool covered one-third of the floor area of these urns, suggesting a natural spring when viewed from within. When the concrete was poured, I left holes into which I could stand extra-large saplings. I set elaborate metal scaffolding around these uprights, bent the larger pieces into the shape I wanted, and then added layers of smaller saplings to complete the surface.

The title of this work, *Call of the Wild*, is not meant to evoke Jack London's book, but to reflect on the current interest in the environment and how the idea of "wilderness" once again has come to capture the imagination. Throughout much of this country's history, Americans thought of wilderness as an unlimited expanse standing in the way of progress and development. Recently, however, the connotations of *wilderness* have shifted from man against the elements to a sense of the fragility of wild spaces in the face of pollution and global warming. I fashioned these urns of twigs and branches hoping to spark in the viewer a memory of wilder places.

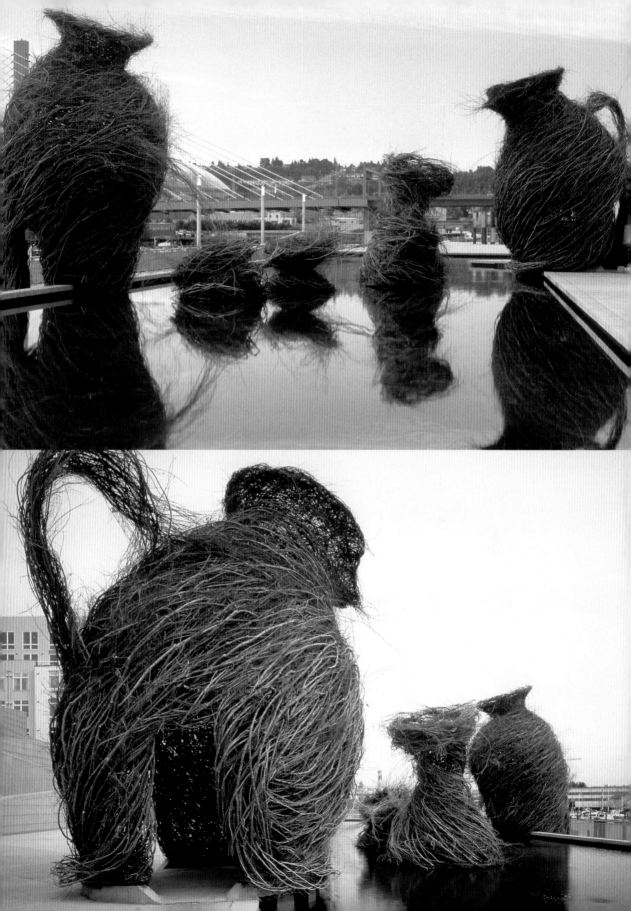

Construction phase: June 1–21, 2002

Exhibition dates: July 6, 2002–June 30, 2003

Site: Lowest reflecting pool of the pedestriar plaza, Museum of Glass, Tacoma, Washington

Sponsoring organization: Museum of Glass

Materials: Vine maple, red twig dogwood, bitter cherry, and willow saplings

Size: Total length from one urn to the other 60'; two pieces, 20' high, 8' in diameter; three pieces, each about 10' high and 4' in diameter

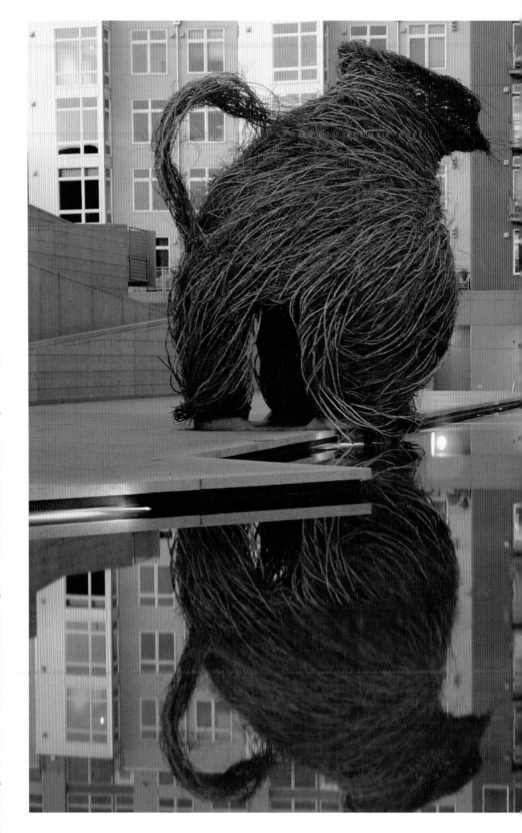

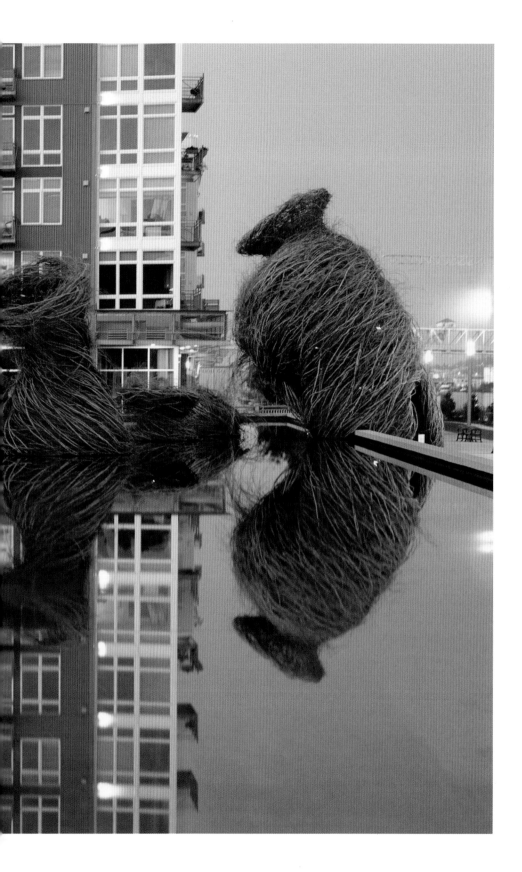

Just Around the Corner

Just Around the Corner was located in New Harmony, Indiana, on the site of its historic "village commons" at the corner of Main and Church streets. New Harmony is a town founded by the Harmonists in 1814 as a utopian community and is celebrated today for its historic architecture.

The site I chose for the installation was a row of young American hornbeam trees, with open trunks and luxurious upper branches. I was able to intertwine five circular elements into the base of this hornbeam hedge to suggest abandoned cliff dwellings or the ruins of an ancient stick city. I blended this sculpture into the streetscape by mimicking the door and window patterns of the nearby buildings. This installation sat at a right angle to the rows of shops on Main Street and contrasted the contemporary small town architecture with dwellings that have the feel of ancient construction.

Finishing this work was very gratifying. On the final day, I pulled the scaffold down, and immediately, this quiet village began to bustle. Well-wishers stepped from their cars, and neighbors left their porches. Haircuts were interrupted as the news spread. The festive crowd grew, and shortly I realized that I was at the center of an impromptu celebration.

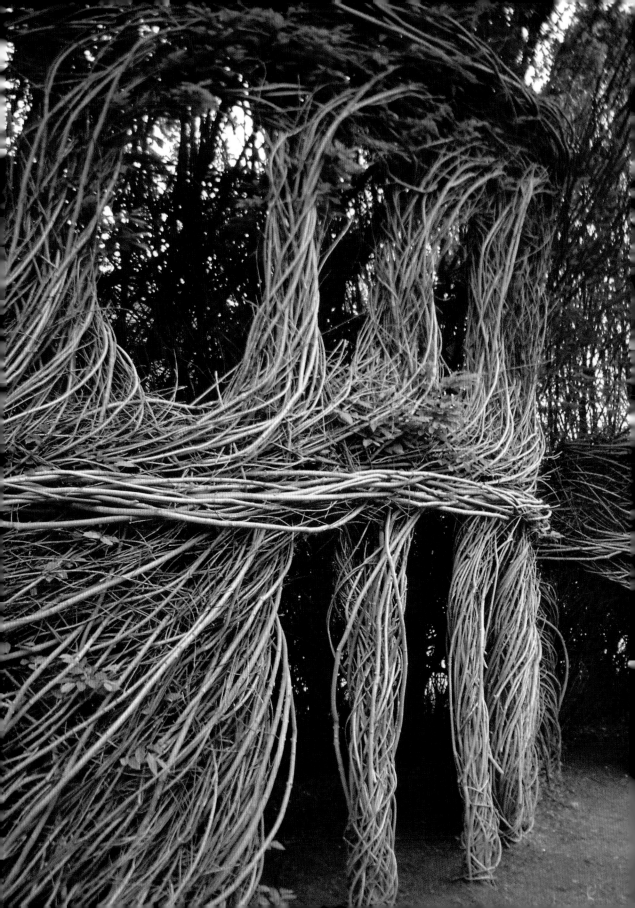

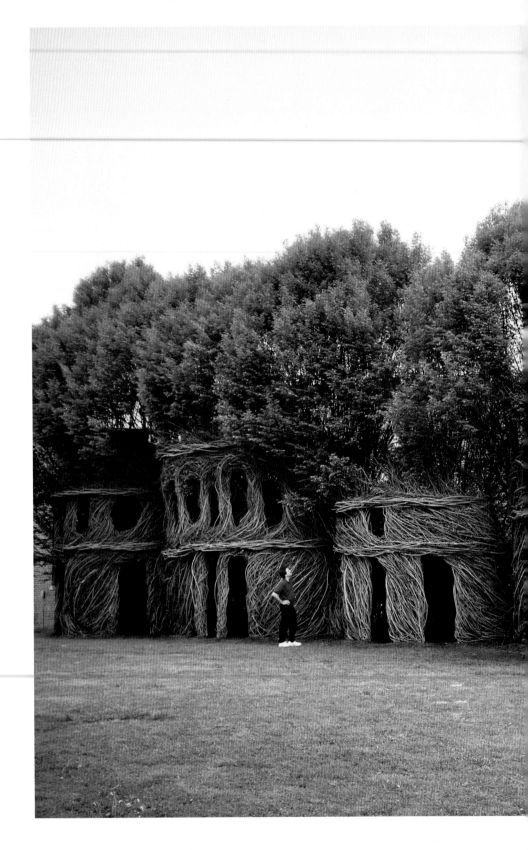

Construction phase: April 1-21, 20003

Exhibition dates: April 21, 2003-December 18, 2006

Site: Corner of Main and Church streets, New Harmony, Indiana

Sponsoring organization: New Harmony Gallery of Contemporary Art, University of Southern Indiana

Materials: Mixed hardwood saplings from several sites in the nearby countryside

Size: 18' high, 100' long, 15' wide

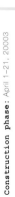

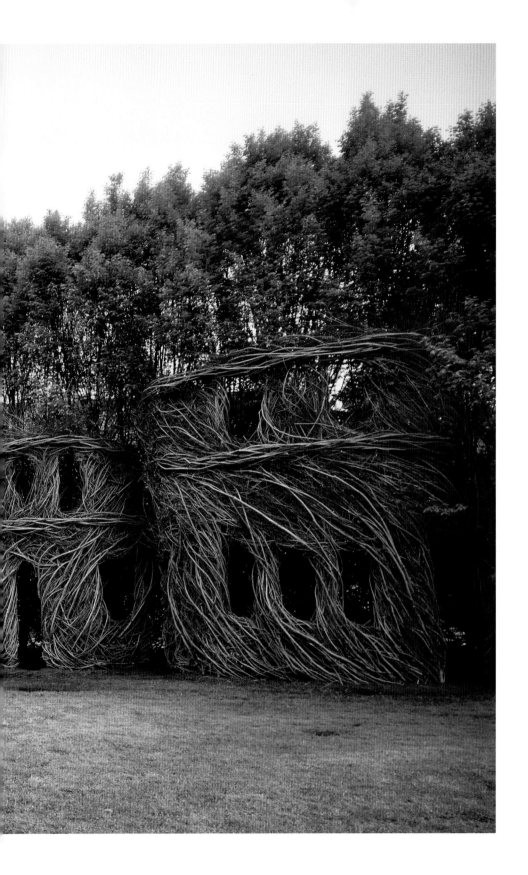

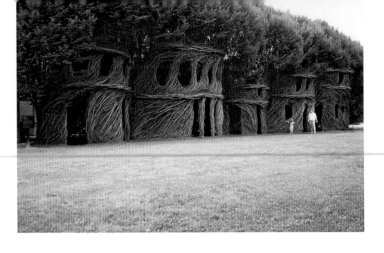

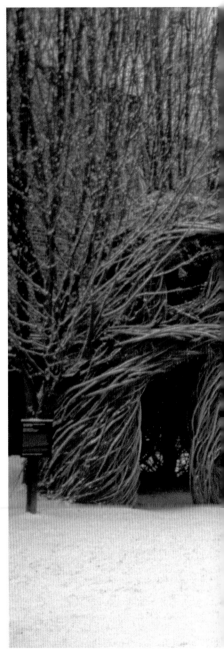

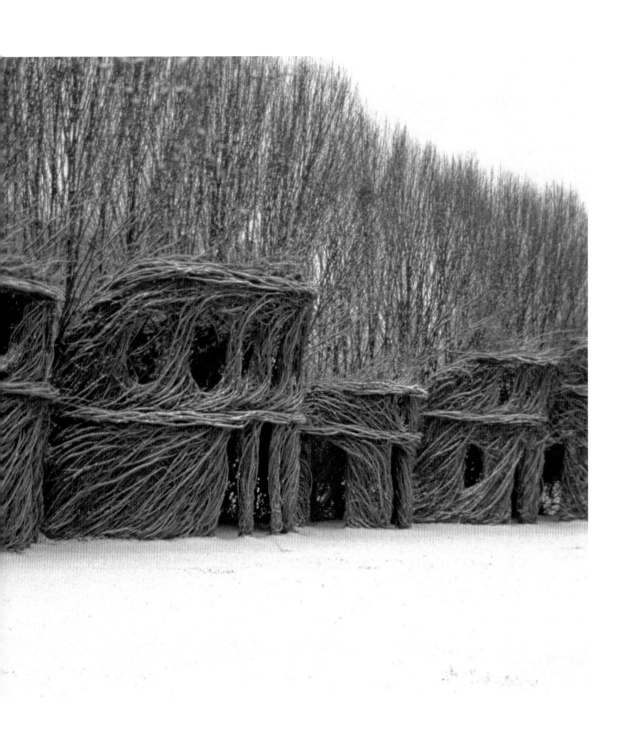

Na Hale 'Eo Waiawi

Within a lifetime of working with saplings and tree branches, it is inevitable that I would eventually be smitten by one particular tree. It happened in the backyard of the Contemporary Museum, Honolulu, during a visit to plan a sculpture for that institution. Generally speaking, sycamore trees are my favorite species because of their large white trunks and mottled bark, but when I saw this monkey pod tree with its huge multiple trunks and limbs that spread over a quarter acre, I was unabashedly infatuated. I wanted to build a work that emphasized its grandeur.

The resulting work entitled *Na Hale 'Eo Waiawi* (Hawaiian for "huts built from strawberry guava") consisted of four elements organized in two pairs under the monkey pod tree. Each of the four pieces started as a triangular enclosure then narrowed near its top and intertwined with the tree's luxurious branches. The four lower walk-in segments of the work were modeled on the gigantic multiple trunks that support this enormous tree.

Although tropical growth is plentiful, finding suitable saplings with the right color and flexibility proved to be a challenge in this island paradise. I made a connection with the Hoomaluhia Botanical Garden and found groves of strawberry guava slated for removal, as well as a group of larger, towering rose apple saplings that could be used as structural supports.

In true island fashion, the museum's staff and its friends entertained me well. I was surprised by an island tradition in which workers stay on after the normal workday and enjoy a few minutes of socializing before heading home. It is not unusual to see a construction crew sitting together in the yard of a new building at five o'clock sharing food and "catching up" with gossip and laughter. In the same manner, each afternoon at quitting time, my entire crew would sit down together, food and drink would appear, and stories would be shared. I was sad to come to the end of my work at the Contemporary Museum, Honolulu—I would miss all that end-of-day friendship and my beloved monkey pod tree.

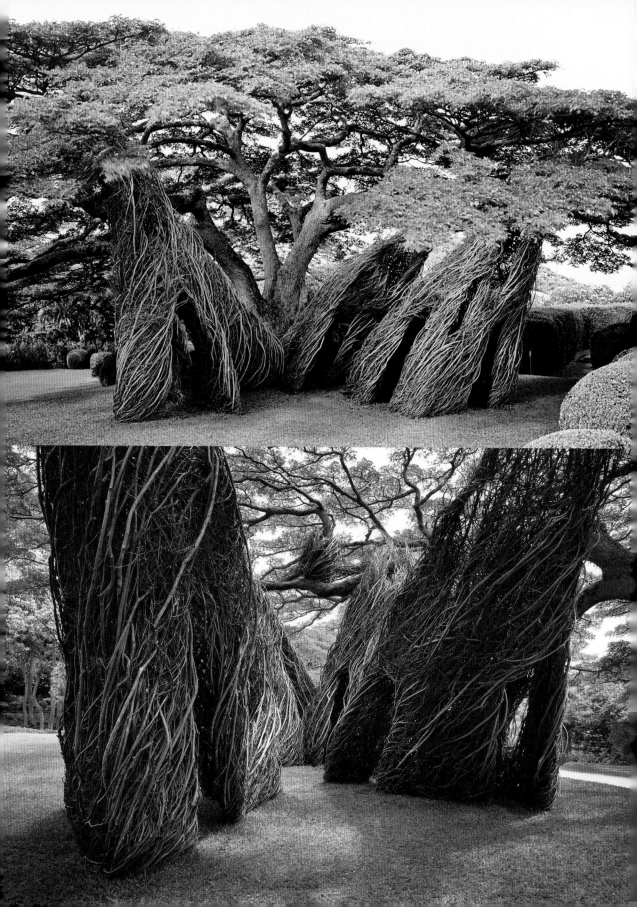

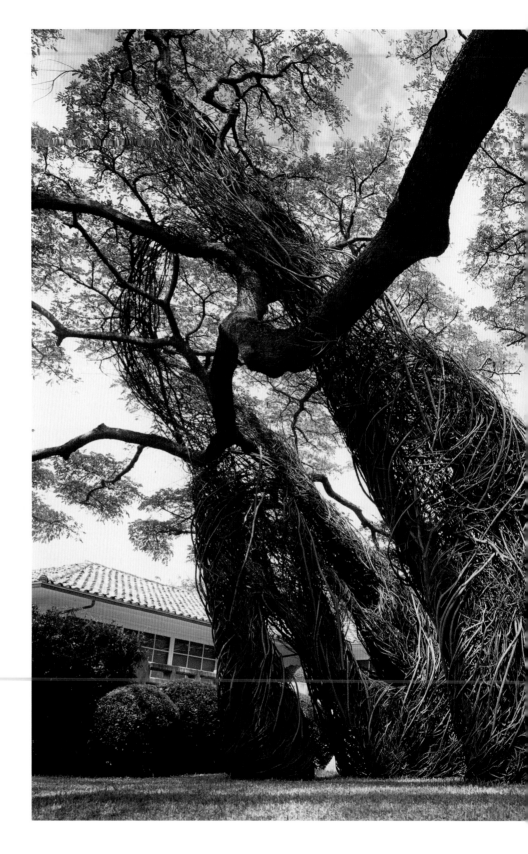

Construction phase: July 1-19, 2003

Exhibition dates: July 19, 2003-May 15. 2005

Site: At the base of the monkey pod tree in the sculpture garden of Contemporary Museum, Honolulu, Honolulu, Hawaii

Sponsoring organiztion: Contemporary Museum, Honolulu

Materials: Strawberry guava and rose apple saplings, gathered from Hoomaluhia Botanical Garden

Size: 30' high, 20' long, 30' wide

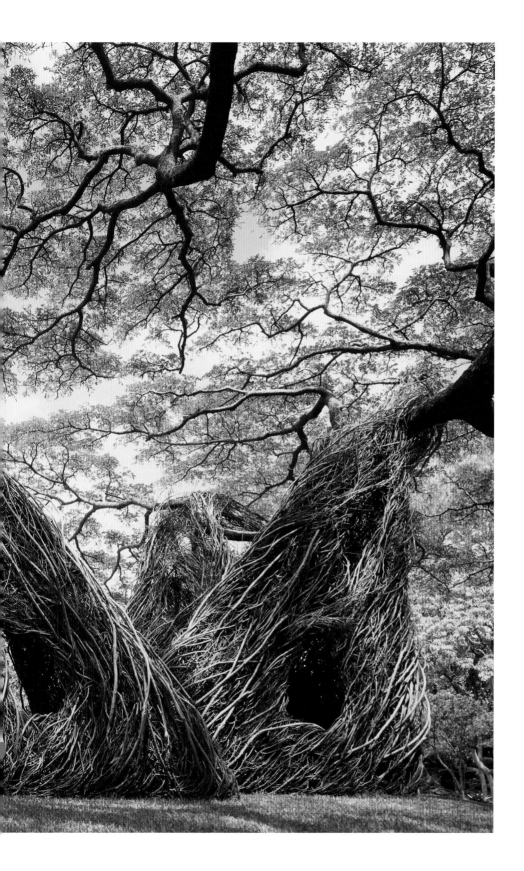

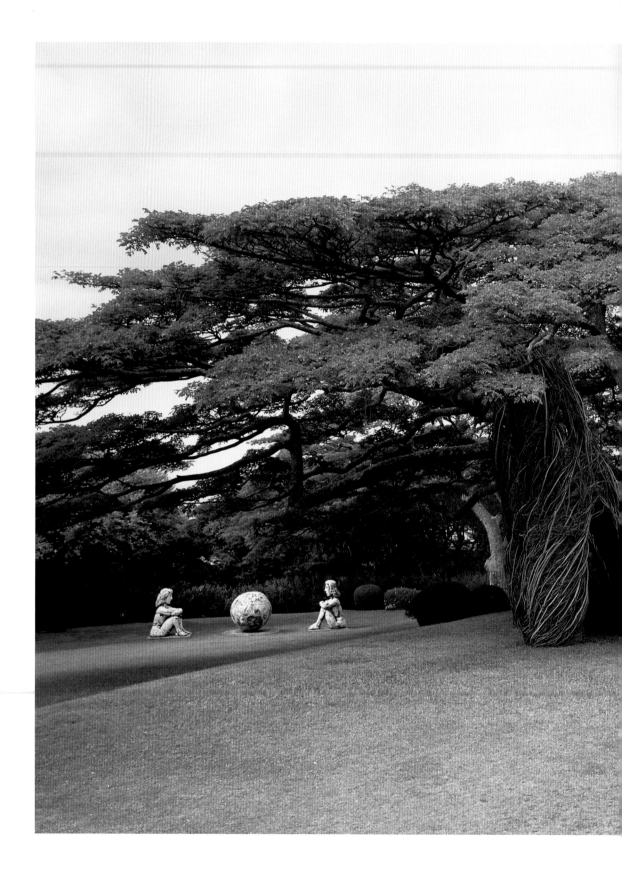

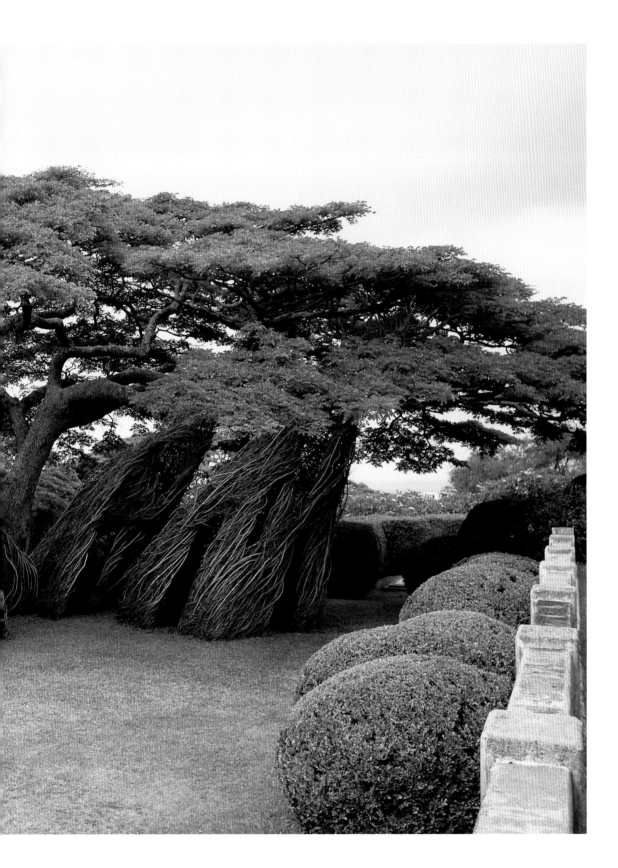

Hat Trick

My first attempt at making something from sticks took place on a picnic table in my front yard: it was a man-sized cocoon made from very thin saplings and was entitled *Maple Body Wrap*. It had the look of a funerary artifact, and I was as surprised as everyone else that I could craft such a thing so easily.

Shortly thereafter, I made a larger work, which I called *From Hedges to Hirshhorn*, at a local artist-run space. I intended to build the object in my woods and then transport it, but when I realized the gallery door was much too small for that plan, I had the impulse to construct the sculpture on-site. The success of this approach has led to over two decades of building works that react to their environs. Now, for every project, saplings are harvested by the truckload, and I custom-fit each sculpture to its site.

Hat Trick, built in an inner courtyard of the Faulconer Gallery at Grinnell College in Grinnell, Iowa, reminded me of the challenges of *Hedges to Hirshorn* because all the saplings had to be threaded through a maze of hallway doors to reach the enclosed garden terrace. Despite its intended use, this space had remained vacant because sculptures built off-site were often too large for the existing doorways.

My initial inspiration for *Hat Trick* came from paintings in the college library depicting burial scaffolding of the Plains Indians. From these images I conceived a work of woven enclosures supported by stiff legs made of tree trunks, echoing the poetic shroud of *Maple Body Wrap*. These containers evolved into nine circular bands of sticks that interacted with each other at different heights and were open to the sky.

My personal associations with funerary rites began to change, however, as the public reacted to the project. One couple talked about being married within its chambers, and a religion class discussed it as an aid to meditation. It is clear that a good sculpture causes many different personal associations with those who see it, and that this sculpture wore many changing hats.

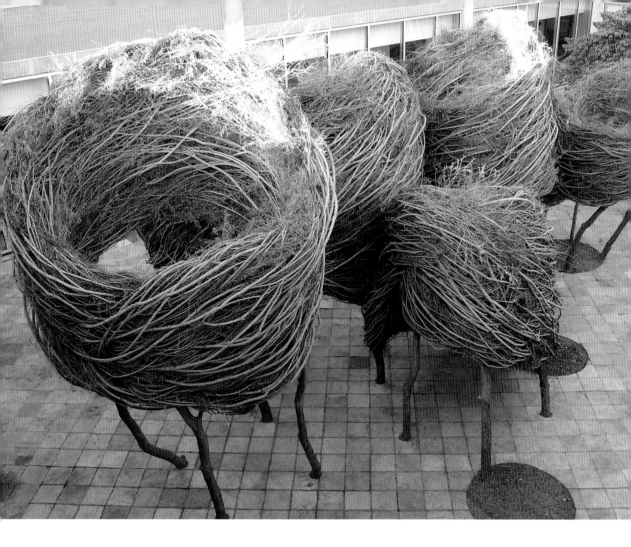

As an artist I am comfortable with the fact that my works are not permanent. I enjoy the concept that, like the sticks they are made from, my sculptures have a limited lifespan and, if left in place, will degrade and become the mulch to nourish new growth. I have also been rewarded by the rich process of building in public and participating in ongoing conversations with those who pass by. Conventional sculptors who build a work in a studio and present it as standard gallery fare do not often enjoy this rich interplay. In addition, this method of working has allowed me to capitalize on some unlikely spaces. I think that artists should move beyond conventional wisdom and follow their own drive to build. I believe that the art world is big enough to accommodate all the good ideas and that art history can look after itself.

Construction phase: October 1–20, 2003

Exhibition dates: October 20, 2003–January 12, 2010

Site: Holder Sculpture Courtyard within the Bucksbaum Performing Arts Center Grinnell College, Grinnell, Iowa

Sponsoring Organization: Faulconer Gallery at Grinnell College

Materials: Rough-leafed dogwood and willow saplings, with elm and mulberry trunks, gathered at the Conard Environmental
 Research Area of Grinnell College

Size: 16' high, 40' long, 20' wide

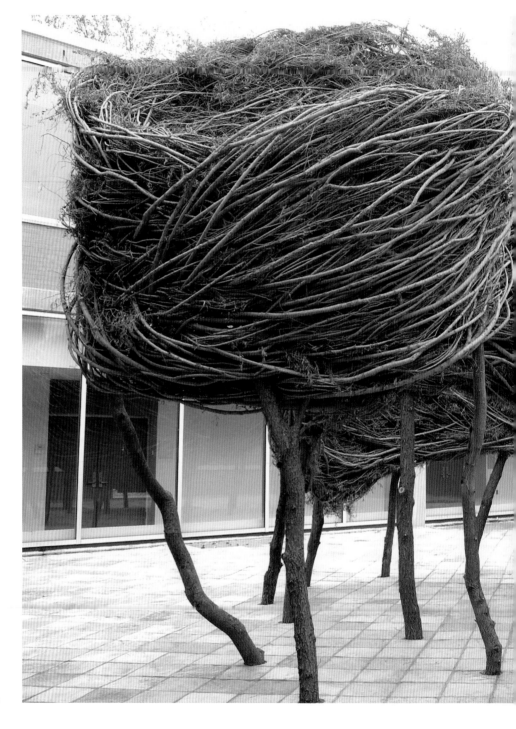

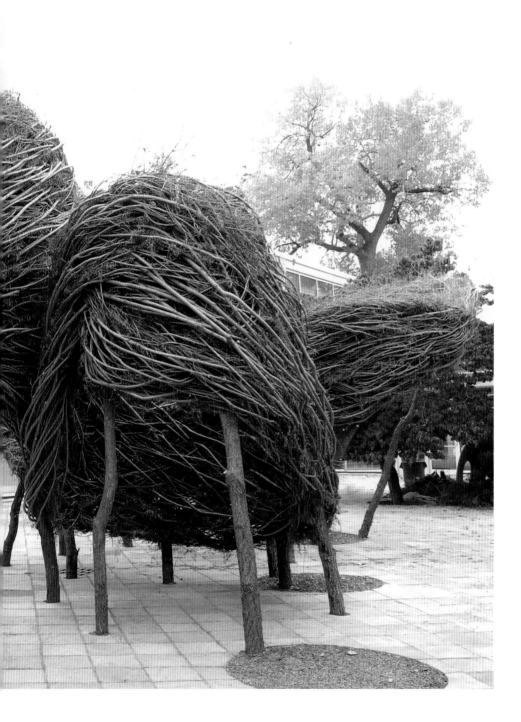

Putting Two and Two Together

The Leigh Yawkey Woodson Art Museum in Wausau, Wisconsin, is internationally known for its annual Birds in Art exhibition, and it is conceivable that the working methods I share with birds led to my invitation. I wish I could take a backyard lesson from these hardworking and ingenious creatures, but when I try to decipher secret avian weaves, I quickly lose my way. Instead, I have learned that when sticks are dragged through the woods, they hang up and entangle easily. It is from this infuriating tendency that I have derived a simple method of joining. It is not so much the conscious effort of a basket weaver, but more a kind of haphazard snagging. Each stick is flexed slightly and randomly dragged through neighboring sticks and a kind of fabric develops. At the Woodson, as is true of everywhere I go, my volunteers and I gathered great piles of saplings, removed the leaves, and began drawing them one-by-one through the mix until we had something to be proud of.

The sculpture entitled Putting Two and Two Together consisted of four thirty-foot cones that protruded from a dense arborvitae hedge toward the back of garden. The sculpture could be entered from the garden path, and the visitor could experience the dappled light of four tall conical spaces. These iconic towers were interconnected for ease of travel and provided visitors a secret path through an otherwise impenetrable hedge. I was satisfied with the results, but a visitor to the Woodson had the last laugh, when he said, "I'd like to see the size of the bird that built this!"

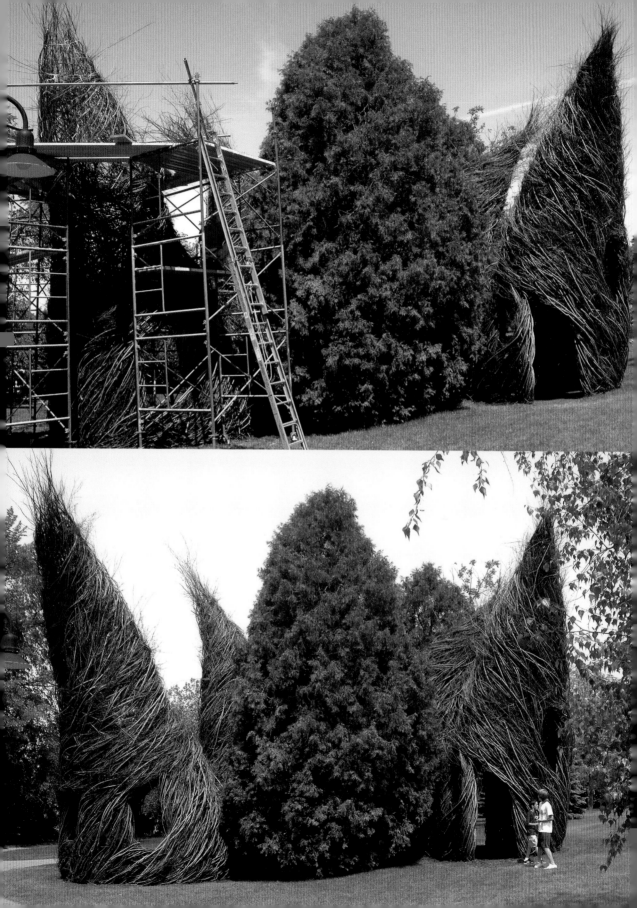

Construction phase: June 6–26, 2004

Exhibition dates: June 26, 2004–December 12, 2005

Site: Margaret Woodson Fisher Sculpture Gallery in the backyard of the Leigh Yawkey Woodson Art Museum, Wausau, Wisconsin

Sponsoring organization: Leigh Yawkey Woodson Art Museum

Materials: Mixed hardwood saplings, including -ed maple, willow and crabapple, gathered in a nearby wooded area

Size: Four segments, each 30' high and 10' in diameter at the base

8. Conifers cone - i - fers cone - i - firs

Using cones which reflect shape of blue spruce in the garden where height is $2\frac{1}{2}$ x the base

cedar hedge

sculpture copse

116

Things to note

1) cones can be high for visibility with small, invisible base

2) cones can be deformed to fit space between the trees — because we have to be careful about ~~the~~ roots of the living other trees

3) cones have to be joined so that viewer does not walk out and then into another — means a valley area ~~but~~ that the cones share

"Putting Two or Two Together"

Patrick Dougherty
Artist

Toad Hall

In 2004 I made a site visit to the Santa Barbara Botanic Garden, and after looking at many sites in the garden, I decided to place my work in the central meadow, with a dramatic backdrop of mountains and changing cloud formations. This site allowed full accessibility to visitors from a path that meanders around the meadow's outer edge. I rejected the possibility of integrating some of the larger coastal oaks that grow in the garden because I did not want to encourage visitors to climb on these protected trees.

Toad Hall mimics the sprawl of the historic Santa Barbara Mission with its central dome and maze of courtyards. It consists of a tower with an enclosed courtyard behind it. I surrounded this rear enclosure with a woven passage — that is, a thick wall with a tunnel inside. This configuration allowed the visitor to enter a doorway in the tower wall and circle out and around through this passage and return into the tower. Another element of surprise into the sculpture's interlocking design is a second secret passage, which meandered through the rear courtyard, adding mystery to the mazelike quality.

Toad Hall is the fourth piece in my California Mission series, started in 1998, the works of which are reminiscent of the religious stations built along the California coast by early Spanish settlers. I imagined these works as contemporary art outposts. Other works in the series include *Face to Face* (1998) at the San Jose Museum of Art, *Saint Denis Tower* (2001) at the Djerassi Foundation in Woodside, *A Capella* (2003) at Villa Montalvo in Saratoga, and *Lookout Tree* (2008) at the McConnell Arboretum in Redding.

Toad Hall was one of the best building experiences of my art career. The Garden staff was particularly kind and helpful, the work went quickly, and it was hard for me to say good-bye.

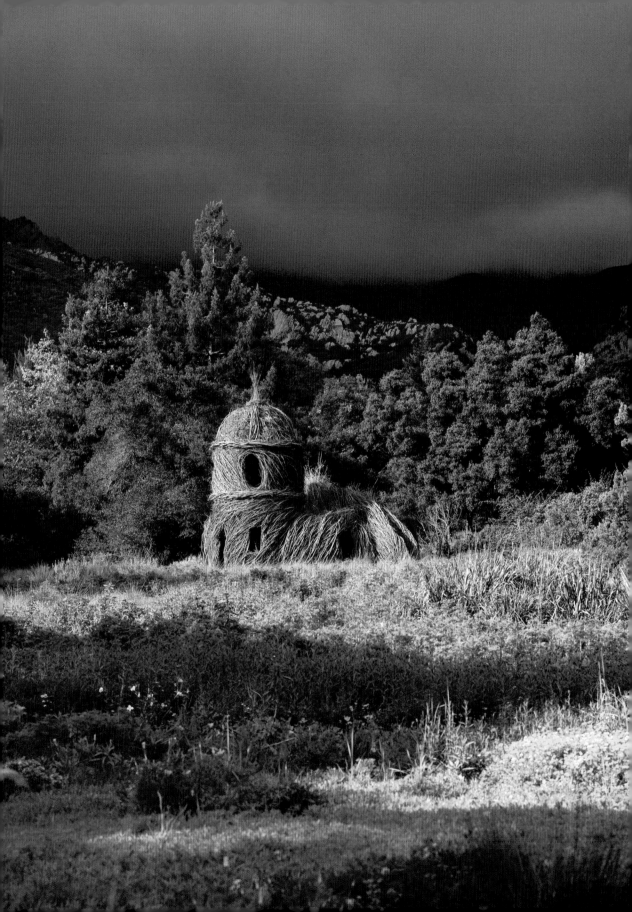

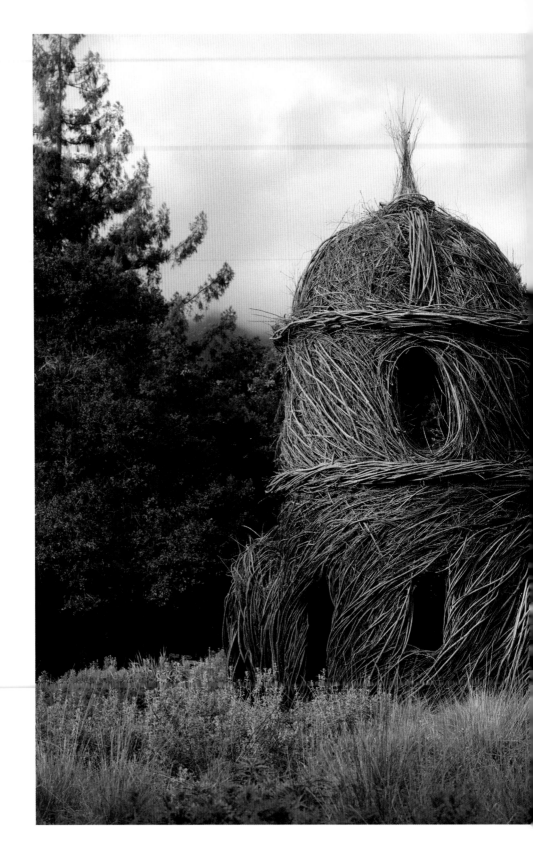

Construction phase: February 7–28, 2005

Exhibition dates: February 28–January 7, 2007

Site/Sponsoring organization: Santa Barbara Botanic Garden, Santa Barbara, California

Materials: Willow from The Willow Farm in Pescadero, California

Size: 30' high, 35' wide, 35' deep

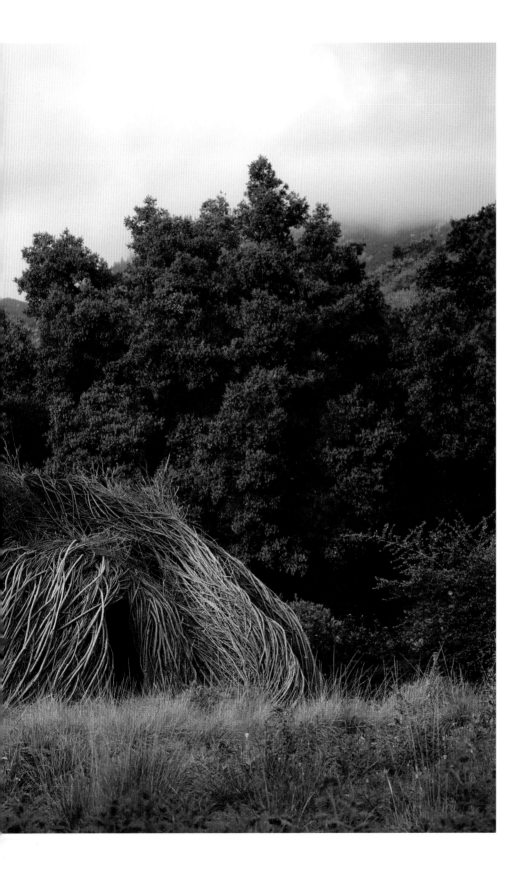

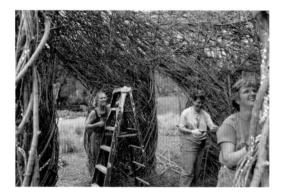

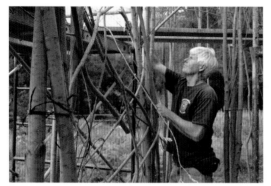

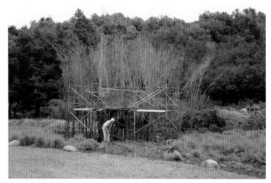

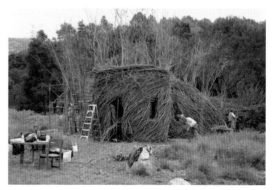

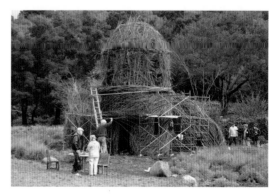

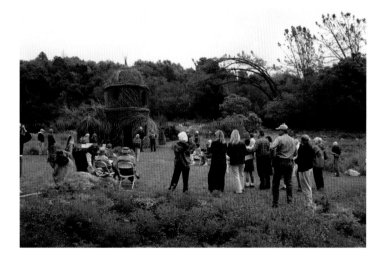

123

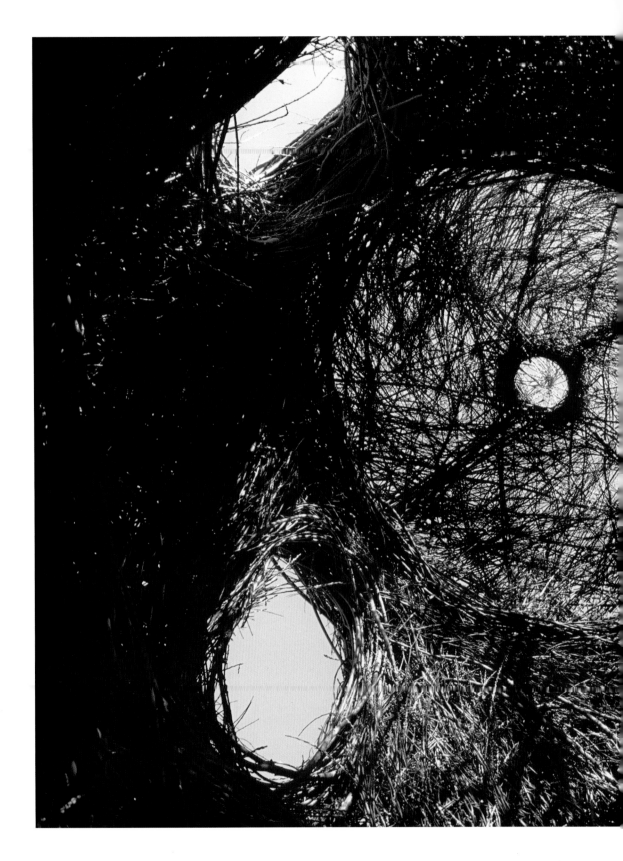

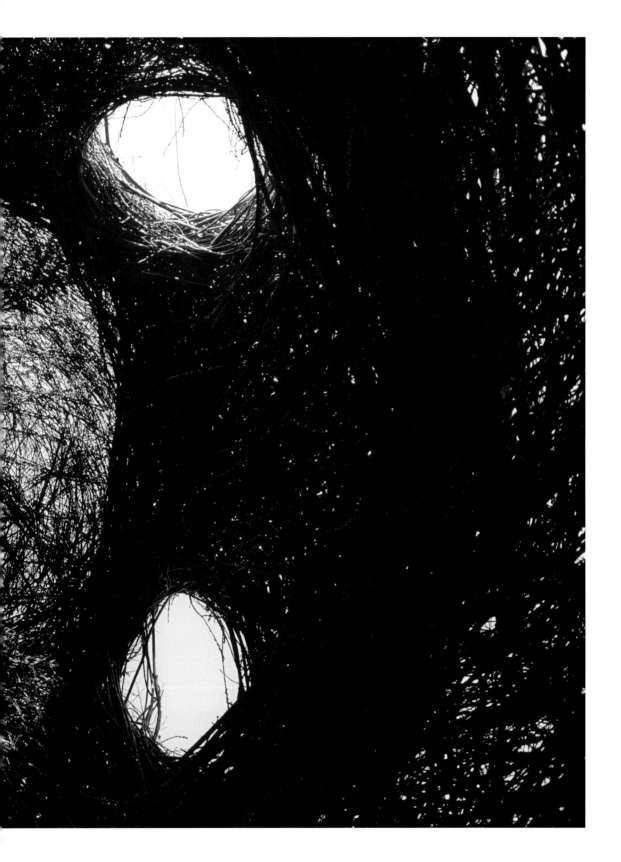

Trail Heads

Trail Heads was commissioned by the North Carolina Museum of Art in Raleigh, North Carolina, for their sculpture park, and it was built in conjunction with the opening of a new trail system in May 2005. The sculpture consisted of three heads perched on shoulders, rendered in a sapling weave and intertwined in a grove of cherry trees. I was intrigued by the possibility that, as walkers surveyed the woods near the trail, they might be pleasantly surprised by the monumental heads looking their way.

Over the years I have developed an organized approach to formulating an idea that fits a specific location. In general, I like a dramatic placement and for a work to sit comfortably in its site, for it to feel familiar there. I plan a scale that can compete with other well-designed objects nearby, such as an impressive facade or a garden feature. I make sure that each approach to the sculpture presents passersby with a tantalizing view that compels a closer look.

Specifically when surveying a place for the first time, I have learned to take note of my impressions and of how a location makes me feel. Secondly, I make word associations with a particular site and write down anything that comes to mind. Next, using these key phrases and initial inclinations, I sketch out some simple ideas. Subsequently, I face the logistical issues, and I ask myself, "How much? How many? Where?" And finally, I think up a personal storyline about this work, a core idea that is not for public consumption but encourages me to invest my energy and focus my best problem-solving skills.

At the North Carolina Museum of Art, I toured the sculpture park and felt drawn to a grove of cherry trees that grew in the corner of a fence line. The baskets of limbs that top these trees gave the impression of bushy heads, and I began to accumulate a list of word associations. I thought about ancient mythology, legends of tree gods, and faces made of leaves and twigs, and wrote down, "The Green Man looks back at you." I sketched tree faces and shoulders with doors. I settled on three such figures turned to face the meadow.

The neighborhood kids were the first to embrace the sculpture. Maybe they sensed my personal storyline. Since childhood, I had imagined a tree house with heads, or a body with extensive rooms. After all these years, a museum had readily paid me to build my dream.

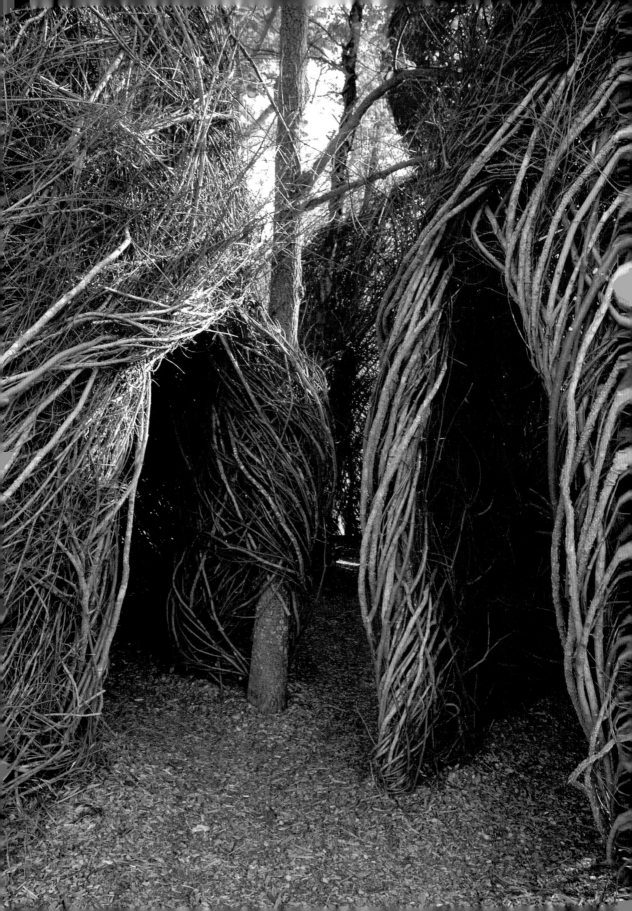

Construction phase: March 7–April 6, 2005

Exhibition dates: April 6, 2005–February 25, 2007

Site: Beside a looping trail in the rear meadow of the sculpture park at the North Carolina Museum of Art,

Raleigh, North Carolina

Sponsoring organization: North Carolina Museum of Art

Materials: Maple and sweet gum saplings

Size: Three figures, each 30' high, 25' long, 10' wide

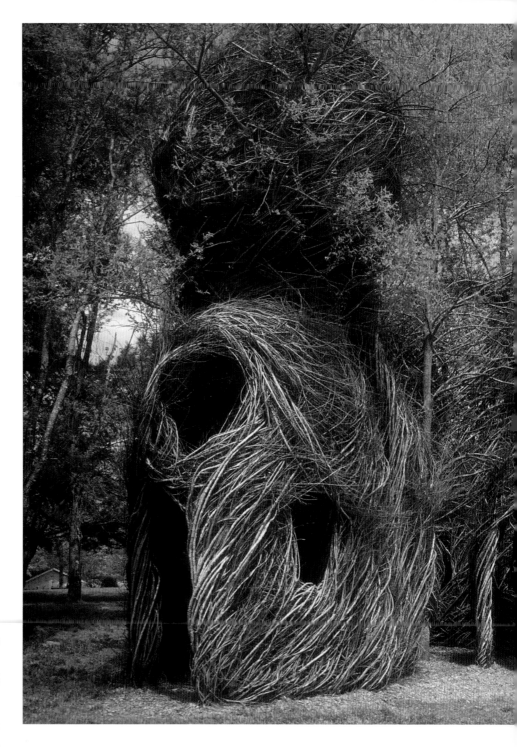

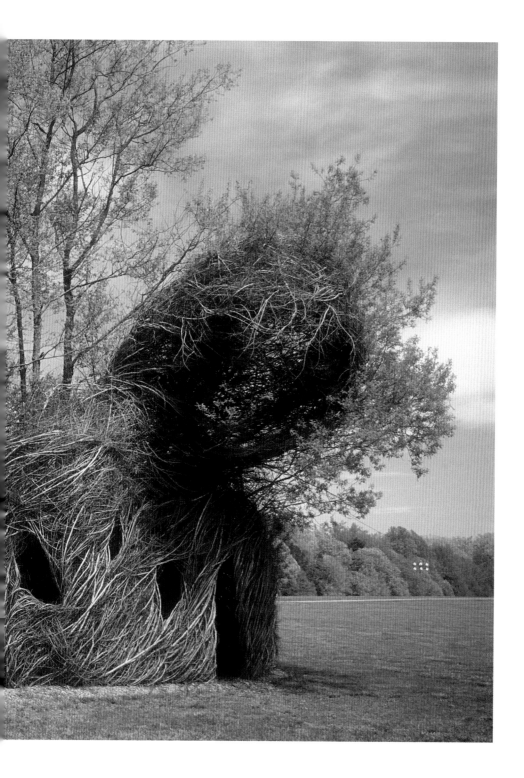

Nine Lives

Building a series of works in one location is especially challenging. Each sculpture needs to respond uniquely to its specific location and contrast with the other pieces in order to offer the public an interesting exhibition. The difficulty for such an event is not generating the ideas, but rather sustaining the project's energy and finding a source for even more saplings, more willing volunteers, and more time in the staff's schedule. Generally, a single sapling sculpture takes twenty-one days, and that length of stay has proven sound. I have found that most organizations can dedicate a three-week burst of energy and for that time, one remains a welcome guest. Asking for repeats of this performance can be a strain on all parties.

Nevertheless, during the spring of 2006 I completed a series of four distinct sculptures with the Franklin Park Conservatory in Columbus, Ohio. The works included *Foreplay,* a group of spinning towers connected together by tendrils of woven saplings and constructed in the park's nineteenth-century conservatory. Since this was a favorite spot for upscale weddings, the sculpture and the title were designed to help the couples get into the swing of things. The next work, *Arabesque,* transformed the architectural element that housed the lobby elevator into a Babylonian temple complete with woven columns. *Room to Spare* occupied a niche garden on the outside of the building and resembled a palace of arches and stick-coated barrel vaults. The fourth work, *Nine Lives*, consisted of a group of human forms positioned in the premier spot in front of the building's main entrance.

The model for *Nine Lives* was a group of nine staff members, all clustered around the chief of security, a very large fellow. Using sticks, I translated these figures into their shrublike guise, with "Mr. Big" at the center. The phrase "nine lives" is usually connected with cats, but I liked the idea that these nine people — people with nine separate lives — could be reanimated as a small grove of tree people.

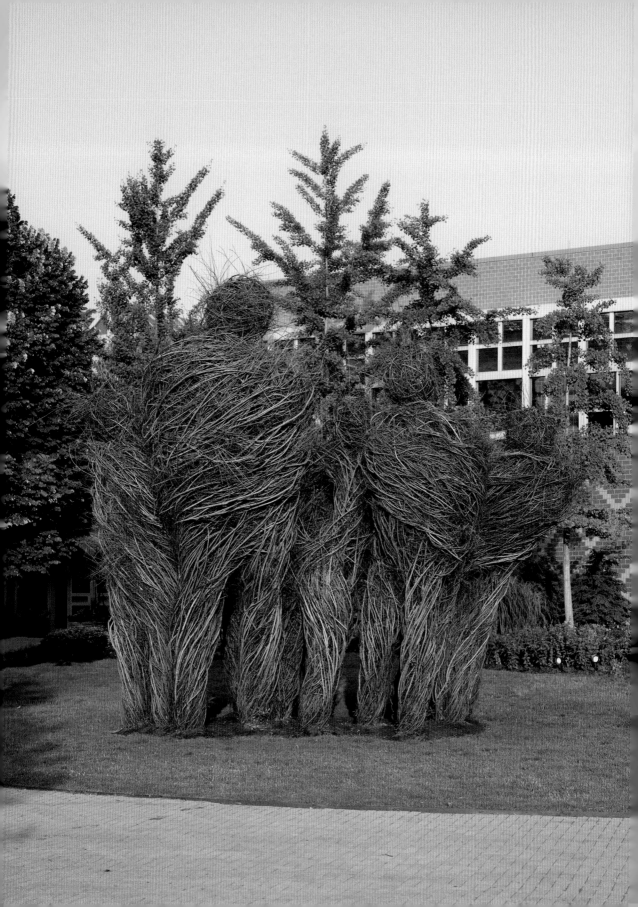

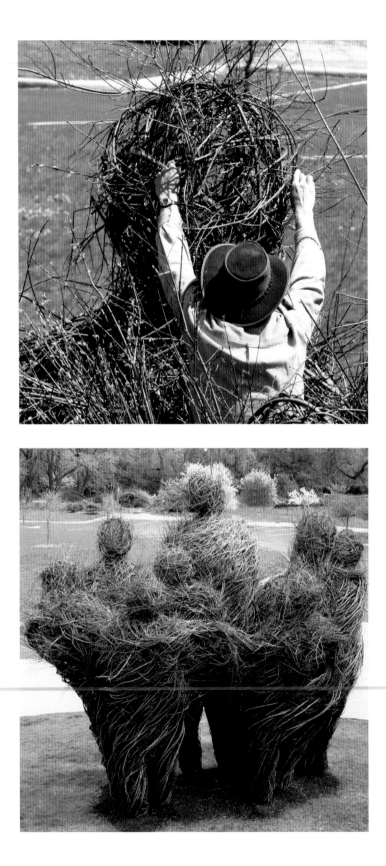

Construction phase: April 2–21, 2006

Exhibition dates: April 21, 2006–December 15, 2007

Site: Front lawn of the Franklin Park Conservatory, Columbus, Ohio

Sponsoring organization: Franklin Park Conservatory

Materials: Red maple and willow

Size: 18' high x 15' wide x12' deep

132

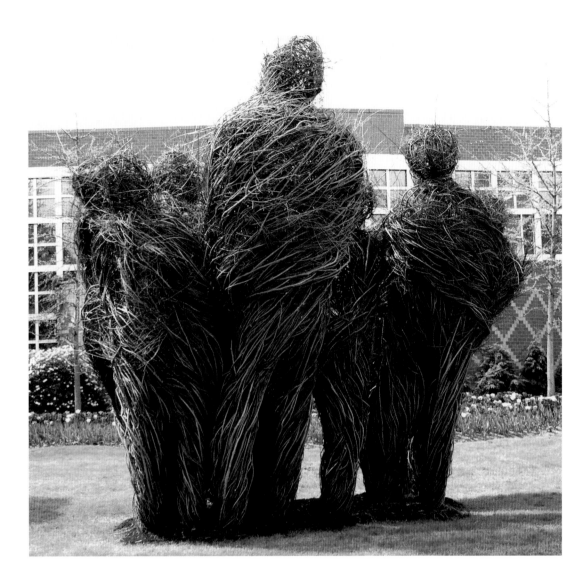

Close Ties

(Also known by those involved as "Big Willow")

The beauty of the Scottish Highlands is forever embedded in my mind from my stay on the Brahan Highland Country Estate during my work on *Close Ties*. My first week back in North Carolina after my stay there was filled with storytelling. I talked to anyone who would listen about the sound of the wind in ancient oak trees on the Brahan Estate, about the strange weather systems that blew across the mountains near where I worked, making sheeting rain and bilious clouds in one field and sunshine in another. I spoke about the beauty of the River Conan below the sculpture site and how the sea intruded into the land everywhere. I certainly saw more rainbows in one week than in all my years put together, and one afternoon a nearby tree stump was so illuminated by the rainbow's end that a pot of gold seemed certain.

Maybe the real treasure, though, was the hardy band of basket makers who came from all over Scotland to help me work on the sapling sculpture. With them, they brought a deep appreciation for the material as well as tales of sticks, especially their own local varieties. It also became clear that these stalwart souls were weatherproof and could work fruitfully despite wind or rain.

The beautiful site was located on the banks of a small pond below a castle, at the end of an alley of ancient oak trees, clearly visible from the kitchen table of Andrew and Judith Matheson, the owners of the estate. I wanted to build something simple but with enough scale to be seen from a distance. While wringing my hands in uncertainty, I happened upon a picture of the ancient stone circle at Calanis. In my mind, the early builders of such circles knew how to organize a compelling public presentation, and I decided to mimic those primal stone shapes, using willow saplings gathered on the estate.

The site was a flurry of activity, and the sculpture developed quickly. It was formally named *Close Ties* at the opening celebration, but its earlier nickname "Big Willow" persisted among the participants. I flew back to the United States on May 29th and, when I next put on my hiking boots, I found Scottish rocks in my shoes.

Most of my sculptures meet a rather ordinary end after a few years, but this one had a spectacular send-off. A festival with music and dance was held to burn it on May 26, 2007.

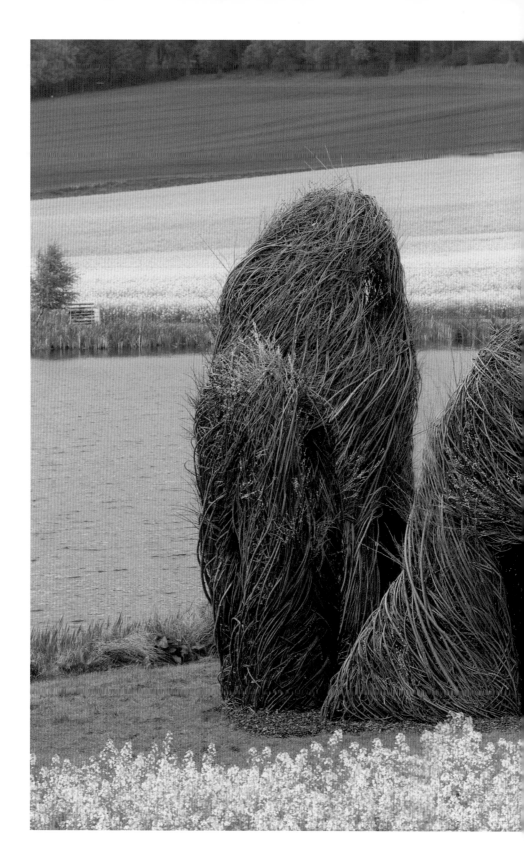

Construction phase: May 1–29, 2006

Exhibition dates: May 29, 2006–May 26, 2007

Site: Brahan Estate near Dingwall, Scotland

Sponsoring organization: Scottish Basketmakers' Circle, Dingwall

Materials: Willow, grown on the Brahan Estate as a biomass project

Size: 23' high, 30' long, 30' wide

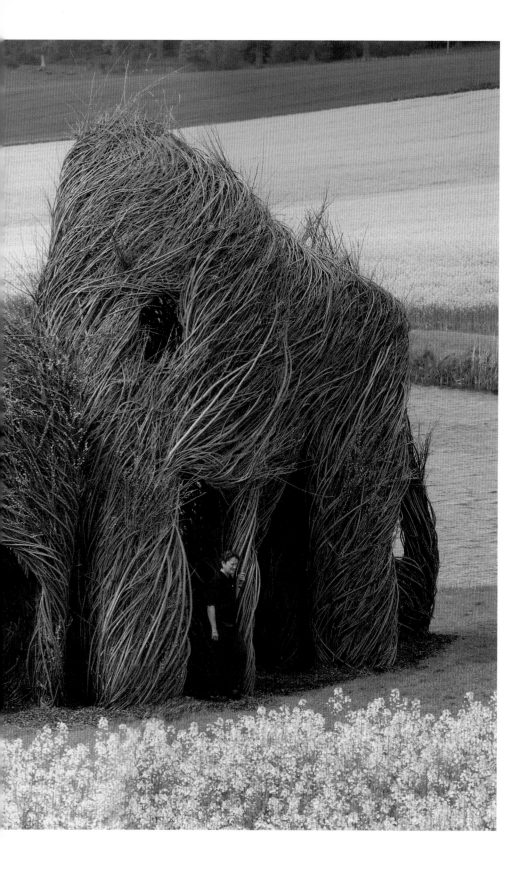

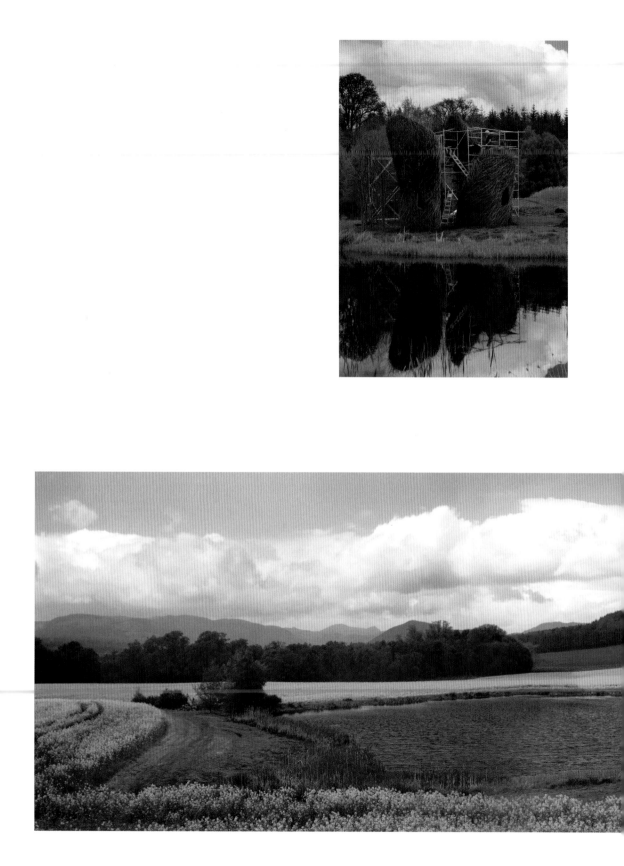

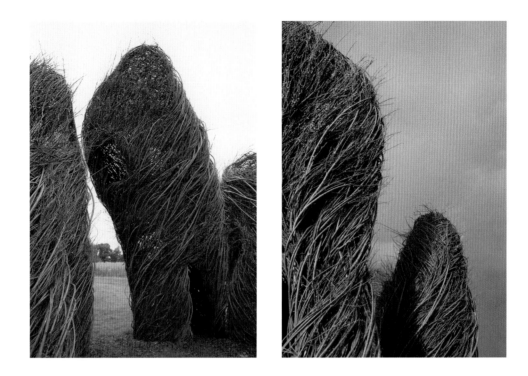

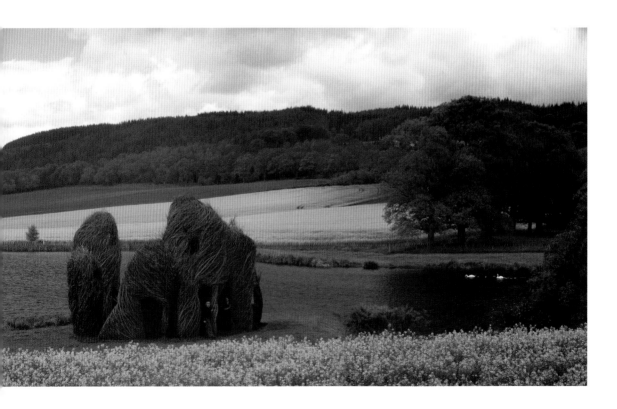

Just for Looks

It was funny to see a tractor-trailer load of sticks making its way up fashionable Melrose Avenue in Los Angeles and to note the uncertain glances of passersby as they watched bundles of saplings being unloaded in the parking lot of the new Max Azria Boutique. I was itching to begin work and give the storefront a new woven facade. I intended to weave a dramatic swath of newly cut saplings up and around the building, and I imagined upholstering this upscale fashion boutique in its own version of paisley cloth.

Melrose Avenue is crowded with cars and pedestrians, and it was a challenge even to stoop down on the sidewalk and begin to work. There were no studio doors to close and no place to hide. As my chief assistant, Romie Throckmorton, and I feverishly assembled the sculpture, two other workers stood close behind us to protect the public on the sidewalk from any flying debris.

Initially our intentions were a mystery to passersby, and people of all walks of life stopped to inquire and to offer their own advice. Was I aware that this particular section of Melrose was a dangerous place? Did someone of authority know what I was doing? Was I involved in some kind of movement, like performance art?

As time went on and the sculpture developed more dimension and vigor, the flavor of the conversation changed, and I heard more observations about the natural world. Did I know that some birds build hotels and that some gorillas build nests? Did I realize that kids today do not get out in the woods like the older generation once did? "Did I tell you about this peculiar sycamore tree that my children call Big Mr. Twister?"

In the final days, I used a motorized lift to add strategic lines and give the sculpture its final luster. I fantasized that the energy of the traffic flow on the street below was adding momentum to the rambunctious sapling walls. During this stage, when I was adding the finishing touches, some shoppers would stop dead in their tracks and drivers would slow down for a second look. It was then that conversations turned rich and full. As a sculptor, I prize that final day during which people whom I did not know were disarmed by what they had seen and moved to say hello and strike up a conversation. *Just for Looks* was a fascinating opportunity to bring high fashion, sculpture, and a community of unsuspecting viewers together.

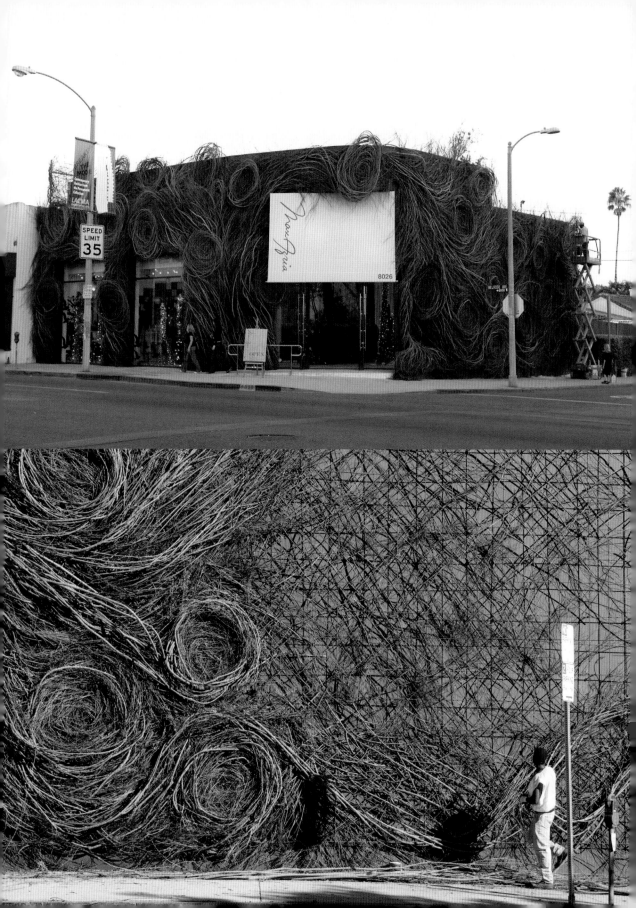

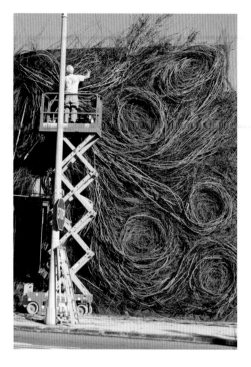

Construction phase: November 1–21, 2006

Exhibition dates: November 21, 2006–present

Site: Max Azria Melrose Boutique

Sponsoring organization: BCBG Max AzriaGroup, Vernon, California

Materials: Willow saplings from The Willow Farm in Pescadero, California

Size: 20' high and 49' long at front of building; 20' high and 38' long at side of building

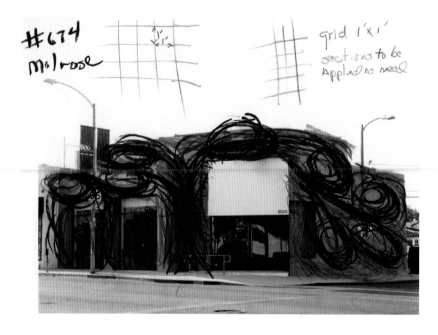

#674
Melrose

grid 1'x 1'
sections to be
Applied as need

Childhood Dreams

A load of green saplings and trees seems out of place in the parched desert of Arizona. Yet in February 2007, saplings gathered from The Willow Farm in Pescadero, California, stood in a heap at the Desert Botanical Garden in Phoenix. Water sprinklers were immediately started in order to keep the sticks wet and flexible. Even so, when I arrived and began pulling limbs from the pile, my plan to fashion a sculpture here in this arid landscape from material culled from a distant forest struck me as unnatural. Rather than focusing on how awkward sticks could look in desert light, I thought of it as a large three-dimensional drawing and used my branches as individual pen strokes.

In planning the work, I fell in love with a group of barrel cacti near my site and decided to model the sculpture on them. These shapes were in harmony with the garden's plant collection and sympathetic with the contour of the surrounding red buttes. The finished sculpture, entitled *Childhood Dreams*, provided the visitor with a shady interior space and a variety of desert views through its portals.

The biggest hurdle in construction concerned sixty holes dug in the desert floor. The soil, called caliche, is akin to compressed concrete dust, and even loosened soil defies removal from the hole. I developed the technique of using a jackhammer to loosen the soil and a large vacuum cleaner to remove it. Still, it took three days of constant work to dig all the necessary postholes and insert the structural supports — the trucked-in poplars.

One of the key factors in my ability to build large sculptures and finish within a three-week period has been the willingness of sponsors like the Desert Botanical Garden to lend their staff and volunteers to the construction. I remind the hesitant volunteers that, when we were young, the ubiquitous stick was an everyday part of childhood play. It was a tool, a weapon, a rafter. I point out my belief that we inherit stick know-how from our first ancestors. So any volunteer can quickly find that knack, the basic urge to build. As the last day approaches, I often notice that a change has taken place. My self-conscious volunteers have set aside their hesitancies and are fully engaged in act of making.

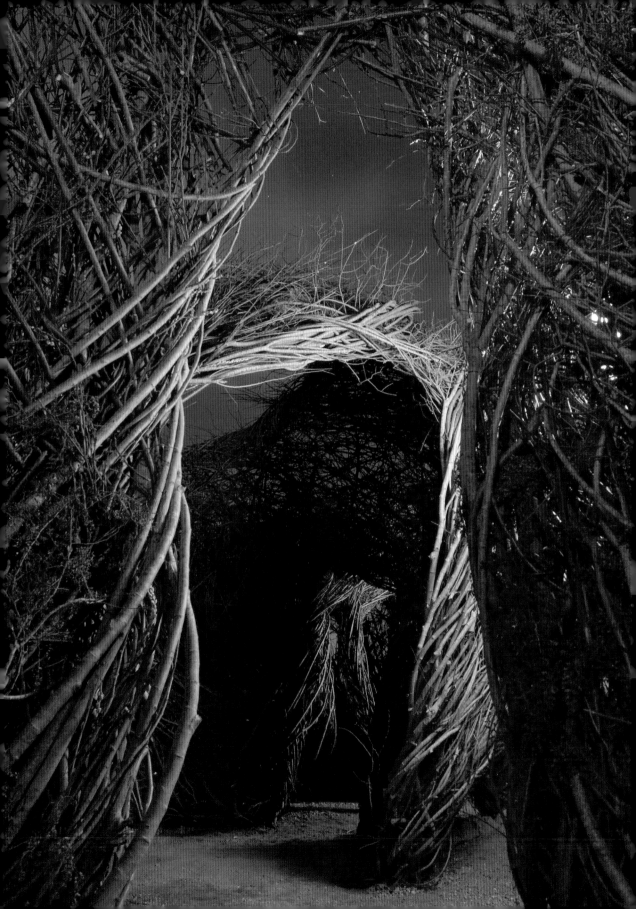

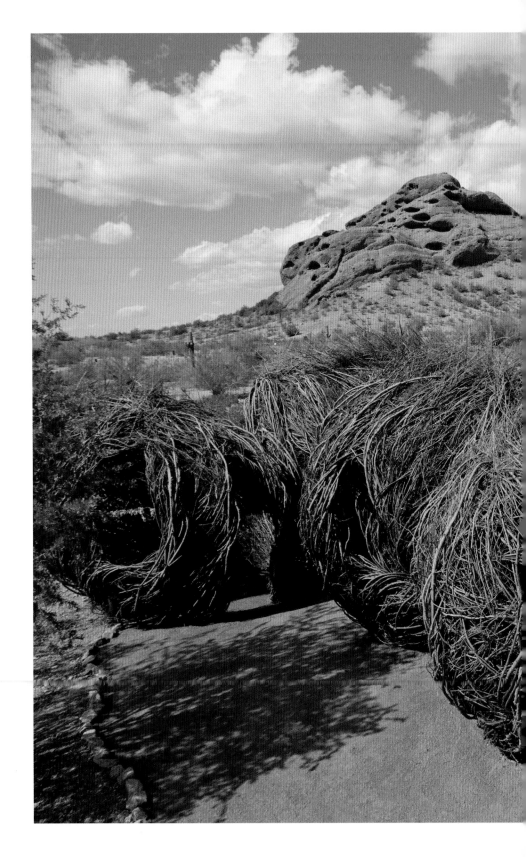

Construction phase: February 4–24, 2007

Exhibition dates: February 24, 2007–August 20, 2008

Site: Alongside the Harriet K. Maxwell Desert Wildflower Trail, Desert Botanical Garden, Phoenix, Arizona

Sponsoring organization: Desert Botanical Garden

Materials: Willow saplings and small poplar trees, from The Willow Farm, Pescadero, California

Size: 15' high, 40' long, 25' wide

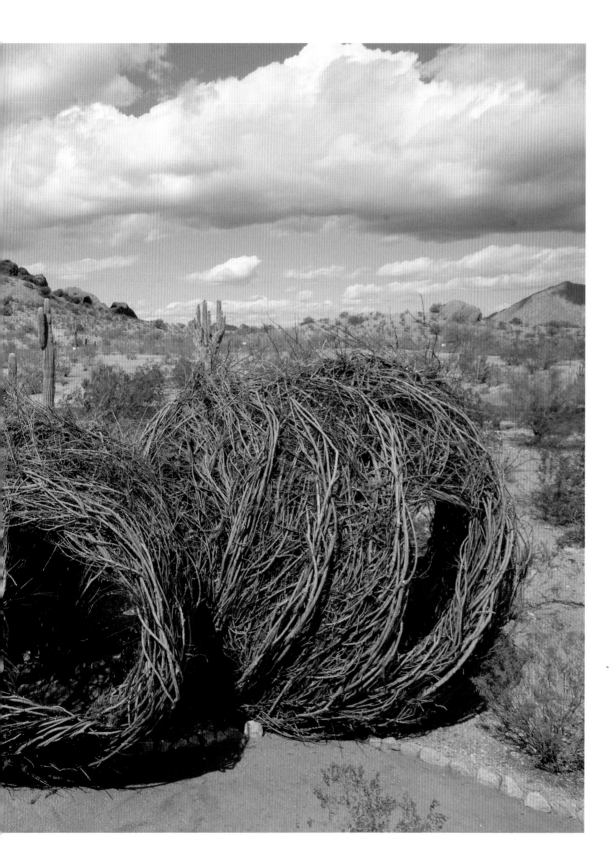

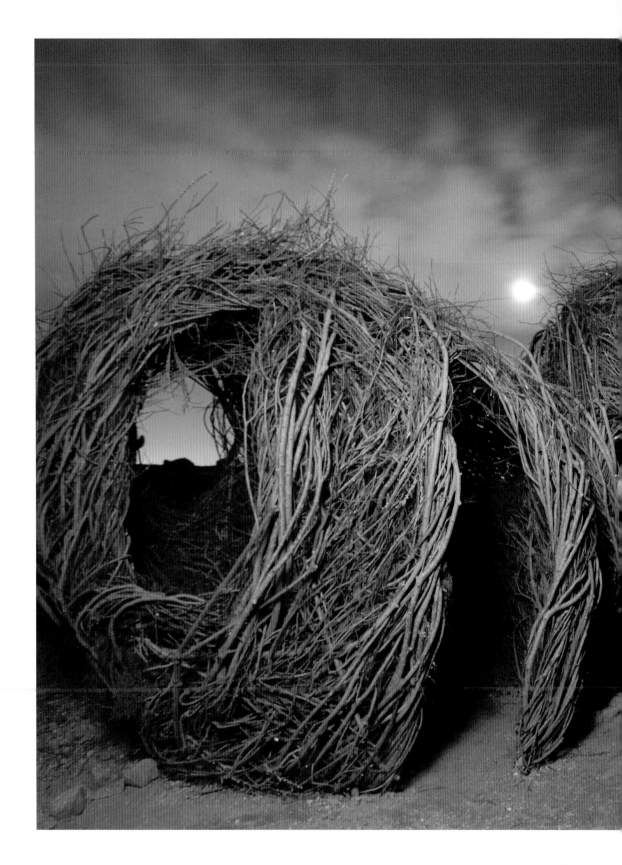

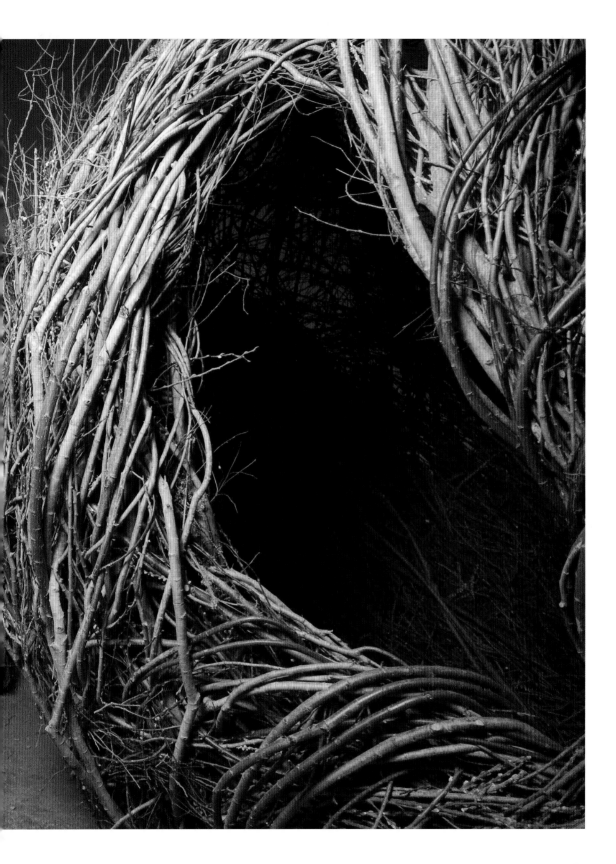

Xanadu

During my art-student days in the early eighties, painting was preferred by some over sculpture because it was viewed as unpremeditated and intuitive. I gleaned that an impulsive process provided a more direct route to the subconscious, which might prove closer to "the real thing." Although I have remained unclear about what "the real thing" is, this concept has influenced my working method.

The first step I take in a project is to walk around a location looking for starting points, associations connected to that specific place. Such cues have included nearby architectural forms, the shapes of bushes, and other physical prompts. Sometimes I am affected by more subtle pressures — triggered memories, an overheard story or phrase, or the sponsor's unspoken feelings. These impressions lead to a series of simple drawings, which in turn I plot on the ground. At this stage, formal planning is often replaced by reactivity and impulse, as I keep molding the sticks in a process of discovery.

At the Morton Arboretum near Chicago, I chose to work in their pinetum, a beautiful secluded grove of pines. During the idea phase, I recalled a vision that the nineteenth-century poet Samuel Taylor Coleridge described in his poem "Kubla Khan; or A Vision in a Dream: A Fragment" (1816) of a magical place for Kubla Khan, a "stately pleasure-dome" with an incense-bearing tree nearby, surrounded by dappled light and greenery. I wondered what a pleasure-dome for this woodsy setting might look like.

The original inspiration for this work is a cog with a hub and teeth — the primitive gear in an old-fashioned clock. I drew this configuration onto the ground with paint. I imagined that this gear was cut from a circle, and the cutaway fragments were retained. I plotted these salvaged shapes as well.

Despite the lack of an overt connection between a palace of sticks, the gruesome khans, and the inner works of a clock, I began to organize the saplings around the markings I had made on the ground. As the work developed, a complicated interior emerged with an inner dome, an oculus, and a throne room with eight short antechambers — the imagined teeth on the gear. Around the exterior were scattered seven odd shapes complete with windows and doors, my imagined cutaway pieces. Overall it had the bucolic feel of that small, enchanted city nestled in "forests ancient as the hills."

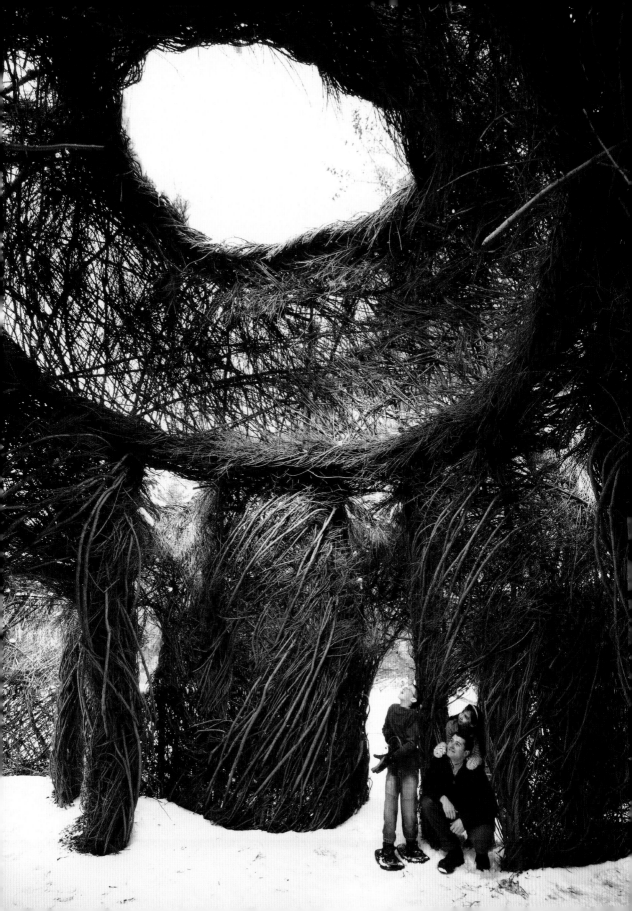

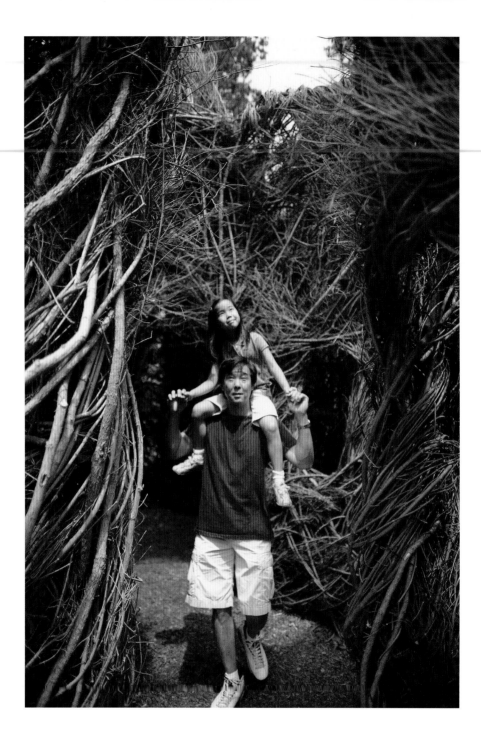

Construction phase: April 5–27, 2007

Exhibition dates: April 27, 2007–March 21, 2008

Site/Sponsoring organization: Pinetum Morton Arboretum, Chicago, Illinois

Materials: Ornamental shrubbery branches and mixed hardwood saplings

Size: 25' high, 35' wide, 35' deep

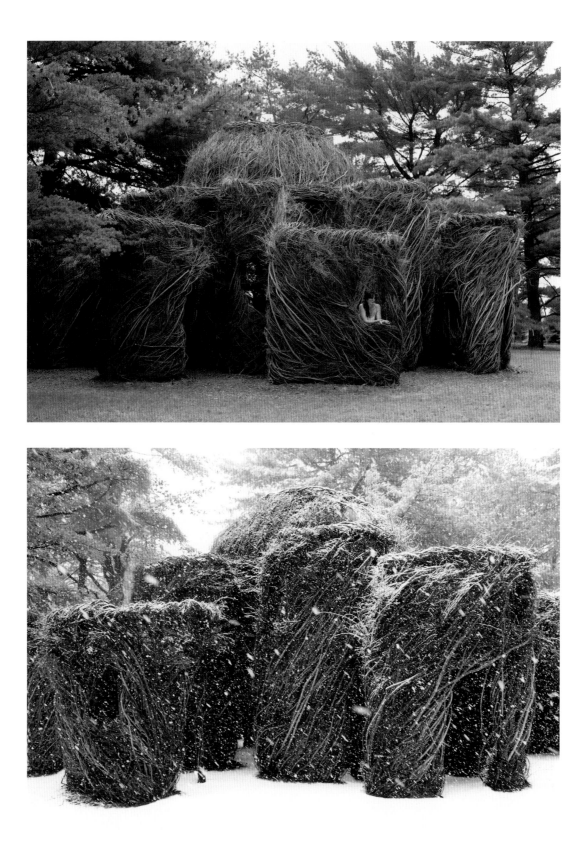

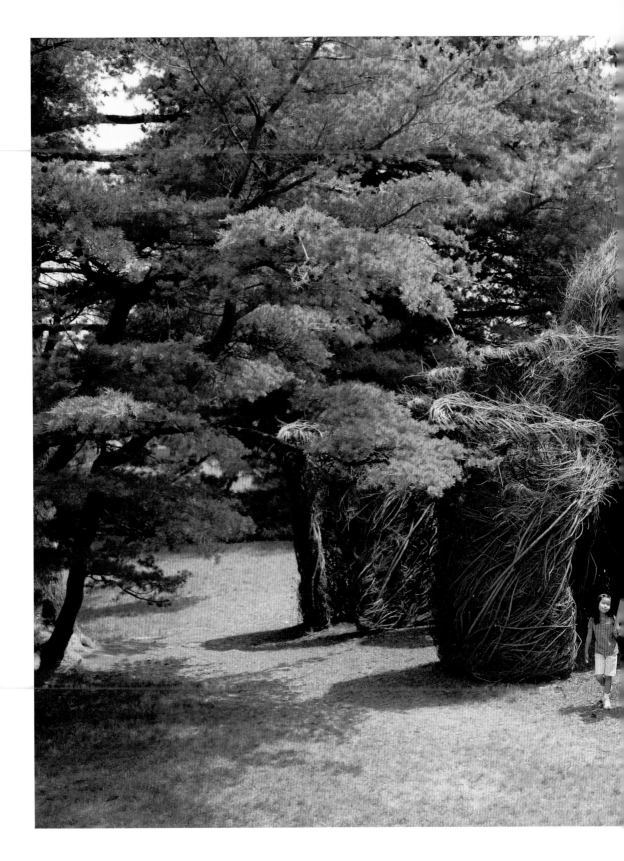

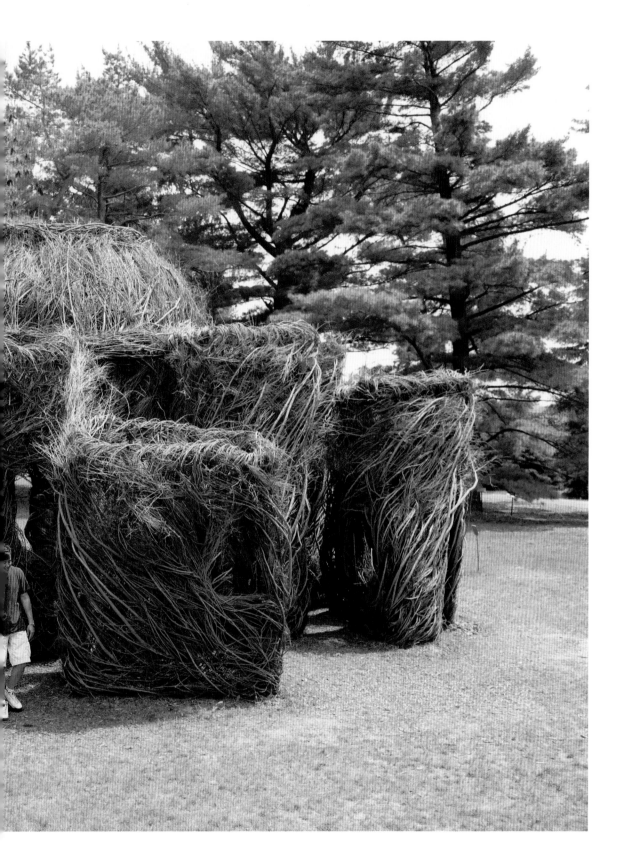

Second Sight

Construction phase: July 4–25, 2007

Exhibition dates: July 25, 2007–July 1, 2008

Site: Lower lobby and the mezzanine area of the Palm Springs Art Museum, Palm Springs, California

Sponsoring organization: Palm Springs Art Museum

Materials: Willow from The Willow Farm in Pescadero, California

Size: Three elements, largest 18' high and 9' in diameter; second 18' high and 6' in diameter; third 12' high and 9' in diameter

In July 2007, when a tractor-trailer arrived at the Palms Springs Art Museum loaded with saplings, it brought more trees than the desert had ever seen. It seemed impossible to fit so many untamed trees onto the loading dock, much less to imagine that they could be conjured into a meaningful sculpture inside the museum's atrium.

Nonetheless, museum employees appeared, and, like ants on the march or bearers on safari, they moved the many bundles into the museum. In subsequent days, these saplings were stripped of leaves, fire-retarded, and ported upstairs to the lobby. The maintenance crew ferried the sticks, housekeepers kept brooms in hand, and guards picked up debris that escaped along the route.

With the saplings came the aroma of willow and a glimpse of wilderness. The museum's display of ancient Indian baskets came to life in my imagination. I felt cold weather coming in and pictured one of these baskets lying casually by the fire. Stirred by this daydream, I planned three large aboriginal forms that would lean informally on the walls and rails near the mezzanine.

Scaffolding was manhandled into place. The structural sticks were arranged and bent. While I worked to establish the shapes, the museum's art handlers finished the upper rim. The museum guards, having observed the process, offered a running commentary, later participating further as spokesmen for the project to the visiting public.

The atrium is a grand place, and the oversized basket forms could be seen from every angle, high and low. On the last day, I stood on the balcony above the mezzanine and watched visitors cross the thresholds into these stick-lined enclosures. I wondered if they, too, felt a primitive urge and the call of the campfire of old.

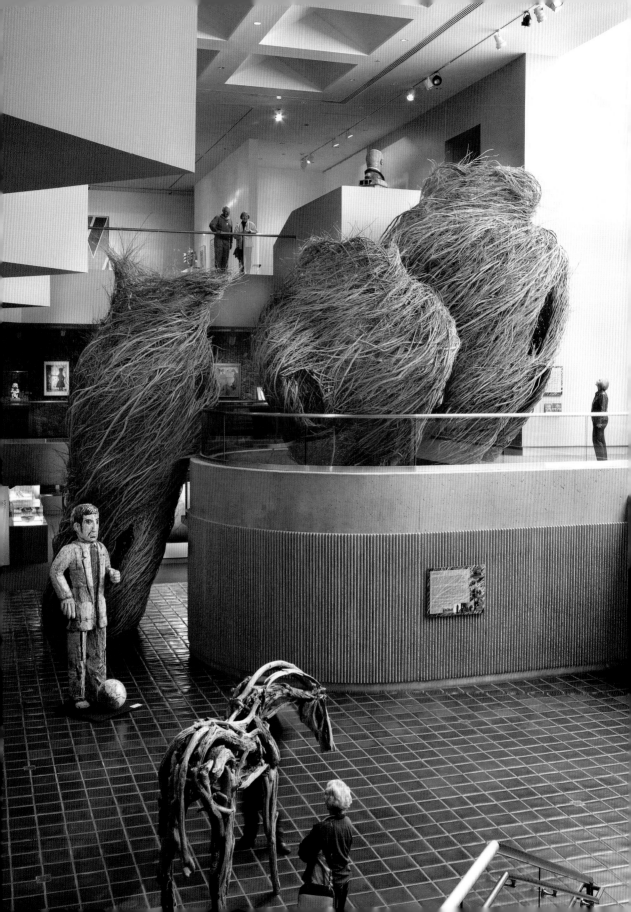

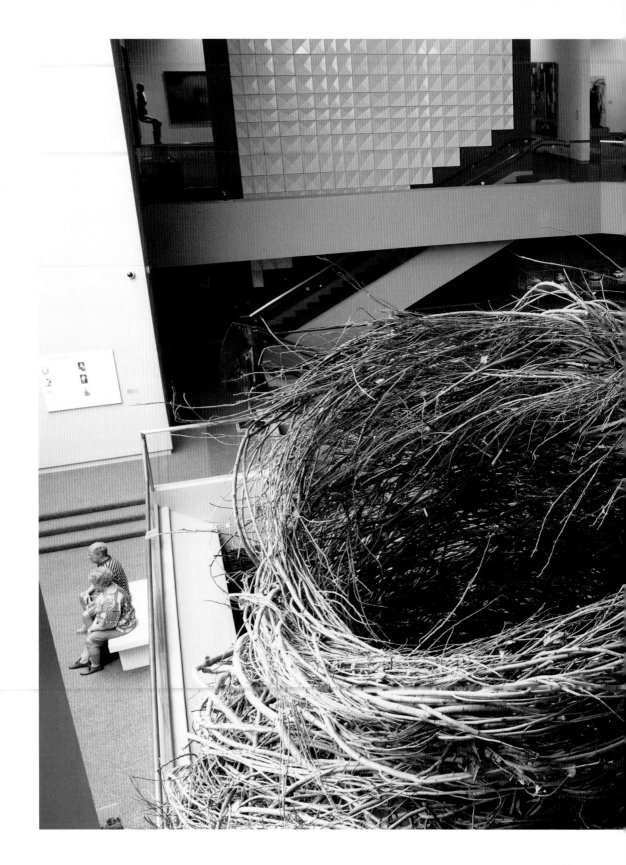

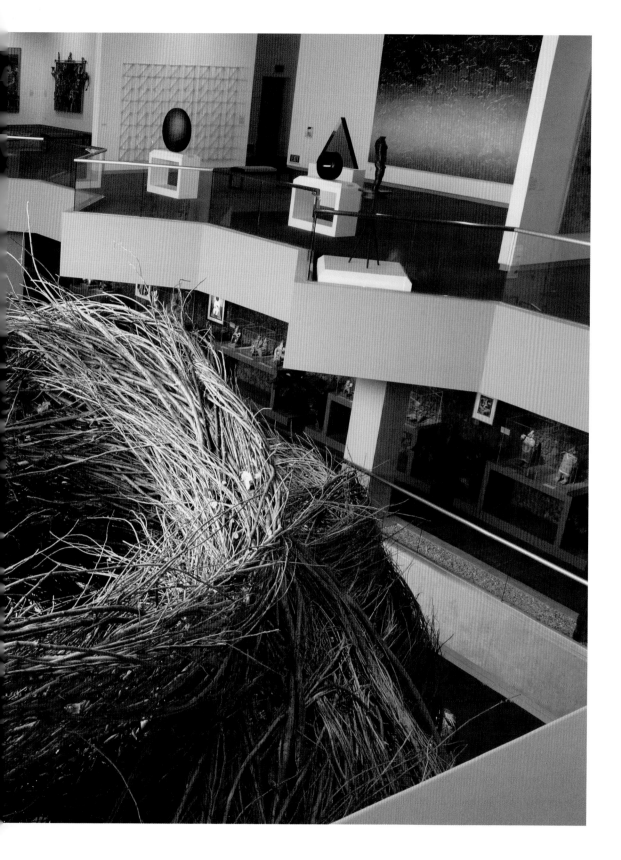

So Inclined

The silver maple saplings used to create *So Inclined* were particularly good for drawing. They had interesting multiple branching patterns that imparted the impression of motion. These sticks were harvested on a nearby creek side by a local landscape company. After the saplings were delivered, members of the Middlebury community, including many classes and service groups, helped to remove their leaves. This work completed by 230 volunteers fulfilled Middlebury College's philosophy of community service.

The Mahaney Center for the Arts, which houses the Middlebury College Museum of Art, is a formidably large building, and required a work of imposing scale. I built nine towering, interconnected tepees, and imagined a temporary village or encampment in the spirit of Chautauqua, nineteenth-century traveling shows that brought a popular form of entertainment and education through lectures, musical features, and dramatic arts.

In order to compete with the scale of the building, I located the sculpture prominently on the entryway plaza, at the junction of all of the major sidewalks. I interrupted the normal flow of traffic in the hope that passersby would stop to enjoy the work. Many students encountered the village on the way to the gym. Event goers passed through it on the way to various performances. The general public saw its distinctive silhouette from Highway 30, and were encouraged to pull over and take a closer look.

Winter weather is an issue in Vermont and had to be considered in my design. I used the tepee or conical shape — on which snow would not accumulate — to ensure the work's survival in this place where five feet of snow is not uncommon; interlocking the conical forms ensured that they could stand up under the occasional gale force winds. To date, this work has survived the bluster of two Vermont winters.

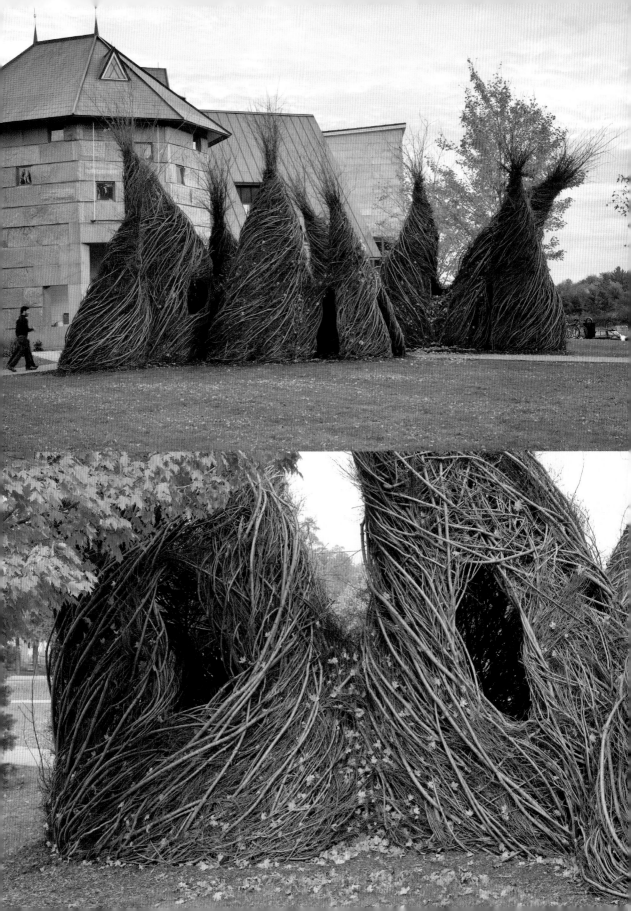

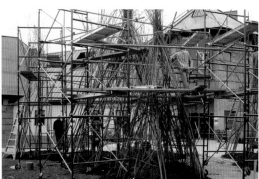

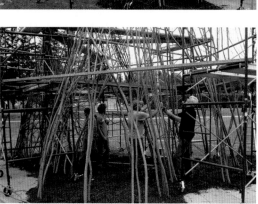

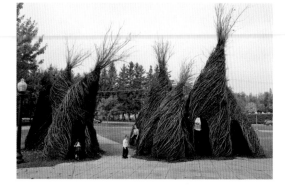

Construction phase: September 9–29, 2007

Exhibition dates: September 29, 2007–August 20, 2008

Site: Plaza in front of the Center for the Arts at Middlebury College in
Middlebury, Vermont

Sponsoring organization: Committee on Art in Public Places,
Middlebury College Museum of Art

Materials: Mixed hardwoods, but primarily silver maple, gathered from a
stream bank nearby

Size: Nine tepee elements, 20' high and average 10' in diameter

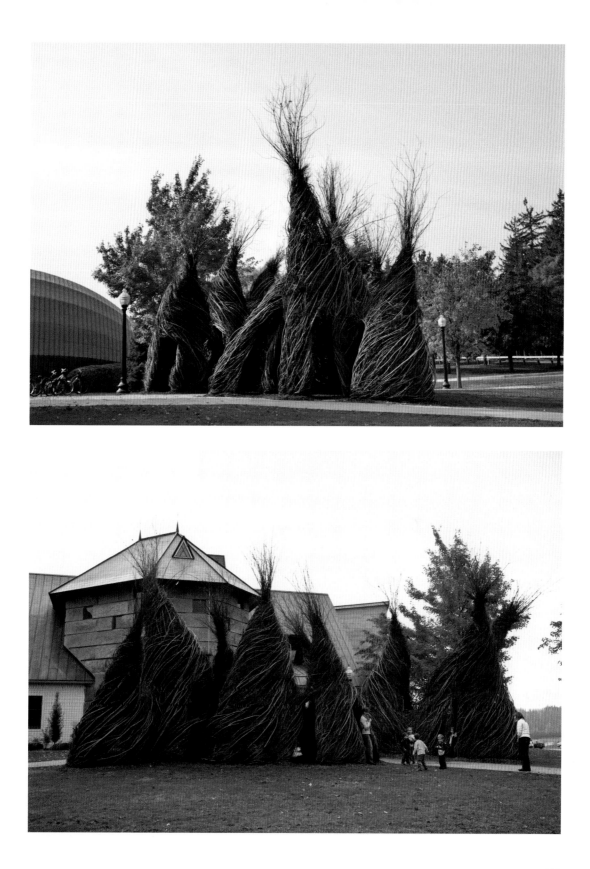

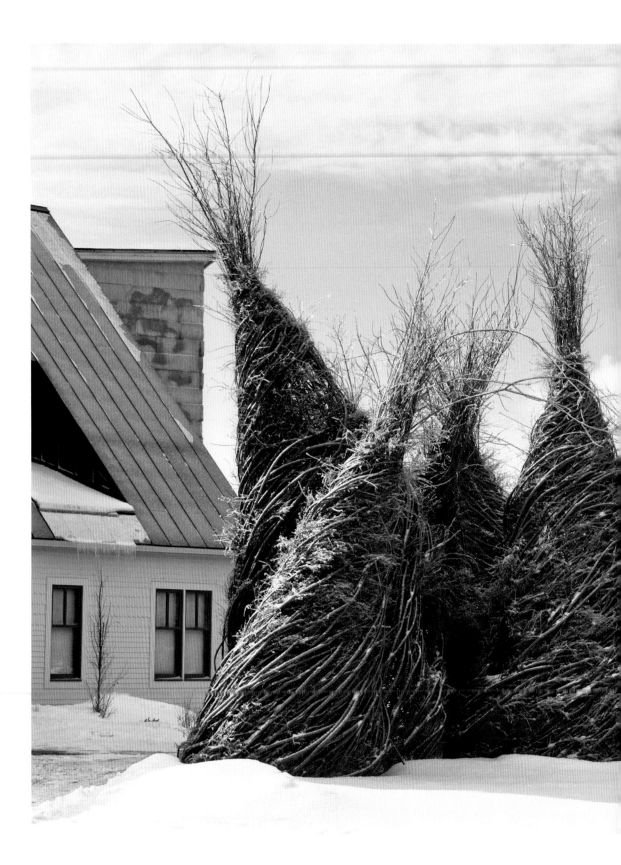

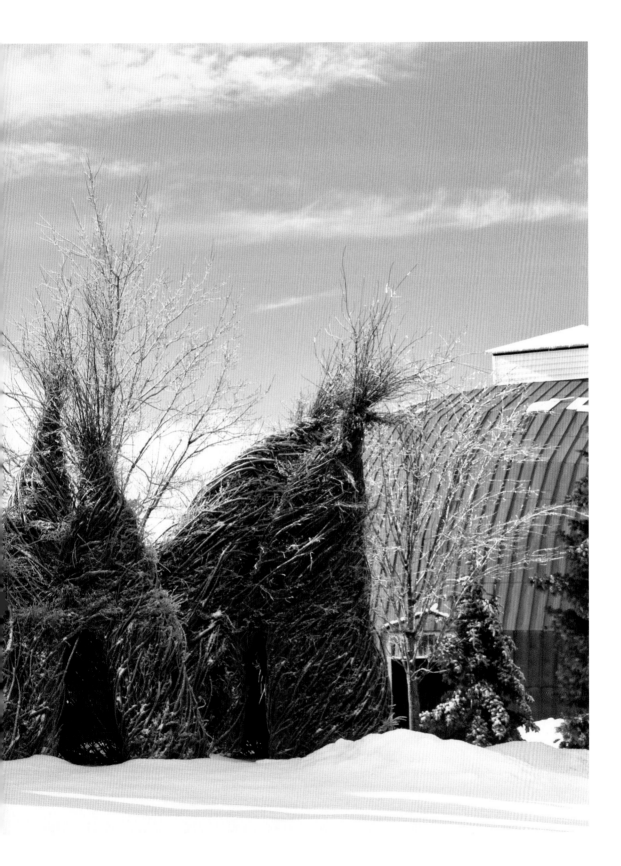

Catawampus

Having succeeded at Brown University in Providence, Rhode Island, at building square objects that tipped and leaned (*Square Roots*, 2006), I wanted to further explore working with squares and rectangular shapes, specifically with small "pillows" to cock larger rectangular forms out of kilter. The resulting work, *Catawampus*, created at the Los Angeles County Arboretum & Botanic Garden in February 2008, consisted of four large rectangular forms and four supporting pillows.

These cockeyed shapes befitted the eccentric characters who volunteered each day, ranging from authentic hunter-gatherers to a locally famous bluesman. There was also a medicine woman who tended the herb garden for the arboretum and brought twenty elders from a local tribe to appraise my work. They showed me how to harvest a certain weed in a nearby flowerbed. Then, using their thigh and a special quick movement of two fingers, the elders twisted the fibrous stems into an extra strong bowstring.

In Los Angeles, talent is plentiful, and everyone seemed to have a day job while also working to find their place in the limelight. Many had been extras in a movie, and one volunteer told jokes during the construction of the sculpture to practice his routine for a comedy club. Often the conversation among the volunteers concerned the movie stars whom they had seen or stories about the famous. Ironically, many of these were tales they heard from service people, ordinary folks who fixed the air conditioning or performed mundane tasks in the homes of the well-known. Every day of working on the sculpture brought new tales from the grapevine.

Working in Los Angeles Arboretum itself was fascinating too. It has been the site for many movies, including *Tarzan* and *Gilligan's Island*, and several movies and photo shoots were going on during my three-week stay. In addition, the vegetation and semitropical plants that are part of the arboretum's collection are varied and amazing. I am particularly interested in bamboo, and I wandered along the secret paths in those groves, imagining what bamboo marvels I could create on my own property.

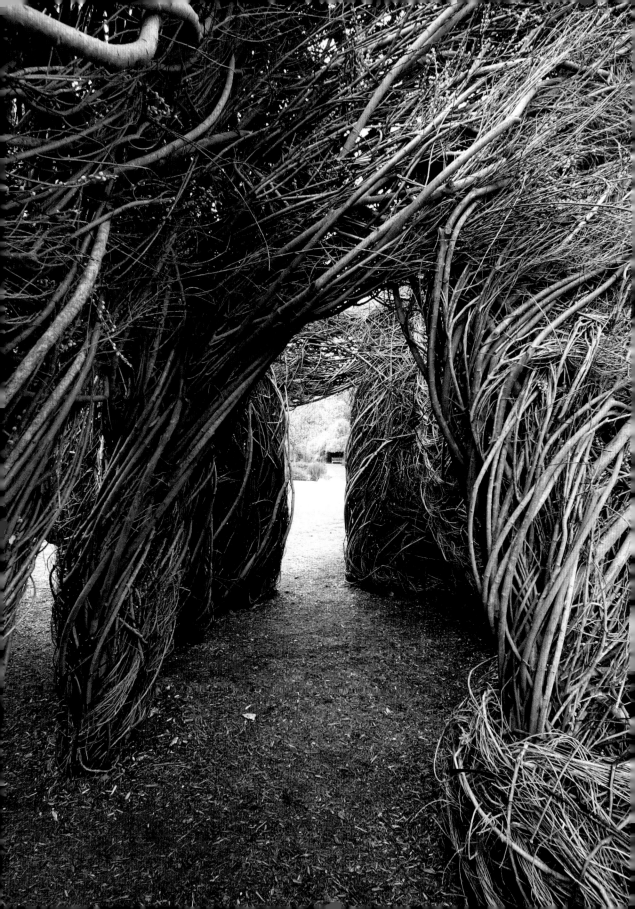

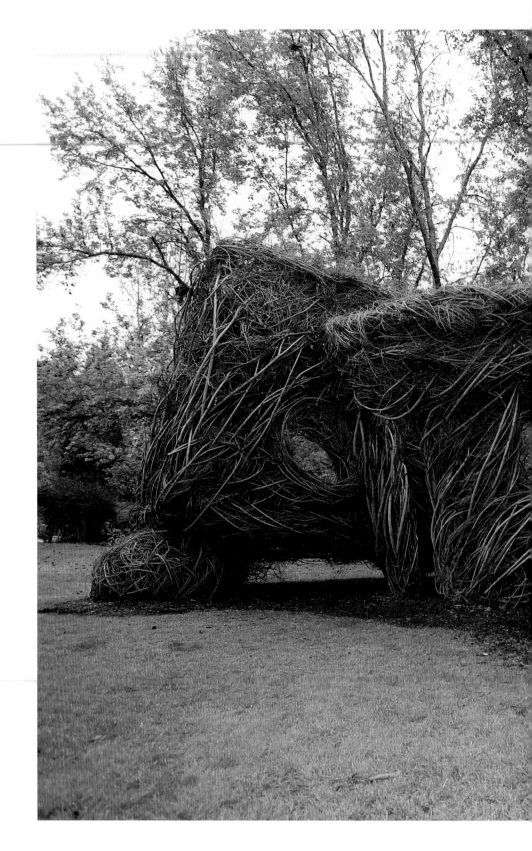

Construction phase: February 2–23, 2008

Exhibition dates: February 23, 2008–prese t

Site: Lawn at the Los Angeles County Arboretu & Botanic Garden, Arcadia, California

Sponsoring organization: Los Angeles County Arboretum & Botanic Garden

Materials: Willow

Size: 18' high, 35' long, 20' wide

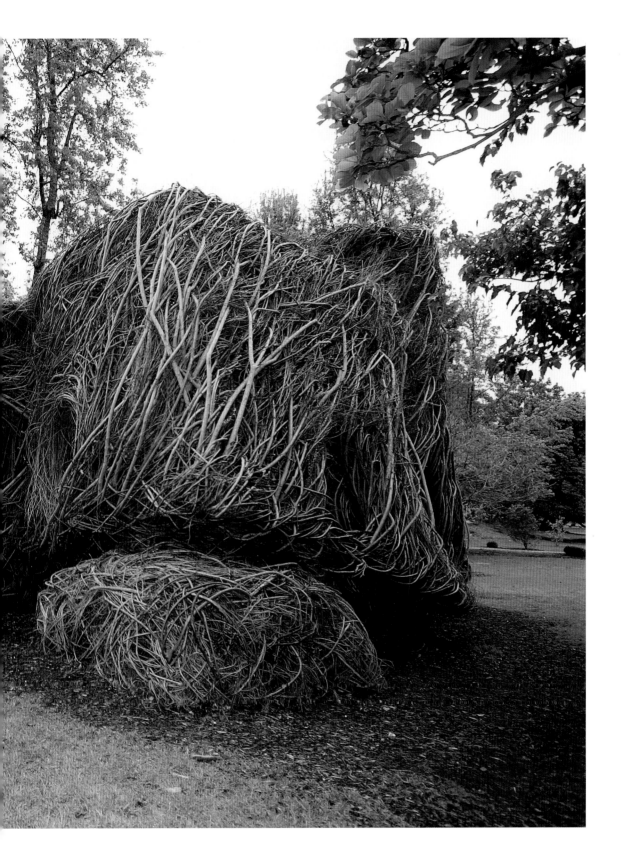

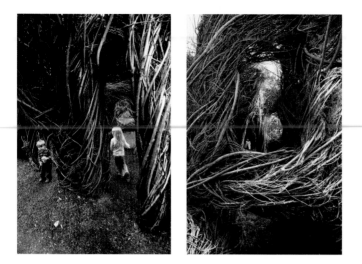

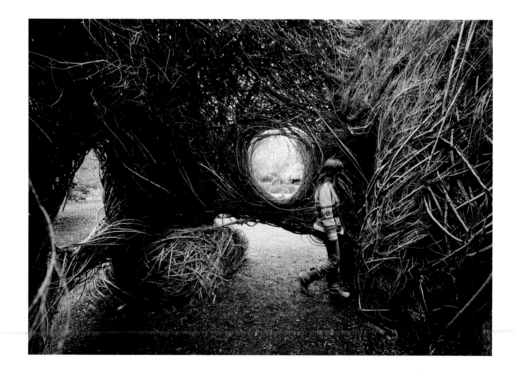

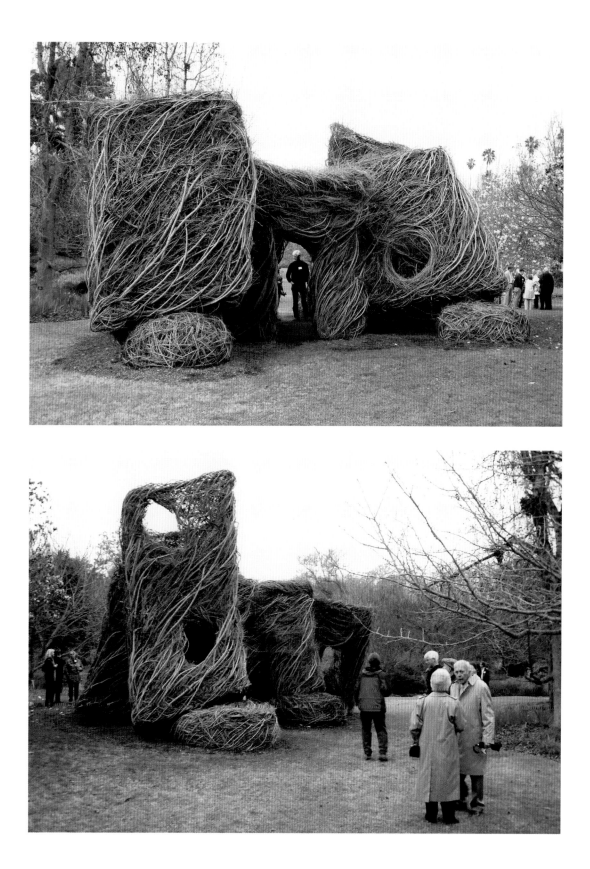

Lookout Tree

My introduction to the McConnell Arboretum in Redding, California, was an unexpected warning from the gate attendant: "Be careful! That rattlesnake might be in the men's bathroom again." Perhaps snake sightings are common at Turtle Bay Exploration Park, home to the arboretum, but my reaction was anything but ho-hum. I immediately pictured myself frantically trying to escape through one of those undersized windows found in men's restrooms. Since there are very few poisonous snakes in Chapel Hill and my encounters with them very limited, I devoted a noticeable portion of my creative energy during the construction phase to nervously scanning my surroundings for the venomous pests. It became my habit to wait until someone else had entered the outdoor lavatory — which was in the entrance area — and, if no screams followed from inside, I figured I could safely enter.

The arboretum has an extraordinary volunteer program. People come from every walk of life to weed, prune, work in the greenhouse, and even to relocate the stray pit viper. Luckily, that meant that when I arrived to work on the sculpture every morning, there was a slew of willing hands available. A hippie might be working with a businessman, a grandmother, or a high school student. For a period of time, all these people came together as "stick-workers" and indulged some of their most basic urges to build.

I am fond of saying that sticks were mankind's first building material, and even the modern-day person continues to have a deep affinity for how to use them. The question that often arises at the beginning of a project is how people without any previous experience will know what to do with the sticks. My approach is simple: I start each day with a few bits of advice about saplings. For example, a sapling with lots of branches can be woven into place more easily by threading the thick end of the stick first. As one pulls on that thick end, the cluster of branches that follows becomes lodged into the existing matrix of sticks. Also, if the branch is flexed a few times before the weaving starts, it will bend more easily as it intertwines with the other sticks. I often suggest to the assistants that they place the sticks randomly to avoid making a geometric grid of branches and pull a branch so that it distorts in an interesting way—I emphasize the visual power of the diagonal line.

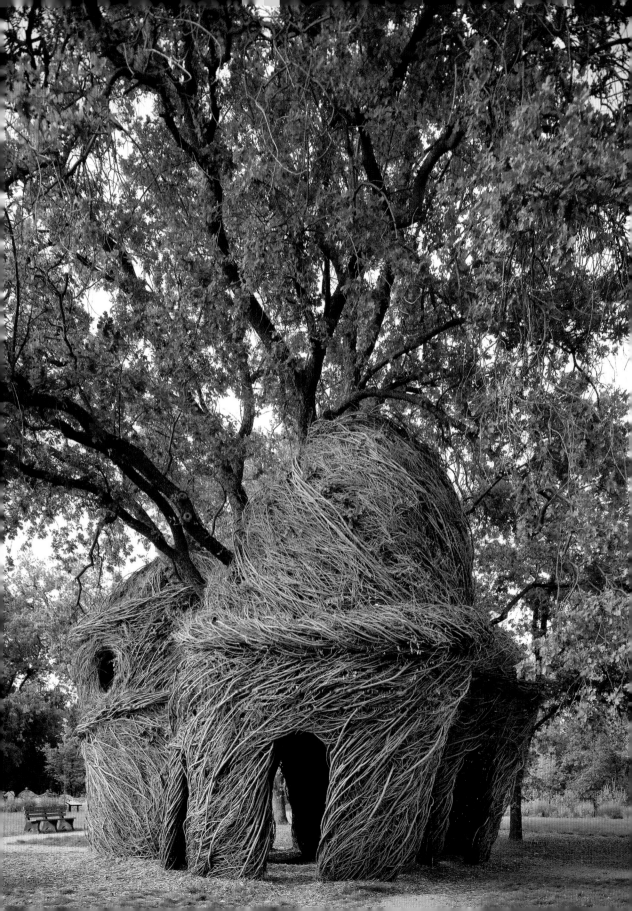

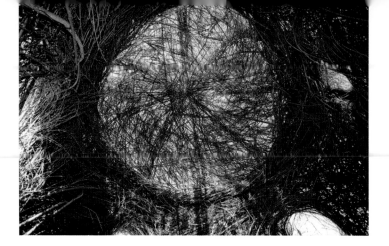

As the volunteers become more familiar with the materials, I demonstrate more branch-taming shortcuts. The last week is the most fun and productive because by then the individuals have formed into an energetic crew that throws its best efforts into developing the idea and completing the sculpture on time.

The work accomplished with the great volunteers at the McConnell Arboretum is called *Lookout Tree*, and it consists of three off-kilter towers intertwined with the large branches of an oak tree in the center of the arboretum's meadow. The limbs provided the necessary structural support, and the trunk was commandeered as the backbone of the sculpture. The title is suggestive of a childhood fort or perhaps a rudimentary warning system during war. It also hints at my predicament during the project: from the work scaffold and upper rims of the sculpture, I could catch sight of any critters that tried to slither under the door marked "Men."

Construction phase: March 2–21, 2008
Exhibition dates: March 21, 2008–present
Site: Carl and Leah's Meadow at McConnell Arboretum and Botanical Gardens, Turtle Bay Exploration Park, Redding, California
Sponsoring organization: Turtle Bay Exploration Park
Materials: Willow
Size: 24' high, 24' wide, 18' deep

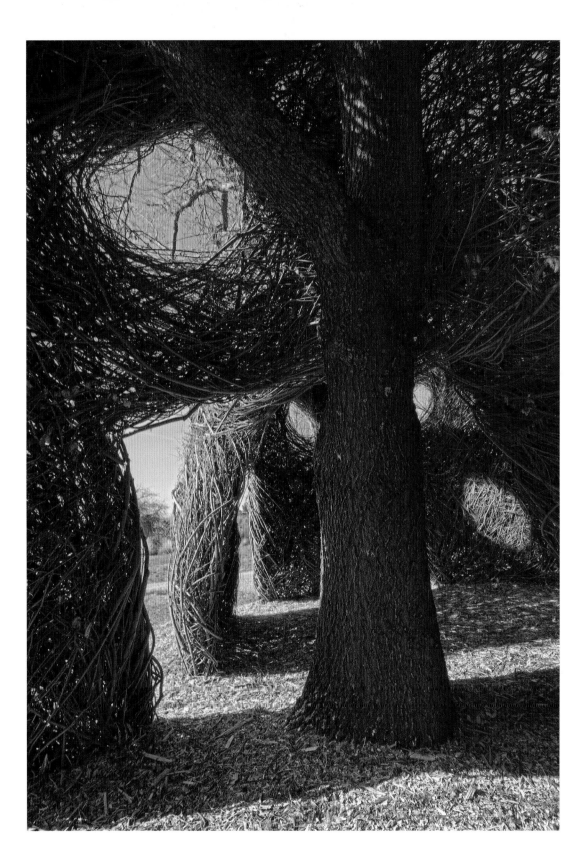

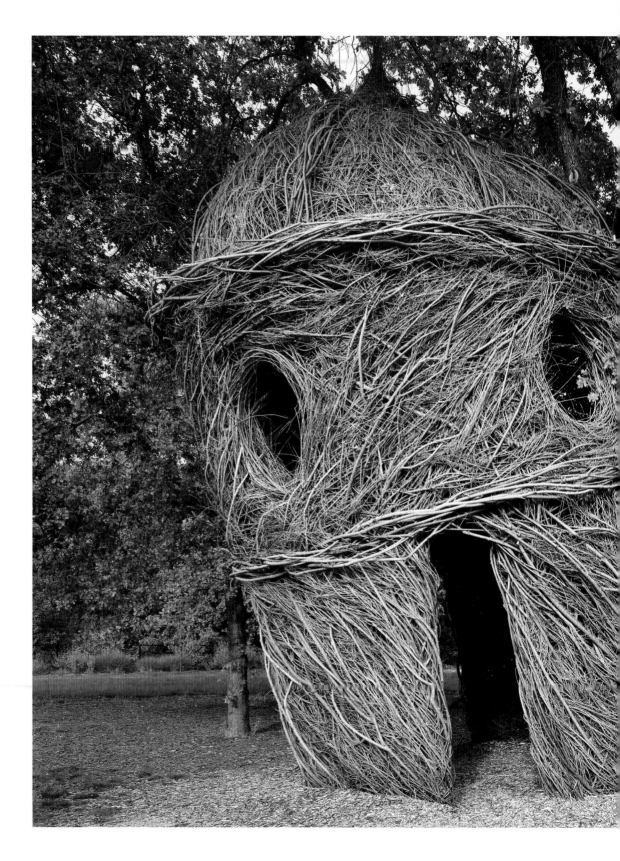

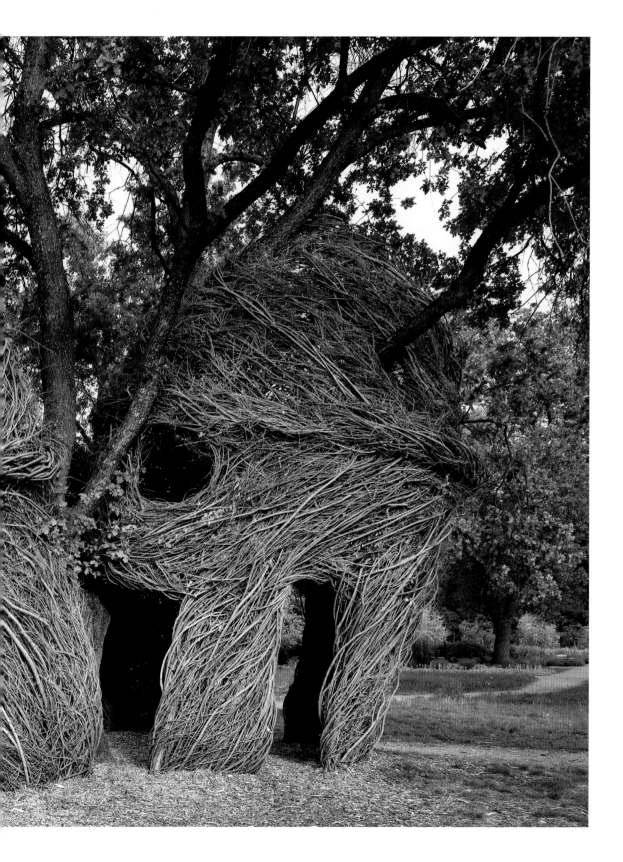

Sortie de Cave

The exhibition series Le Jardin des Arts was the brainchild of Mr. and Mrs. Burel, who own an historic hotel with a millpond and a large wooded park in Chateaubourg, France. Mrs. Burel had the idea of hosting a sculpture show every year and involving all her friends to help finance it. For the 2008 exhibition she asked me come to France.

I was nervous because I do not speak French, and she was very nervous that they might not be prepared for my method of working. However, she and her cohorts were very organized, and the project went smoothly. At a local water-treatment plant, we found an abundance of willow, which had been planted to filter gray water. Through my project these lowly trees found a higher calling and provided the material for artistic expression.

Sortie de Cave consists of nine giant bottles of Bordeaux, all within view from two nearby restaurants that serve this excellent wine. In France *sortie de cave*, literally "out of the cellar," is a saying that alludes to the idea that when wine emerges from the cellar, the bottles themselves are able to celebrate their release and become tipsy. The idiom is employed in situations of sudden freedom, such as when teenagers escape their parents' watchful eyes.

The project attracted a lot of attention locally, and in addition to various employees from Mr. Burel's office his secretary and her husband, and the accountant, for example — many men and women from the community came to lend a hand. The Burels even brought their whole family to work on the sculpture on Saturdays. Each day Mrs. Burel treated the entire crew, whoever was present, to a wonderful lunch on the hotel terrace overlooking the site. It was a very moving experience to work with so many dedicated people and to see how the process took on a life of its own. As a result, the final product had a deep sense of authenticity.

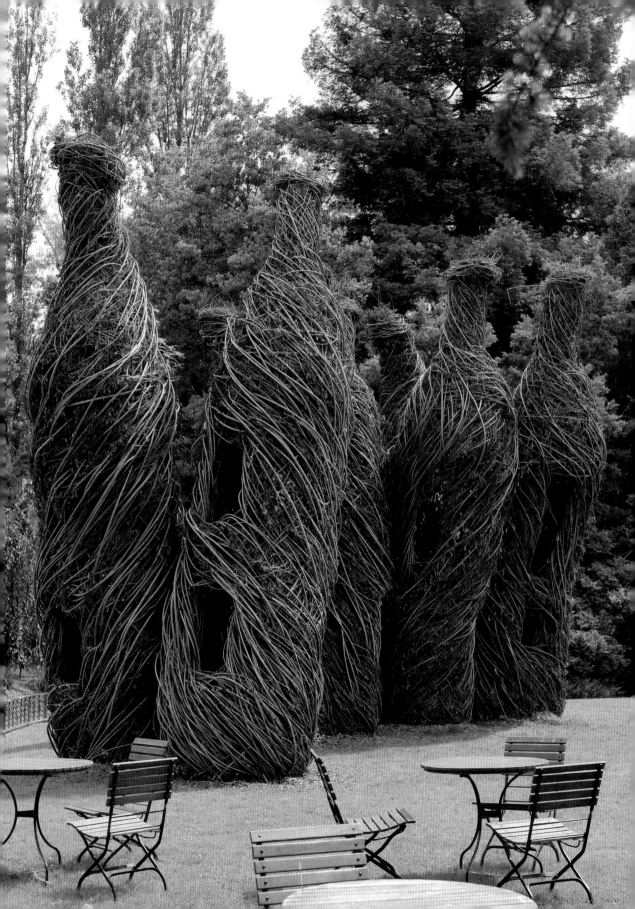

Construction phase: May 3-22, 2008

Exhibition dates: May 22, 2008-present

Site: Mill Pond at Le Jardin des Arts, Chateaubourg, France

Sponsoring organization: Sculpture committee for Le Jardin des Arts

Materials: Willow saplings, gathered from a local sewage treatment plant

Size: Nine bottles, each approximately 22' high and 6' in diameter

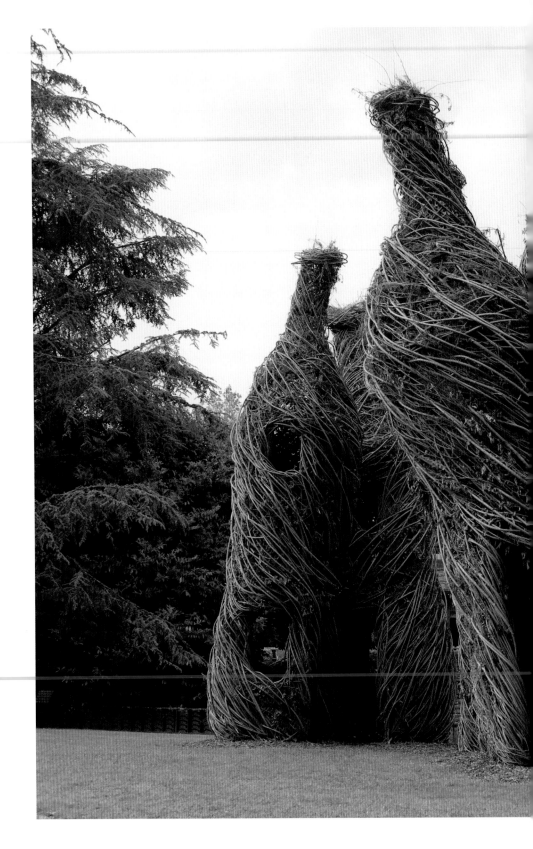

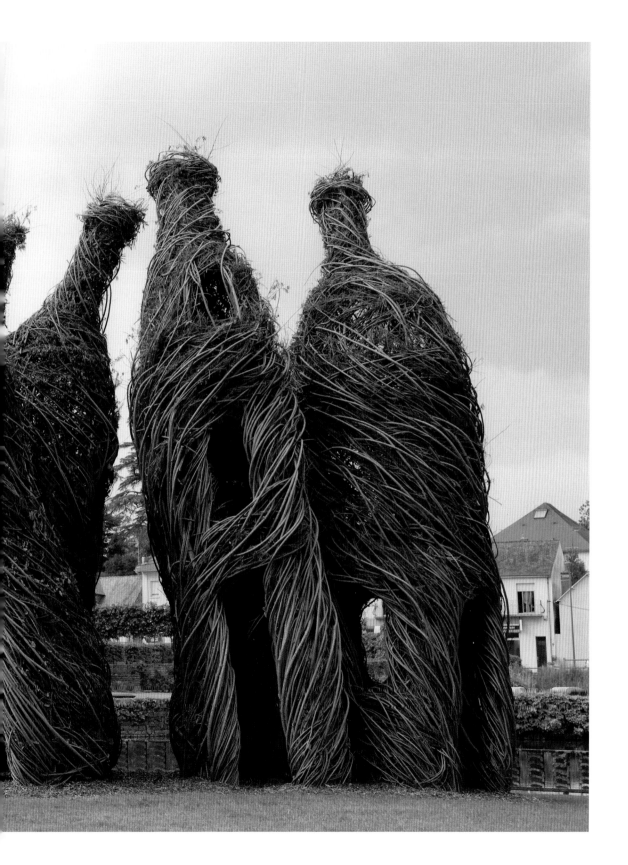

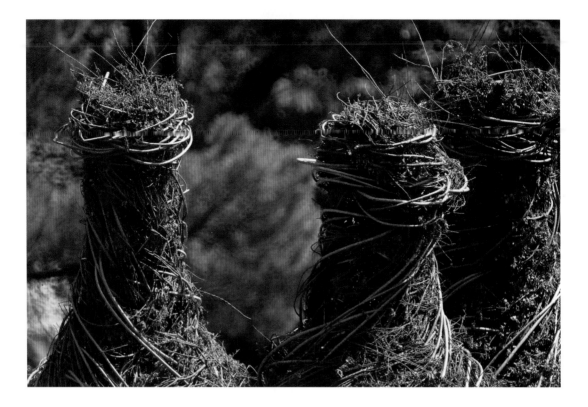

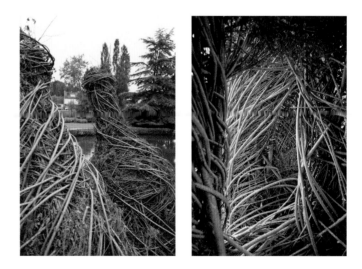

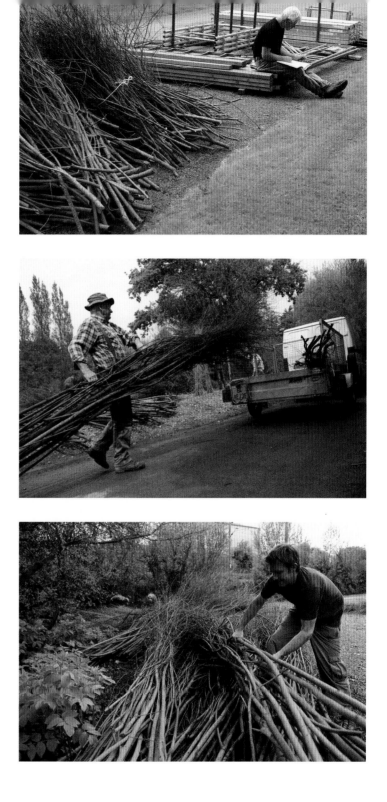

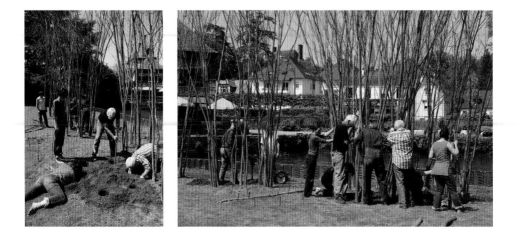

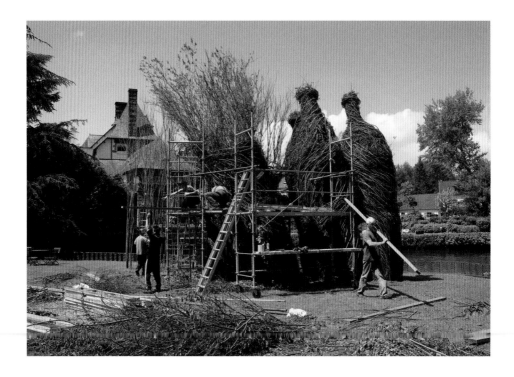

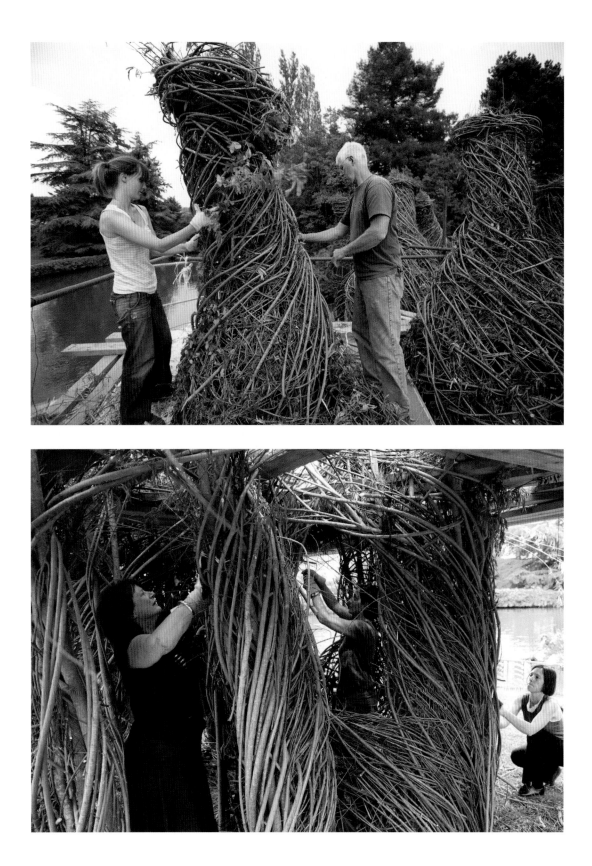

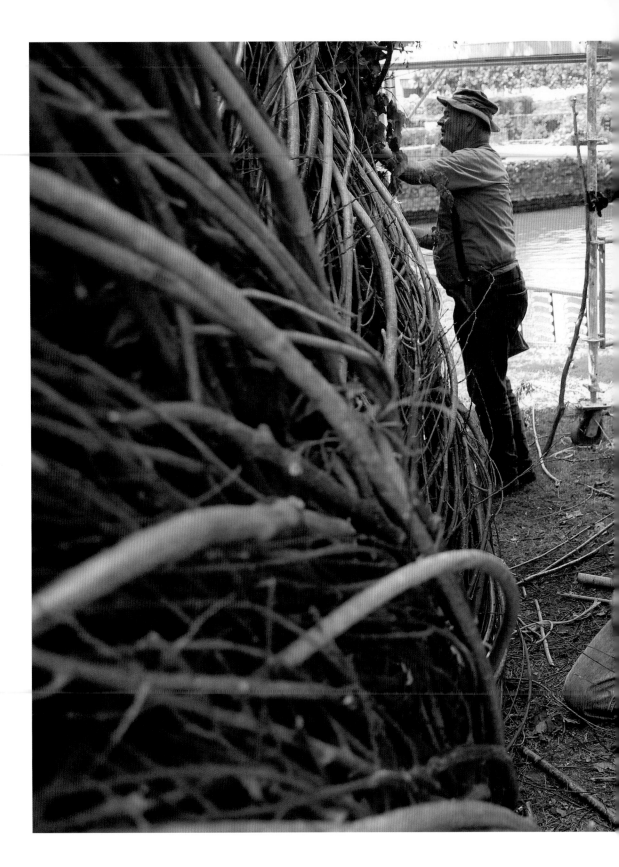

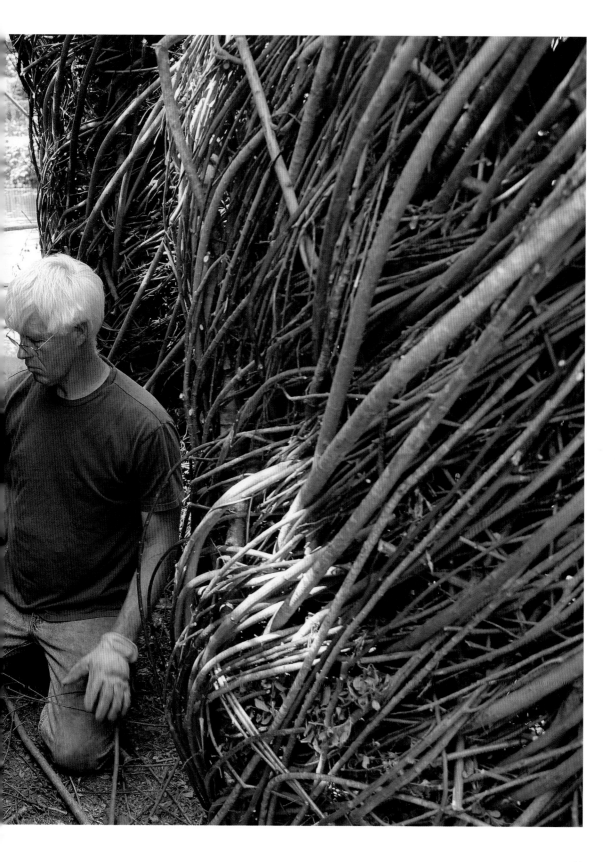

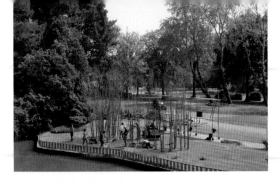

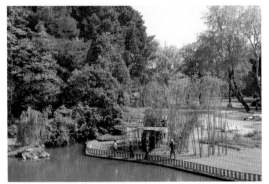

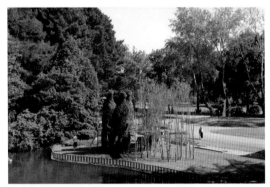

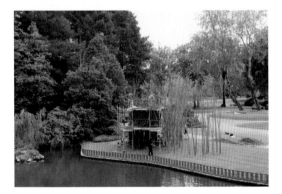

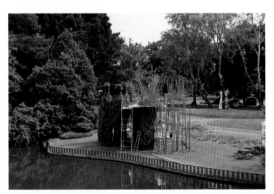

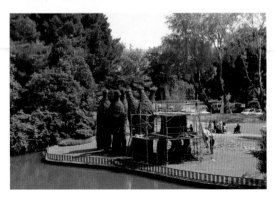

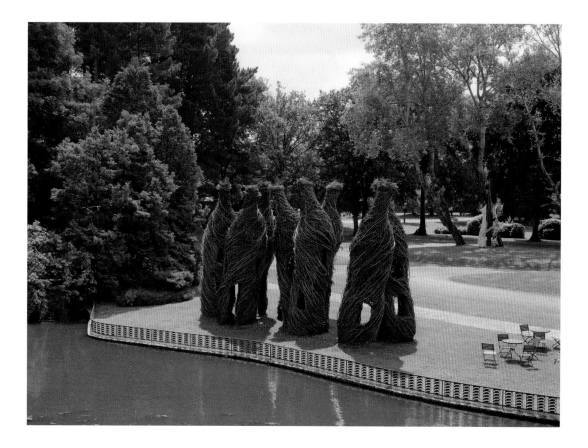

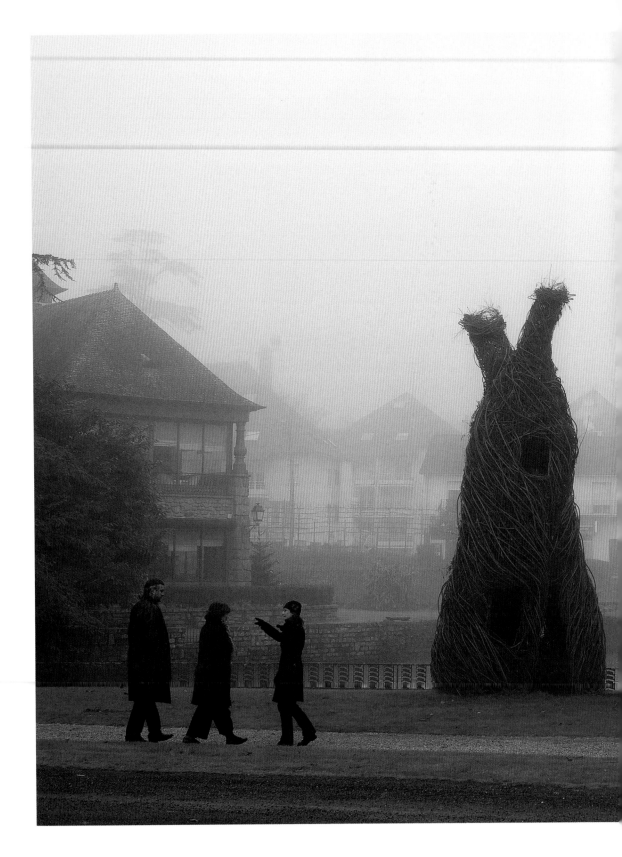

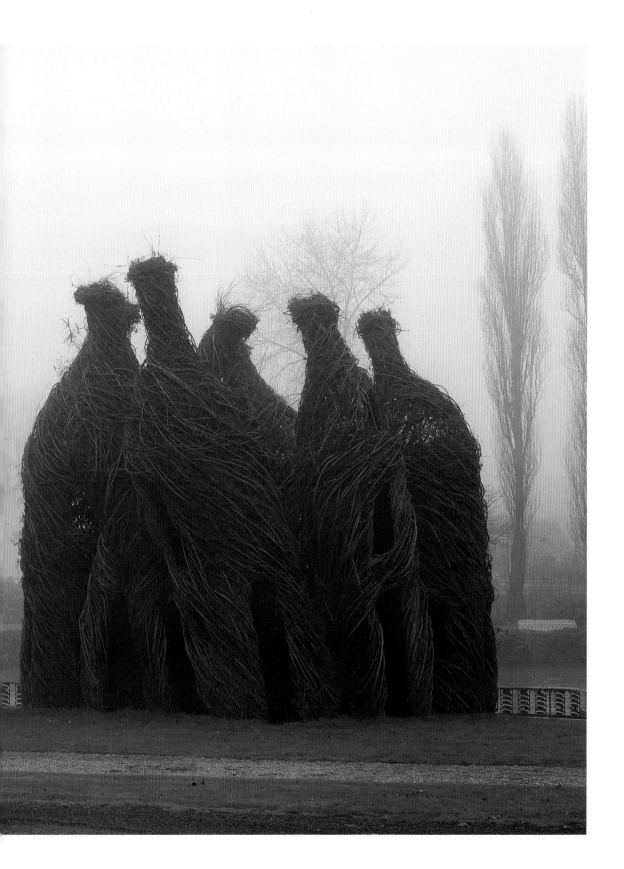

Hocus Pocus

Hocus Pocus was a private commission for Jim and Betty Becher at Bittersweet Farms, their weekend retreat in the mountains of North Carolina. The Bechers are both larger-than-life personalities, and I imagined a grand sculpture that befitted them. I pictured a garden folly with a main hall and antechambers on all four sides. It featured a round dome on top of a square base — a true architectural challenge when using nothing but the sticks.

Jim and I found a large field of maple saplings on a neighbor's land, and he had his farm laborers help gather the material and strip the leaves. Although the members of the crew were generally helpful, they drew the line at weaving the sticks. Since I was the sculptor, they seemed to think their participation in sculpting would be cheating. I had forgotten how much stick weaving I could do on my own if pressed like this. Still, it was fortunate that I had arranged for a student to help me the last week of my three-week stay, and without that final push, I may not have finished.

Working on a private farm in a rural community was unusual for me. Many neighboring farmers and friends came to see my progress and give advice. The first reaction from the locals was, "What the hell is this?" Trying to explain to them what I intended the sculpture to mean was fun, and it is always humbling to get such down to earth reactions.

Betty asked her friends to help title the work, and they decided on *Peek-a-boo Palace*. That sounded like a negligee to me, so this work has one vernacular title, *Peek-a-boo Palace*, and one formal title, *Hocus Pocus*. The latter can be defined as a trick performed by a sculptor forced by farm workers to do all the stick work himself or face an honor-code violation.

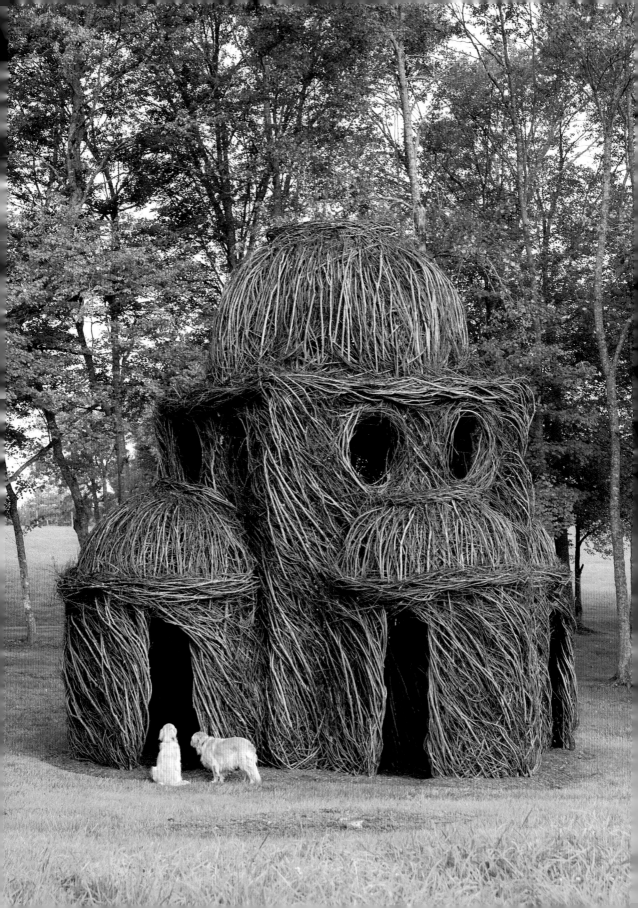

Construction phase: August 4–24, 2008

Exhibition dates: August 24, 2008–present

Site: Bittersweet Farms, Ennice, North Carolina

Sponsoring organization: Private commission by Jim and Betty Becher

Materials: Red maple, gathered on a nearby farm

Size: 25' high, 25' long, 25' wide

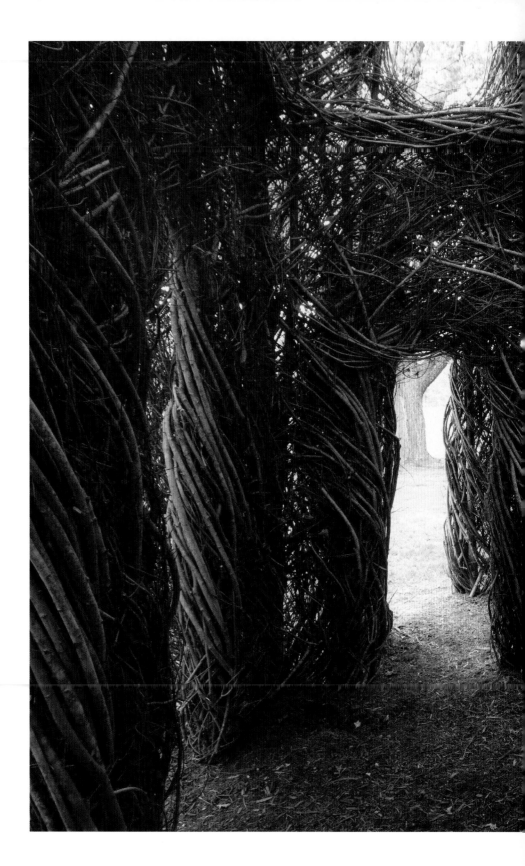

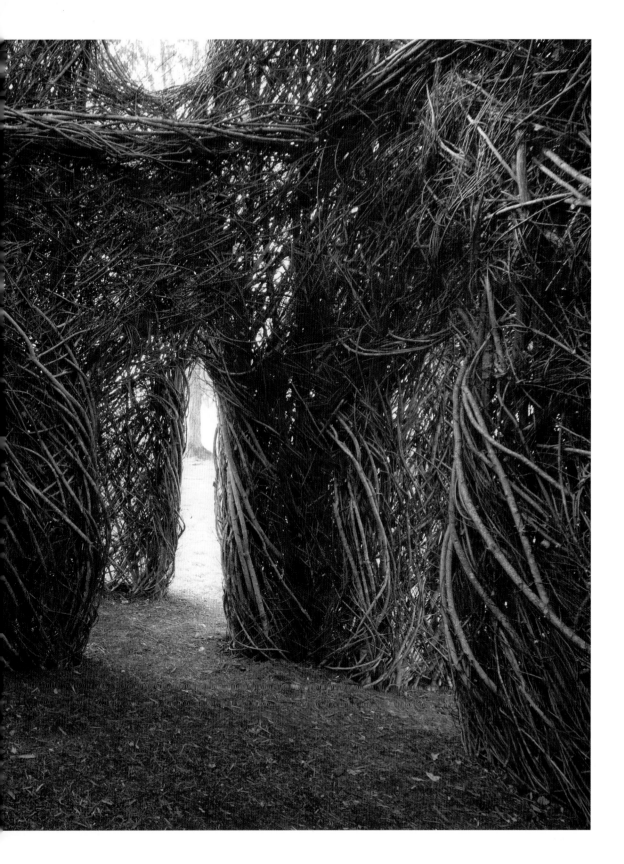

Restless by Nature

Restless by Nature is approximately three hundred feet in length and my longest sculpture to date. It is a series of corridors and rooms built into an existing grove of willow trees that serve as its structural base. The work is a shortcut for a well-used trail at the popular Ada Hayden Heritage Park in Ames, Iowa. It is an alternate path that the park visitor can take — one onto which the walker is swept — leaving the paved road behind.

Inside the installation there are various nooks and crannies and strange architectural configurations the visitor can explore. Many windows and doors allow views to the natural world from within this construction. At either end is a large swirling foyer from which the viewer can step again onto the pavement of the regular trail.

Some unexpected logistical difficulties added to the challenges of the project. With a giant pile of sticks at the ready, I was frustrated by a lack of volunteer helpers in the first days. I set my own ego aside and began to prod, push, and finagle what I needed in order to realize the project. I made calls to professors at Iowa State University looking for student volunteers; I commandeered the walking public to help me set my scaffolding. I put on my cheerleader's outfit, and the project began to blossom.

Despite the slow start, I finished on time, and at the opening the mayor and hundreds of well-wishers tried the sculpture on for size. The arts commission received rave reviews from the public, and I felt proud of the work. In this, as in all my sculptures, my main obligation was to the viewing public. In exchange for borrowing public space to create my work, I pledge to produce something that has real power and meaning.

Construction phase: September 28–October 16, 2008

Exhibition dates: October 16, 2008–the present

Site: Walking path at Ada Hayden Heritage Park, Ames, Iowa

Sponsoring organization: City of Ames Public Art Commission

Materials: Willow, gathered at the park and along a nearby county road

Size: 15' high, 300' long, 12' wide at the widest point

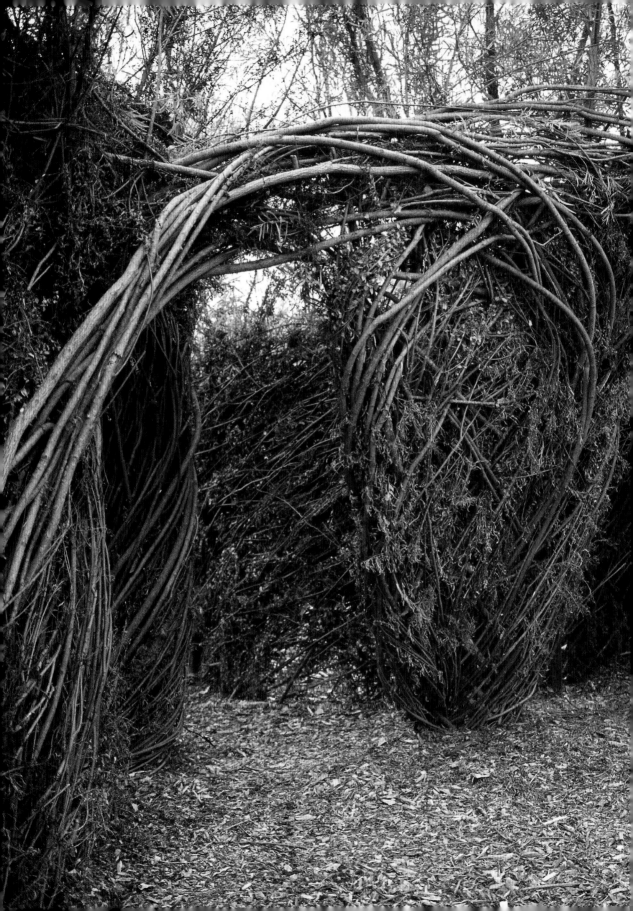

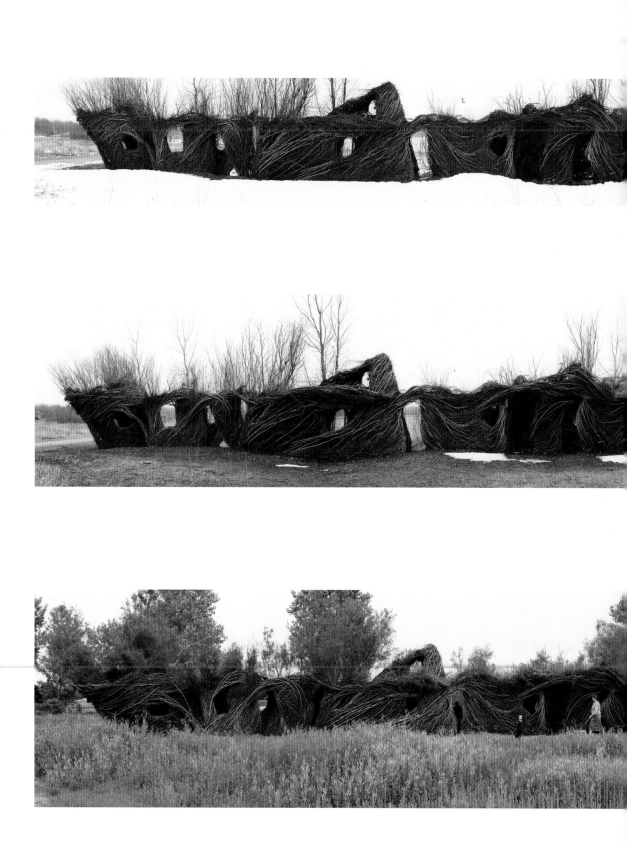

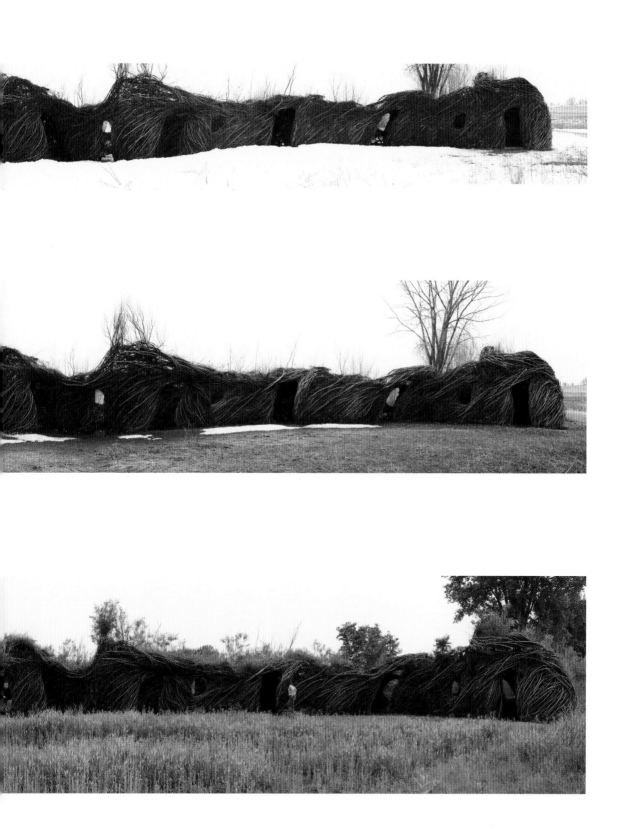

Complete Works

1. *Handmade House*, 1977, Chapel Hill, NC
2. *Early Works*, 1981-83, constructed in back yard and shown at various venues
3. *Waiting It Out in Maple*, 1983, Southeastern Center for Contemporary Art, Winston-Salem, NC
4. *From Hedges to Hirshhorn*, 1984, Center Gallery, Carrboro, NC
5. *Maple Sugar Daddies*, 1985, Center Gallery, Carrboro, NC
6. *Brushwork*, 1985, Waterworks Visual Arts Center, Salisbury, NC
7. *Radley House Sculpture*, 1985, Duke University, Bryan Center, Durham, NC
8. *Hanging around the South*, 1985, Duke University Bryan Center, Durham, NC
9. *Penland Yardage*, 1985, Penland School of Crafts, Penland, NC
10. *Topsy-Turvy*, 1986, Spirit Square Center for the Arts, Charlotte, NC
11. *Come Hell or High Water*, 1986, Greenhill Center for North Carolina Art, Greensboro, NC
12. *Topiary Heroes*, 1986, University of South Florida, Tampa, FL
13. *Cleveland Spinner*, 1987, Spaces Gallery, Cleveland, OH
14. *Cornering the Market*, 1987, Market House, Fayetteville, NC
15. *Rites of Time*, 1987, American Dance Festival, Durham, NC
16. *Spiral-Bound*, 1987, Mint Museum, Charlotte, NC
17. *Turnabout Is Fair Play*, 1987, 1708 East Main Gallery, Richmond, VA
18. *Window Installation*, 1987, Man Bites Dog Theater, Durham, NC
19. *Homespun*, 1988, Mint Museum, Charlotte, NC
20. *Rites of Passage*, 1988, Eno Festival, Durham, NC
21. *A Stitch in Time*, 1988, The Art Center, Carrboro, NC
22. *No Such Thing as Nervous*, 1988, Broadway Windows, New York University, New York, NY
23. *Shrubterranean*, 1988, Southeastern Center for Contemporary Art, Winston-Salem, NC
24. *Sailors Take Warning*, 1988, Newhouse Gallery, Snug Harbor Cultural Center, Staten Island, NY (see pages 24-27)
25. *Rolla Coaster*, 1988, Marin Civic Center Lagoon, San Rafael, CA
26. *Highfalutin'*, 1988, One World Trade Center, New York, NY
27. *Two-Hut Tango*, 1988, Second Street Gallery, Charlottesville, VA
28. *Raring to Go*, 1988, Birmingham Museum of Art, Birmingham, AL
29. *Shelters of Transition*, 1989, North Carolina Museum of Art, Raleigh, NC
30. *Woodwinds*, 1989, Brooks Museum of Art, Memphis, TN (see pages 28-29)
31. *Ollie, Ollie in Free*, 1989, Wake Forest University, Winston-Salem, NC
32. *Catch As Catch Can*, 1989, High Museum of Art, Atlanta, GA
33. *Let's Give It a Whirl*, 1989, St. Andrew's-Sewanee School, Sewanee, TN
34. *Second Growth*, 1989, Durham Arts Council Building, Durham, NC
35. *The Terror of Split Ends*, 1989, North Art Center Gallery, Atlanta, GA
36. *Triage*, 1989, La Jolla Museum of Contemporary Art, La Jolla, CA
37. *No Strings Attached*, 1989, Columbus Museum, Columbus, GA
38. *Speedball*, 1990, Henry Art Gallery of the University of Washington, Seattle, WA (see pages 30-33)
39. *Patrick Dougherty's Nature*, 1990, Atlanta College of Art Gallery, Atlanta, GA
40. *Urban Tangle*, 1990, BMW Gallery, New York, NY
41. *Spinoffs*, 1990, DeCordova Museum and Sculpture Park, Lincoln, MA (see pages 34-37)
42. *Out of Bounds*, 1990, Hudson River Museum, Yonkers, NY
43. *Snowman*, 1990, North Carolina Museum of Art, Raleigh, NC
44. *Undertow*, 1990, East Hampton Center for Contemporary Art, East Hampton, NY
45. *Decked Out in Maple*, 1990, Alexandria Museum of Art, Alexandria, LA
46. *Shelterbelt*, 1990, North Dakota Museum of Art, Grand Forks, ND
47. *Untitled*, 1990, Hodges-Taylor Gallery, Charlotte, NC
48. *Homebound*, 1991, Socrates Sculpture Park, Long Island City, NY
49. *Virginia Reel*, 1991, Virginia Beach Center for the Arts, Virginia Beach, VA
50. *Spinning Yarns*, 1991, Wilson Arts Council Gallery, Wilson, NC
51. *Homemade*, 1991, World Gallery, Asheville, NC

52. *Round and Round Again*, 1991, North Miami Beach Center of Contemporary Art, Miami, FL (in collaboration with Ron Fondaw and Karen Rifas)
53. *Simple, Hard and Easy*, 1991, Burroughs Wellcome Building, Research Triangle Park, NC
54. *Shuckin' and Jive*, 1991, Jacksonville Art Museum, Jacksonville, FL
55. *Family Trees*, 1991, Katonah Museum of Art, Katonah, NY
56. *Rip-Rap*, 1991, Manchester City Art Galleries, Manchester, England (see pages 38-43)
57. *Nooks and Nitches*, 1991, Roanoke Museum of Fine Art, Roanoke, VA
58. *In and Out the Window*, 1991, Ness Gardens, Wirral, Cheshire, England
59. *Portals, Pivots, and Perspectives*, 1991, Smith College Museum of Art, Northampton, MA
60. *Sacred Grove*, 1991, Carteret County Courthouse, Beaufort, NC
61. *Whim-Whams*, 1992, Laumeier Sculpture Park, St. Louis, MO
62. *Remodeled*, 1992, University of North Carolina, College of Architecture, Charlotte, NC
63. *Two Over, One Under*, 1992, Pamela Joseph Estate, Pound Ridge, NY
64. *Holy Rope*, 1992, Rinjyo-in Temple, Chiba, Japan (see pages 44-47)
65. *Spring Forward, Fall Back*, 1992, Tozurahara Art Park, Fujino Art Village, Japan
66. *Untitled*, 1992, in collaboration with landscape architect Tsutomu Kasai, Kakitagawa Museum, Mishima, Japan
67. *Architectural Detail*, 1993, Hanes Gallery, University of North Carolina, Chapel Hill, NC
68. *Out of Hand and Chit Chat*, 1993, The Phillips Collection, Washington, DC
69. *Wild As All Get Out*, 1993, Aspen Art Museum, Aspen, CO
70. *Cliff Dwelling*, 1993, Suzanne Farber Estate, Aspen, CO
71. *On the Verge*, 1993, Artspace, Raleigh, NC
72. *By Leaps and Bounds*, 1993, Hough End Park, Manchester, England
73. *Huddle Up*, 1993, Yorkshire Sculpture Park, West Bretton, England
74. *Bird's Eye View*, 1993, Carolina Union Gallery, University of North Carolina, Chapel Hill, NC
75. *Yard Bird*, 1994, Javitts residence, Chapel Hill, NC
76. *Bushman's Holiday*, 1994, Salina Art Center, Salina, KS
77. *When Push Comes to Shove*, 1994, South Carolina State Museum, Columbia, SC
78. *The Four Gates of Eden*, 1994, Gouverneurstuin [Governor's garden], Assen, The Netherlands
79. *From Aah to Uum*, 1994, Dittmer residence, Aspen, CO
80. *Homing Instincts*, 1994, Seidel residence, Aspen, CO
81. *Little Big Man*, 1994, Krakamarken/Nature Art Park, Randers, Denmark (see pages 48-51)
82. *Coming Up for Air*, 1994, Arte Sella Sculpture Park, Trento, Italy
83. *Talking Up a Storm*, 1994, Penland School of Crafts, Penland, NC
84. *Him and Her*, 1994, Iscol Estate, Pound Ridge, NY
85. *Tension Zone*, 1995, John Michael Kohler Arts Center, Sheboygan, WI
86. *Basket Case*, 1995, South Florida Art Center, South Miami Beach, FL
87. *A Detailed Account*, 1995, Green Hill Center for Art, Greensboro, NC
88. *Strictly for the Birds*, 1995, Blue Jay Point County Park, Raleigh, NC
89. *The Marriage Ring*, 1995, Moore Ranch, Aspen, CO
90. *Bridging the Rio Grande*, 1995, Museo de Arte Carrillo Gil, Mexico City, Mexico
91. *Caught in the Act*, 1995, Herron School of Art, Indianapolis, IN
92. *Colonnade*, 1995, Kemper Museum of Contemporary Art and Design, Kansas City, MO
93. *Sittin' Pretty*, 1996, South Carolina Botanical Garden, Clemson, SC (see pages 52-55)
94. *Points of Attachment*, 1996, Ringling School of Art, Sarasota, FL
95. *Running in Circles*, 1996, TICKON Sculpture Park, Langeland, Denmark (see pages 56-59)
96. *Natural Selection*, 1996, Copenhagen Botanical Garden, Copenhagen, Denmark
97. *Reading between the Lines*, 1996, Georgia Museum of Art, Athens, GA
98. *Crossing Over*, 1996, American Craft Museum, New York, NY (see pages 60-63)
99. *Ever So Humble*, 1996, Hiestand Galleries, Miami University, Oxford, OH
100. *Whirlaway*, 1996, Memorial Park, Spalding University, Louisville, KY
101. *Oh, Me, Oh, My, Oh*, 1996, Allen Parkway, Buffalo Bayou Artpark, Houston, TX
102. *Hoopla*, 1997, Neuburger Museum of Art, Purchase, NY
103. *The Path of Least Resistance*, 1997, Spoleto Festival, Charleston, XC

104. *Comets, Spheres, and Curlicues*, 1997, North Carolina Museum of Art, Raleigh, NC

105. *Desire Line*, 1997, Salina Art Center, Salina, KS

106. *Prairie Temple*, 1997, Brad Stuie Residence, Salina, KS

107. *Déjà Vu*, 1997, Oakdale Park, Salina, KS

108. *Wide Bodies*, 1997, Wichita Center for the Arts, Wichita, KS

109. *Standing Room Only*, 1997, Western Michigan University, Kalamazoo, MI

110. *Roundabout*, 1997, Tallaght Community Arts Centre, Dublin, Ireland (see pages 64-67)

111. *Face to Face*, 1998, San Jose Museum of Art, San Jose, CA

112. *Cell Division*, 1998, Habersham Hall, Savannah College of Art and Design, Savannah, GA (see pages 68-71)

113. *Bottleneck*, 1998, University of Michigan, Ann Arbor, MI

114. *In Nature's Sway*, 1998, Evanston Art Center, Evanston, IL

115. *Lemonwheel*, 1998, Lemonwheel Music Festival, Limestone, ME

116. *High Strung*, 1998, Ackland Art Museum, Chapel Hill, NC

117. *Dixie Cups*, 1998, University of Wisconsin, Madison, WI

118. *Short Cut* (interior), *Easy Does It* (exterior), 1998, Hollywood Art and Cultural Center, Hollywood, FL

119. *Be It Ever So Humble*, 1999, Savannah College of Art and Design, Savannah, GA

120. *Greenware*, 1999, Alfred University, Alfred, NY

121. *Garden Variety*, 1999, Artsplosure, Raleigh, NC

122. *From the Castle's Kitchen*, 1999, Schloss Ebenau, Weitzelsdorf, Austria

123. *Jug or Naught*, 1999, Frederik Meijer Gardens & Sculpture Park, Grand Rapids, MI (see pages 72-75)

124. *Balancing Act*, 1999, Compton Verney, Warwick, England

125. *Owache*, 1999, Northern Illinois University Art Museum, Dekalb, IL (see pages 76-77)

126. *Rough Cut*, 1999, Ft. Lauderdale Museum of Art, Ft. Lauderdale, FL

127. *Whatchamacallit*, 2000, National Museum of Natural History, Smithsonian Institution, Washington, DC

128. *Sleepwalking*, 2000, Atelier 340 Muzeum, Brussels, Belgium (see pages 78-79)

129. *Set for LUYALA*, 2000, Bryan Center at Duke University, Durham, NC

130. *Keepsake*, 2000, John Michael Kohler Arts Center, Sheboygan, WI

131. *Wound Up*, 2000, Weston Art Gallery at the Aronoff Center, Cincinnati, OH

132. *Yard Work*, 2000, Symposium d'Art Nature, Cime et Racines, Quebec, Canada

133. *Abracadabra*, 2000, Swarthmore College, Swarthmore, PA (see pages 80-83)

134. *Cakewalk*, 2000, Bowling Green State University, Bowling Green, OH

135. *Tea Time*, 2000, Lancaster Museum of Art, Lancaster, PA

136. *Standby*, 2001, Raleigh-Durham International Airport, Raleigh, NC

137. *Spittin' Image*, 2001, South Carolina Botanical Garden, Clemson, SC (see pages 84-87)

138. *Slip-Slidin'*, 2001, Meyers School of Art, University of Akron, Akron, OH

139. *Paradise Gate*, 2001, Smith College, Northampton, MA

140. *St. Denis Tower*, 2001, Djerassi Foundation grounds, Woodside, CA

141. *Rerun,* 2001, Iscol Estate, Pound Ridge, NY

142. *Tea for Two*, 2001, Eskin Residence, Aspen, CO

143. *Simple Pleasures*, 2001, Bowdoin College Museum of Art, Brunswick, ME (see pages 88-91)

144. *Full Court Press*, 2001, Munson-Williams-Proctor Arts Institute, Utica, NY

145. *The Real McCoy*, 2002, Huntington Museum of Art, Huntington, WV

146. *Threadbare*, 2002, University of Cincinnati, Cincinnati, OH (see pages 92-93)

147. *Off the Beaten Path*, 2002, Stone Quarry Art Park, Cazenovia, NY

148. *Call of the Wild*, 2002, Museum of Glass, Tacoma, WA (see pages 94-97)

149. *Headstrong*, 2002, Boise Art Museum, Boise, ID

150. *The Cure*, 2002, Brattleboro Museum, Brattleboro, VT

151. *Mum's the Word*, 2002, San Diego Wild Animal Park, San Diego, CA

152. *Twiganometry*, 2002, Carleton College, Northfield, MN

153. *Shades of Home*, 2002, Marianna Kistler Beach Museum of Art, Kansas State University, Manhattan, KS

154. *A Cappella*, 2003, Villa Montalvo, Saratoga, CA

155. *Fiddlesticks*, 2003, Children's Museum of Richmond, Richmond, VA

156. *Just around the Corner*, 2003, the village commons of New Harmony, IN (see pages 98-103)

157. *Bivouac,* 2003, Three Rivers Arts Festival, Pittsburgh, PA

158. *Rough Housin'*, 2003, Powell Gardens, Kingsville, MO

159. *Na Hale 'Eo Waiawi*, 2003, The Contemporary Museum, Honolulu, HI (see pages 104-9)

160. *Cabin Fever*, 2003, Maclaren Art Centre, Barrie, Ontario, Canada

161. *Hat Trick*, 2003, Faulconer Gallery, Grinnell College, Grinnell, IA (see pages 110-13)

162. *Cascadia*, 2003, Lynden Pioneer Museum, Lynden, WA

163. *Haywire,* 2004, Bay Area Discovery Museum, Sausalito, CA

164. *Arcadia*, 2004, on the street in front of Artspace, West Edge Arts District, Shreveport, LA

165. *Growth Spurt*, 2004, in front of Heger Tor [Heger Gate], Osnabrück, Germany

166. *Putting Two and Two Together*, 2004, Leigh Yawkey Woodson Art Museum, Wausau, WI (see pages 114-17)

167. *Rough around the Edges*, 2004, Allentown Art Museum, Allentown, PA

168. *On the Outskirts of Town*, 2004, Artspace, Shreveport, LA

169. *Cue Ball*, *Cross Hatching*, *Doin' the Locomotion*, *Free Wheeling*, *Tower Vertigo*, 2004, Grounds for Sculpture, Hamilton, NJ

170. *Inside View*, 2005, Augusta State University, Augusta, GA

171. *Toad Hall,* 2005, Santa Barbara Botanic Garden, Santa Barbara, CA (see pages 118-25)

172. *Trail Heads*, 2005, North Carolina Museum of Art, Raleigh, NC (see pages 126-29)

173. *L'Aurore des Borries*, 2005, Savannah College of Art and Design, Lacoste, France

174. *Twigamore*, 2005, Sioux City Art Center, Sioux City, IA

175. *Still Life with Sticks*, 2005, Indianapolis Art Center, Indianapolis, IN

176. *Roustabout*, 2005, Community Council for the Arts building, Kinston, NC

177. *Side Steppin'*, 2005, Nasher Museum of Art, Duke University, Durham, NC

178. *Pines Portico*, 2005, Penland School of Crafts, Penland, NC

179. *Out in the Sticks*, 2006, Wieden and Kennedy Building, Portland, OR

180. *Foreplay*, *Arabasque*, *Nine Lives*, *Room to Spare*, 2006, Franklin Park Conservatory, Columbus, OH (see pages 130-33)

181. *Close Ties*, 2006, Brahan Estate, Dingwall, Scotland (see pages 134-39)

182. *Half a Dozen of the Other*, 2006, Cornell University, Ithaca, NY

183. *Square Roots*, 2006, David Winton Bell Gallery, Brown University, Providence, RI

184. *Just for Looks*, 2006, Max Azria Melrose Boutique, Los Angeles, CA (see pages 140-45)

185. *Stir Crazy*, 2007, Frederik Meijer Gardens & Sculpture Park, Grand Rapids, MI

186. *Childhood Dreams*, 2007, Desert Botanical Garden, Phoenix, AZ (see pages 146-51)

187. *Home Sweet Home*, 2007, Village green at Palmetto Bluffs resort, Bluffton, SC

188. *Xanadu*, 2007, Morton Arboretum, Chicago, IL (see pages 152-57)

189. *Second Sight*, 2007, Palm Springs Art Museum, Palm Springs, CA (see pages 158-61)

190. *So Inclined*, 2007, Middlebury College Museum of Art, Middlebury, VT (see pages 162-67)

191. *Simple Logic*, 2007, DePauw University, Greencastle, IN

192. *Catawampus*, 2008, Los Angeles County Arboretum and Botanic Garden, Arcadia, CA (see pages 168-73)

193. *Lookout Tree*, 2008, Turtle Bay Arboretum, Redding, CA (see pages 174-79)

194. *Stickwork*, 2008, Museum of Outdoor Art, Denver, CO

195. *Sortie de Cave*, 2008, Parc Ar Milin, Chateaubourg, France (see pages 180-93)

196. *Ruaille Buaille*, 2008, Sculpture in the Parklands, Tullamore, County Offaly, Ireland

197. *Shortcut*, 2008, University of Wyoming, Laramie, WY

198. *Hocus Pocus*, 2008, Bittersweet Farms, Ennice, NC (see pages 194-97)

199. *Twisted Sisters*, 2008, Wheaton College, Norton, MA

200. *Restless by Nature*, 2008, Ada Hayden City Park, Ames, IA (see pages 198-201)

201. *Creature Comforts*, 2008, Colorado College, Colorado Springs, CO

202. *Upper Crust*, 2009, Joseph L. Alioto Performing Arts Piazza, San Francisco, CA

203. *Lookin' Good, Lookin' Good*, 2009, Montgomery Museum of Fine Arts, Montgomery, AL

204. *Summer Palace*, 2009, Morris Arboretum of the University of Pennsylvania, Philadelphia, PA

205. *Bedazzler,* 2009, Spencer Museum of Art, University of Kansas, Lawrence, KS

206. *The Rambles*, 2009, Florence Griswold Museum, Old Lyme, CT

207. *Your Story*, 2009, Joslyn Art Museum, Omaha, NE

208. *Here's Lookin' at You,* 2009, Bosque School, Albuquerque, NM

209. *Hedging Your Bets*, 2009, Mulvane Art Museum, Washburn University, Topeka, KS

210. *Outside the Box*, 2009, North Carolina Museum of Art, Raleigh, NC

Further Reading

Banti, Sara. "Nidi D'autroe." *Casamica,* November 2007, 63-66.

Beardsley, John. *Art and Landscape in Charleston and the Low Country*. Washington, DC: Spacemaker Press, 1998.

Beardsley, John. *Earthworks and Beyond*. 3rd ed. New York: Abbeville Press, 1998.

Cooper, Audrey. "A Tree Sculpture Grows in Civic Center." *San Francisco Chronicle*, February 22, 2009.

de Rooij, Marie Jeanne. "Art in Nature — Nature in Art." *Bloom,* June 2001, 102-7.

Deitz, Paula. "Switch-Hitter: Patrick Dougherty has Built His House the Same Way as His Twig Art, by Hand." *House & Garden*, June 2002, 88-92.

Dewberry, Elizabeth. "Branching Out." *Southern Accents*, May-June 2009, 84-89.

Dougherty, Patrick. *Patrick Dougherty*. Self-published catalog, 2008.

Edwards, Charlottes. "Sticks in Time." *World of Interiors*, August 2007, 88-93.

Farrell, Kate. "Dream Nests." *Resurgence,* July-August 2003, 52-53.

Feireiss, Kristin and Lukas Feireiss, eds. *Architecture of Change*. Berlin, Germany: Gestalten, 2008.

Fleming, Lee. "Nesting Instincts." *Garden Design*, July-August 1993, 18-21.

Fogel, Faith. "An Intersection with Patrick Dougherty." *Art New England*, April-May 2003, 13.

Genocchio, Benjamin. "Talk About a Strong Nesting Instinct." *New York Times*, October 31, 2004.

Grande, John K. *Art Nature Dialogues: Interviews with Environmental Artists*. Albany, NY: State University of New York Press, 2004.

Grande, John K. "Yardworking: Interview with Patrick Dougherty." *Artfocus*, January 2001, 23-26.

Hammatt, Heather. "Sticking With It." *Landscape Architecture*, March 2001, 86-89.

Ingalls, Zoe. "Branches and Conversation are an Artist's Media at Smith College." *Chronicle of Higher Education*, May 4, 2001.

Johnson, Linda L. *A Dialogue with Nature: Nine Contemporary Sculptors*. Washington, DC: The Phillips Collection, 1992.

Jones, Mimi. "Twigonometry: Patrick Dougherty's New Spin on Art." *Reader's Digest*, October 2002, 130-33.

Keeps, David A. "A Look that Sticks," *Los Angeles Times*, November 23, 2006.

Klanten, Robert. *Spacecraft II: More Fleeting Architecture and Hideouts*. Edited by Lukas Feireiss. Berlin: Gestalten, 2009.

Kobasa, Stephen Vincent. "Wood Working." *New Haven Advocate*, August 6, 2009.

Lebow, Edward. "Patrick Dougherty." *American Craft*, June-July 2005, 32-37.

Nakamura, Hideki. "Patrick Dougherty." *Ikebana Ryusei,* August 1993, 28-30.

Nickamatul, Huang. "Strange Forces & Hidden Places." *Home Concepts,* August 2008, 32-37.

Niros, Bertrand. "Architectures de Brindilles." *Marie Claire Maison*, April 2007, 168-71.

Out of the Cellar. Directed by Aurelie Froc. Chateaubourg, France, 2008. Available for viewing at http://www.stickwork.net/resources.php.

Perreault, John. "Patrick Dougherty: Sculpture of the Third Kind." In *Crits: Discourses on the Visual Arts*, edited by Robert Godfrey, 20-25. Cullowhee, NC: Western Carolina University, 1989.

Py-Lieberman, Beth. "The Twigman Cometh." *Smithsonian*, December 2000, 124-28.

Redd, Chris. "Interview: Patrick Dougherty." *Art Papers*, July-August 1989, 26-32.

Reilly, Jesse. "Patrick Dougherty Creates Art that Breathes." *Montgomery News*, April 13, 2009.

Renzi, Jen. "Nesting Instinct." *Interior Design*, August 2007, 182-87.

Richardson, Phyllis. "Stick Figures." In *XS Green: Big Ideas, Small Buildings*. London: Thames and Hudson, 2007, 66-71.

Richardson, Tim. "Wickerman." *Daily Telegraph,* November, 24, 2001.

Rocca, Alessandro. "Patrick Dougherty." In *Natural Architecture*. Milan: 22 Publishing, 2006, 160-71.

Rogalski, Ulla. "Elle Incontra Patrick Dougherty Incantesimi Vegetali." *Elle* (Italian)*,* February 2002, 114-18.

Ronnau, Jorn. *Krakamarken: Land Art As Process*. Auning, Denmark: Forlaget Djurs, 2001.

Rudge, Geraldine, ed. "Bending the Rules." *CRAFTS*, November-December 1991, 34-37.

Siedel, Barbara. *Intimate Agenda: Inside the Creative Process*. Aspen, CO: Third Eye Press, 1996.

Smith, Virginia A. "Big Sticks, Speaking Softly." *Philadelphia Inquirer*, April 10, 2009.

Sokolitz, Roberta. "Linear Energy: An Interview with Patrick Dougherty," *Sculpture Magazine*, March 2000, 18-25.

Sozanski, Edward. "Brushes with Art." *Philadelphia Inquirer,* October 5, 2000.

Summers, Pat. "Patrick Dougherty: Itinerant Artist." *Sculpture Magazine*, July-August 2005, 52-57.

Teal, Monika. "Playing by the Rules of Nature: Patrick Dougherty's Installations Have a Life of Their Own." *The Arts Journal* 16, no. 5 (February 1991), 4-7.

Temin, Christine. "10 Best in Visual Arts." *Boston Sunday Globe*, December 30, 1990.

Thym, Jolene. "Sticks and Domes." *Oakland Tribune*, April 15, 1998.

Turner, Elisa. "The Heart of His Art: Trees, Branches Make Sculptor's Livelihood a Pleasure." *Miami Herald*, February 20, 1995.

Twisted Logic. Produced by Rich Butterfoss. Pennington, NJ: BG&V Productions, 2005. Available for viewing at http://www.stickwork.net/news.php.

VanDeMark, Suzanne. "Art in the Landscape: Weaving Wood, People, and Place." *Landscape Architecture*, September 2007, 22-29.

Wodek. An essay by John Grande. In *Le Mouvement Intuitif: Patrick Dougherty/Adrian Maryniak*. Brussels: Atelier 340 Muzeum, 2004.

Yilmaz, Burcin. "Heykele Donusen Agaclar" [Trees Transformed into Sculpture]. *Yapi*, August 2007, 102-5.

Image Credits

1 Jim Fraher, courtesy of Sculpture in the Parklands, County Offaly, Ireland

2-3 Richard Levy

4-5 Karen Malinofsky, courtesy of North Carolina Museum of Art, Raleigh, NC

6 Jerry Hardman-Jones, courtesy of Yorkshire Sculpture Park, West Bretton, England

7, 135-39 Fin Macrae, courtesy of Basketmakers' Circle

8-9 Rob Cardillo, courtesy of Morris Arboretum of the University of Pennsylvania, Philadelphia, PA

10 Scott Bauer, courtesy of Colorado College, Colorado Springs, CO

15 Charles Crie, courtesy of Jardin des Arts, Chateaubourg, France

19 top left Dennis Cowley

19 top center Tadahisa Sakurai, courtesy of Ikebana Ryusei magazine, Chiba-Ken, Japan

19 top right, 57 top, 57 bottom Hatten 18, courtesy of TICKON Sculpture Park, Langeland, Denmark

19 bottom left, 35, 36 bottom, 37 George Vasquez, courtesy of the DeCordova Museum and Sculpture Park, Lincoln, MA

19 bottom right Tadahisa Sakurai, courtesy of Ikebana Ryusei

21 top Dawn Barrett

21 bottom right Glenn Mitchell Tucker, courtesy of North Carolina Museum of Art

21 bottom left, 26-27, 36 top, 39-43, 58-59, 66-67, 70, 93 bottom, 116-17, 123 Patrick Dougherty

25 James T. Murray

29 Buddy Fong

31-33 Richard Nicol, courtesy of Henry Art Gallery, University of Washington, Seattle, WA

45 Tadahisa Sakurai, courtesy of Ikebana Ryusei

47 Diane Neptune

49-51 Jorn Ronnau

53 Sam Wong, courtesy of Brooks Museum of Art, Memphis, TN

54 Courtesy of South Carolina Botanical Garden, Clemson, SC

55 Dave Lewis, courtesy of South Carolina Botanical Garden

61-63 Dennis Cowley

65 Karl Browne, courtesy of Tallaght Community Art Centre, Dublin, Ireland

69, 71 Wayne Moore, courtesy of Savannah College of Art and Design, Savannah, GA

73 David R. Ferris, courtesy of Frederick Meijer Garden & Sculpture Park, Grand Rapids, MI

74-75 Caleb Brennan, courtesy of Fredrick Meijer Garden & Sculpture Park

77 Larry Gregory, courtesy of the Northern Illinois University Art Museum, DeKalb, IL

79 Wotjek Konarzewski, courtesy of Atelier 340 Muzeum, Brussels, Belgium

81 Eric Mencher

82-83 Diane Mattis, courtesy of the Scott Arboretum, Swarthmore College, Swarthmore, PA

85-87 Courtesy of South Carolina Botanical Garden, Clemson University, Clemson, SC

89-91 Melville McLean, courtesy of Bowdoin College Museum of Art, Brunswick, ME

93 top Jay Yocis, courtesy of the University of Cincinnati, Cincinnati, OH

95-97 Duncan Price, courtesy of Museum of Glass, Tacoma, WA

99-103 Doyle Dean, courtesy of New Harmony Gallery, New Harmony, IN

105-9 Paul Kodama, courtesy of The Contemporary Museum of Honolulu, Honolulu, HI

111-13 Dan Strong, courtesy of Faulconer Gallery of Grinnell College, Grinnell, IA

115 Richard Wunsch, courtesy of Leigh Yawkey Woodson Art Museum, Wausau, WI

119-21, 124-25 Nell Campbell, courtesy Santa Barbara Botanic Garden, Santa Barbara, CA

122, 123 bottom Don Matsumoto, courtesy Santa Barbara Botanic Garden

127-29 Courtesy of North Carolina Museum of Art

131 Greg Sailor, courtesy of Franklin Park Conservatory, Columbus, OH

132-33 Jen Lindsey, courtesy of Franklin Park Conservatory

141-45 David C. Calicchio, courtesy of BCBG Max Azria Group

147-51 Adam Rodriguez, courtesy of Desert Botanical Garden, Phoenix, AZ

153 Jeffrey Ross

154, 155 top, 156-57 Tom Maday, courtesy of Morton
 Arboretum, Lisle, IL

155 bottom Gina Tedesco, courtesy of Morton Arboretum

159-61 Mark Stephenson, courtesy of Palm Springs Art
 Museum, Palm Springs, CA

163, 165-67 Tad Merrick, courtesy of Middlebury
 College, Middlebury, CT

164 Andy Lynch, courtesy of Middlebury College

169-72 Raul Roa, courtesy of Los Angeles County
 Arboretum and Botanic Garden, Arcadia, CA

173 Michelle Gerdes

175, 178-79 Harvey Spector, courtesy of Turtle Bay
 Arboretum, Redding, CA

176 Wyatt Olsen, courtesy of Turtle Bay Arboretum

177 Tom Vlaho, courtesy of Turtle Bay Arboretum

181-93 Charles Crie, courtesy of Jardin des Arts

195-97 Robin Dreyer

199-201 Matthew Corones, courtesy of city of Ames, IA

208 Jim Fraher, courtesy of Sculpture in the Parklands

Biography

Born in 1945 and raised in the woodlands of North Carolina, Patrick
Dougherty developed an appreciation for the utility of sticks during
childhood play and became aware that sometimes a thicket of branches
can achieve the effect of a natural drawing. Despite a career in
health administration, he continued to pine for wild places, and
in the early 1980s he tried his hand at weaving tree saplings into
large three-dimensional sketches. In subsequent years, Dougherty has
developed a body of work that seems to fly through trees, overtake
buildings, and define, in his stand-alone structures, a kind of modern
primitive architecture. He has made over two hundred sculptures
around the world and currently lives in Chapel Hill with his wife,
Linda, and his son, Sam.